HOW TO DRAW BOLD MANGA CHARACTERS

EBIMO

TUTTLE Publishing

Tokyo | Rutland, Vermont | Singapore

Contents

Chapter 1

Chapter 2

Chapter 3

Shining a Bold Light on a Bold Pose

A natural light effect as seen from diagonally above

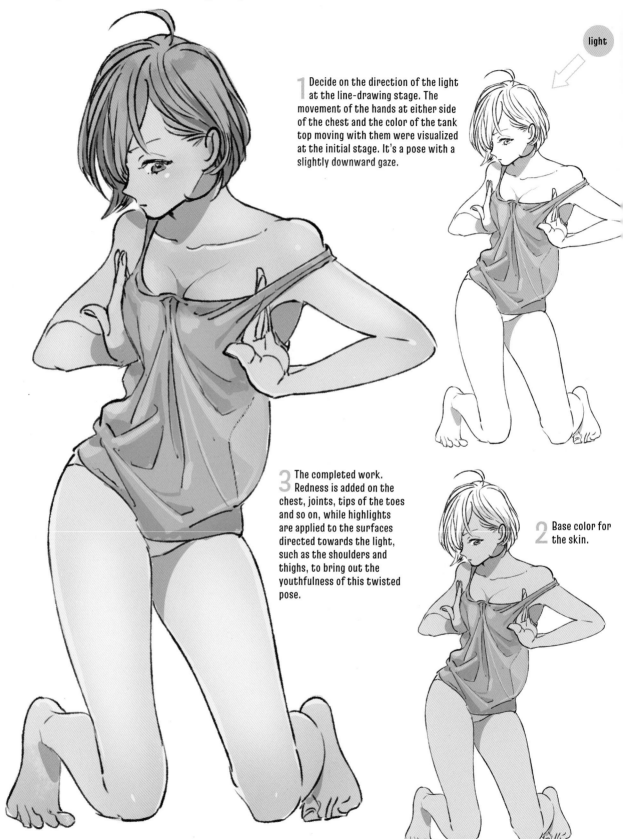

1 Decide on the direction of the light at the line-drawing stage. The movement of the hands at either side of the chest and the color of the tank top moving with them were visualized at the initial stage. It's a pose with a slightly downward gaze.

light

3 The completed work. Redness is added on the chest, joints, tips of the toes and so on, while highlights are applied to the surfaces directed towards the light, such as the shoulders and thighs, to bring out the youthfulness of this twisted pose.

2 Base color for the skin.

Spotlight effects

1 Prepare the line drawing. In this example, let's direct the spotlight onto the body from the front.

light

★The viewer's gaze is directed to the eyes of the character looking towards them as well as to the parts that are exposed when hit by light, heightening the sense of excitement for those viewing the work.

2 The base skin color and underwear color are applied at this stage. In order to compare the effect of light, the same skin color has been used as for the works on page 4.

3 The completed work. In order to make a bold, sexy pose attractive, light is concentrated on the arms and chest area to focus attention on them. As the light is slightly from below, the impression of viewing the figure from a low angle is strengthened. The color of the shadow is applied over the entire figure, then an airbrush is used to "hollow out" only the areas being lit up (the same method is used on page 18 to depict backlighting). Adding deep shadow to the rounded, blurred vignette and crisp lighting on parts with lots of undulations such as around the eyes and ears makes for a remarkable end result.

▲ Lighten the side to make it appear more solid.

▲

Narrow Down Colors to Paint with Shading

Example of a work where a "loop" is made into a dimensional skirt, light source coming from the front

Refer to the instructions on page 138.

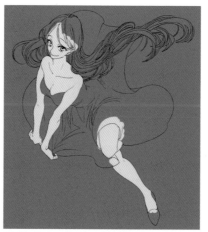

1 A deep color is used for the background of the line drawing so that it will be easy to find unpainted areas or areas where paint has gone outside the lines.

2 The base color for the skin is applied.

3 The base color for the dress is applied on a separate layer. This yellow-green color will cover a large area so factor it in to balance out the overall composition.

★The work on page 139 is the same line drawing iterated in the two tones of red and black with the skin left white. Try changing the overall feel through tones.

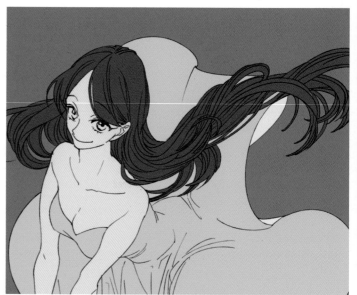

4 Maintaining the same hue as for the dress, whitish colors are applied to the reverse side of the dress and to the shoes to create cohesion.

5 Intermediate colors of navy and gray are used for the hair base. The yellow-green adds softness while the blue tones in the navy add a fresh feel, creating a light, cool impression.

*Hue refers to individual shades such as yellow and red.

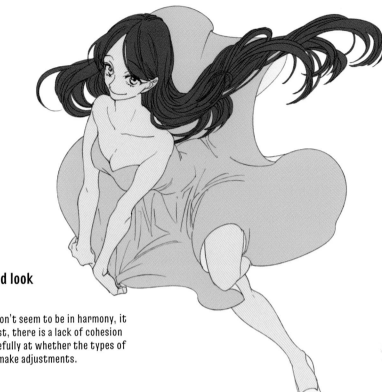

Delete the background and look at the overall balance

6 If the tones from each color don't seem to be in harmony, it indicates that at the very least, there is a lack of cohesion in the number of colors. Look carefully at whether the types of colors suit the overall image and make adjustments.

7 As colors containing gray were used overall, the eye color is blended to match the tone (top) and colored blue to tie in with the hair (bottom).

8 A small amount of nearly-blue purple is applied to the eyes to create nuance.

9 Multiplication mode is used to add color to the skin base. Dull reddish beige is blended in over the cheeks, shoulders and so on to bring out color.

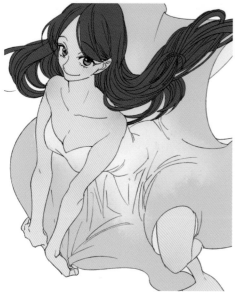

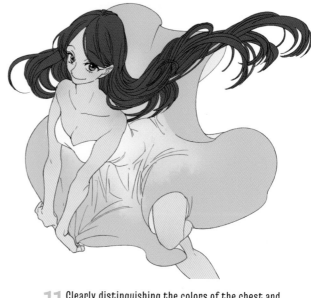

10 Movement is added to the single color of the dress. Increasing whitish surfaces makes for a cheerful impression.

11 Clearly distinguishing the colors of the chest and the upturned sections of skirt lends a sense of rhythm and solidity.

Hair is made lighter around the halo line.

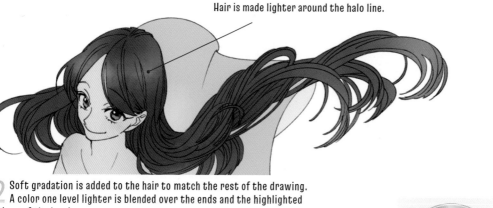

12 Soft gradation is added to the hair to match the rest of the drawing. A color one level lighter is blended over the ends and the highlighted sections of the head.

Blue shades are applied for shadows.

Apply shadow to the hair and clothes

13 The hair silhouette is treated as a single unit, with the entire silhouette considered when shadow is roughly applied.

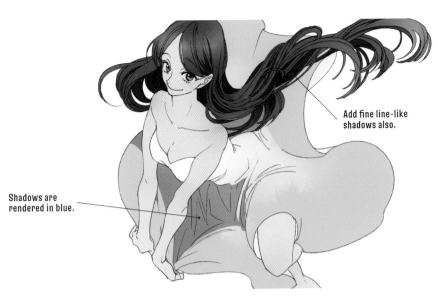

Pressure is applied to the pen to extend the crease line made in the line drawing.

Add fine line-like shadows also.

Shadows are rendered in blue.

15 The shadow created in the hollow of the flipped-up skirt is captured with a curved outline in order to play up the smooth movement in the fabric, while the inside is completely painted in.

14 Distinguishing between areas of deep shadow (the hidden section around the neck) and minimal shadow (the ends and the section billowing around at the front) in the hair brings out a sense of solidity, chibi-style. Shadow is also added where the clothing tapers.

Use shadows to create a sense of solidity

17 Creasing is added to the fabric caught under the bent leg.

16 Shadows are increased, following the creasing in the clothing.

18 In order not to lose the billowing in the skirt, shadows formed from both blocks and lines are used to render a sense of solidity.

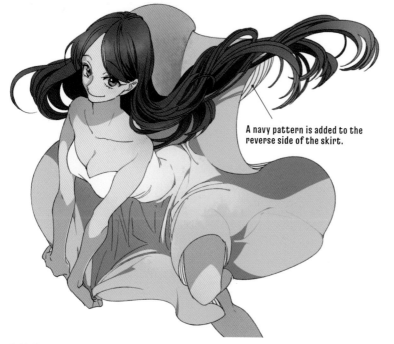

A navy pattern is added to the reverse side of the skirt.

19 Shadow is applied to the skin. The large shadow created by the head is dropped onto the shoulder area, while the area from the elbows down is entirely covered in shadow. Unlike in hair and clothing, fine wrinkles in the skin don't stand out so are erased completely. The shadows in the hollows of the body are rounded in line with protuberances in the flesh, while shadows formed by hair, clothing and so on are treated differently according to type.

20 The color of the line drawing is altered. The pure black of the line drawing is made slightly fainter in order to blend into the colors that have been painted. Reddish brown is applied to areas of the skin exposed to light, while deep navy is added to hair and deep green is added to clothing.

Correct the expression to complete the work

21 Gloss is added to the skin and highlights to the hair, but moderation is exercised so that the skin does not stand out too much. Fluid light is scattered over the hair in line with its flowing motion. The face is important, so lines in the eyes are made finer and eyelashes are added.

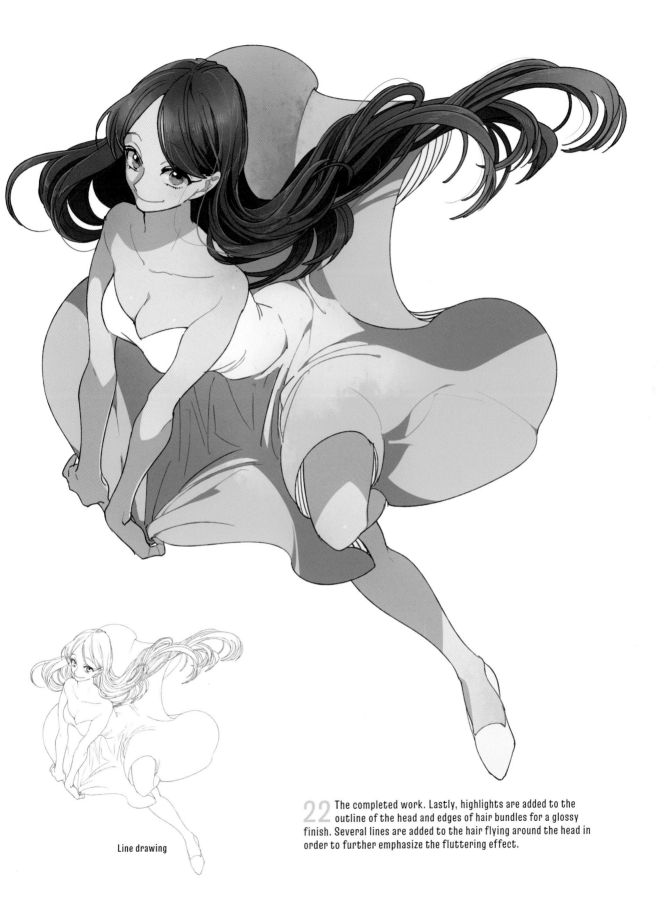

Line drawing

22 The completed work. Lastly, highlights are added to the outline of the head and edges of hair bundles for a glossy finish. Several lines are added to the hair flying around the head in order to further emphasize the fluttering effect.

Paint with Well-Defined Color Schemes

Example of a work where a "brush" has been used to bring out perspective: shine light from diagonally above

Refer to the instructions on page 150.

Brown is used as it works well with the skin.

1 As a well-defined color scheme is to be used, the thickness of the line around each body part is altered to create a sense of movement starting from the line drawing stage.

2 The base color for figure 1. The shirt and pants are both in blue shades. Teaming refreshing colors with the flirty vibe created by the facial expression and the way the clothes are worn adds a feeling of freshness.

★ Complementary color refers to colors that are exactly opposite one another on the color wheel. They serve to bring out each other's hue (see page 23).

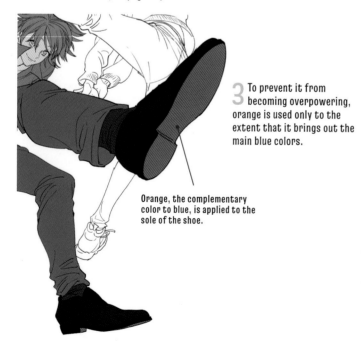

3 To prevent it from becoming overpowering, orange is used only to the extent that it brings out the main blue colors.

Orange, the complementary color to blue, is applied to the sole of the shoe.

4 Blue and orange are used for eyes that make an impression.

5 The stripe pattern is added in.

6 The pattern is added in line with the divisions created by the body's roundness and the flow of creases in the shirt.

7 The pattern is drawn in so that it incorporates the detailed convex and concave forms rather than appearing to float over them.

Check the color scheme for Figure 1

8 The stripes in the shirt and the vertical lines in the socks have been added at this stage.

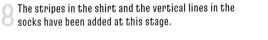

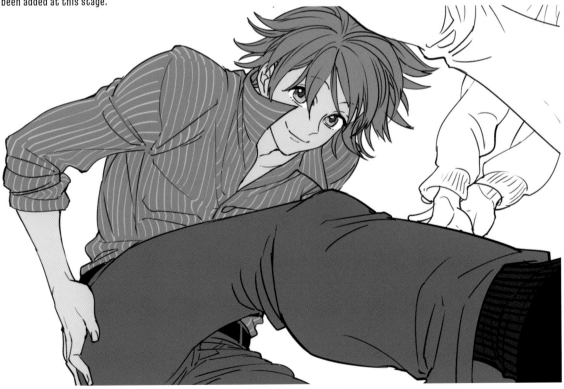

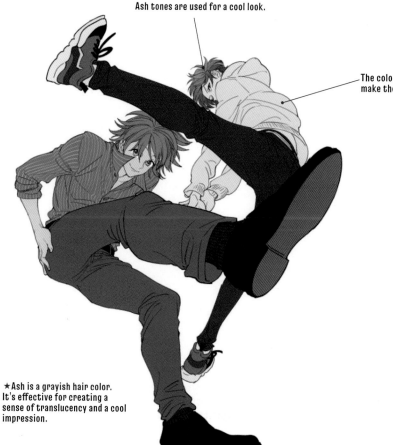

Ash tones are used for a cool look.

The color of the hoodie is kept simple to make the red pants stand out.

★Ash is a grayish hair color. It's effective for creating a sense of translucency and a cool impression.

9 For Figure 2, a color scheme is used that contrasts with Figure 1. Small, subtle points such as the color of the belt are used to add detail to simple colors. In order to bring a sense of presence to each character's clothing, a natural brown was chosen as the base color for the hair, making sure that it doesn't look blurry in particular areas or that there is too much visually confusing overlapping color.

Considering the balance of the pair's color scheme

Key Point

The color scheme is applied so that blue and red form two overlapping 〈 shapes.

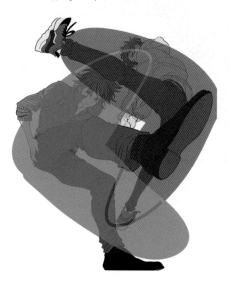

Roughly bringing colors together creates a sense of cohesion even when there are multiple colors.

Shadow is added in red tones

Large shadows are applied over hollowed-out areas.

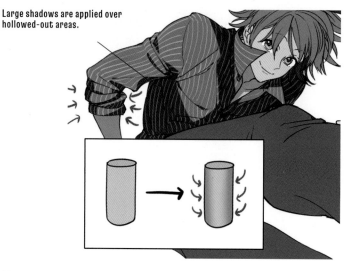

10 A new layer is created to add reddish beige shadows. For cylindrical body parts such as arms and legs, shadows are cast so as to wrap around both sides for a more solid appearance. This varies depending on the light source, but keep it in mind to bring out the form of an object.

12 Shadow from the raised right leg of the bending figure is boldly cast onto the left leg.

11 Shadows are cast onto the hair at the back on both sides of the head, following the roundness of the scalp for a look of solidity (top). This method was used in this instance, but varies according to the situation. Fine shadows are added into the bundles of hair also (bottom).

13 In the same way as for the creases in the shirt sleeve, shadows are applied around both sides of the leg for the effect of solidity.

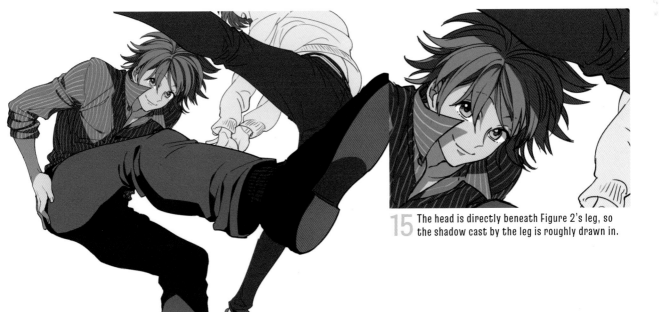

15 The head is directly beneath Figure 2's leg, so the shadow cast by the leg is roughly drawn in.

Use light and shade to adjust relative positions

14 As Figure 1's right leg is raised and a lot of its surface is exposed to light, keep the areas of shadow to a minimum to create a dynamic air.

16 In order to depict depth, the arms of Figure 2 in the background are encircled in shadow. First, make a large shadow.

17 Adjust the shape, as if shaving off the shadow. Use the edge of the shadow on the sleeves and cuffs to bring out the thickness of the fabric.

18 Add shadow to Figure 2's hoodie. In contrast to the fine, straight lines of shadow on Figure 1's shirt, cast curved shadows in the hollows of the parka as the fabric is soft and thick.

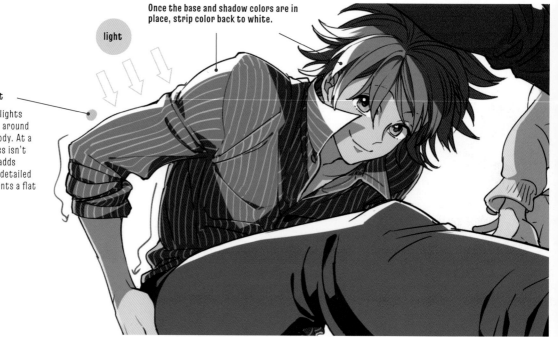

light

Once the base and shadow colors are in place, strip color back to white.

Light blue highlight

Use moderate highlights to remove borders around each part of the body. At a glance, this process isn't noticeable, but it adds dimension even to detailed sections and prevents a flat look.

19 Use white highlights to illuminate only the section in the top diagonal left, which gets the strongest direct light. Apply them only to sections of the shirt, pants and hair to make the crisp white stand out. As light and shade in the hair were quite strongly rendered at the shadow stage, white stands out more. Use moderate highlights to finish off the details.

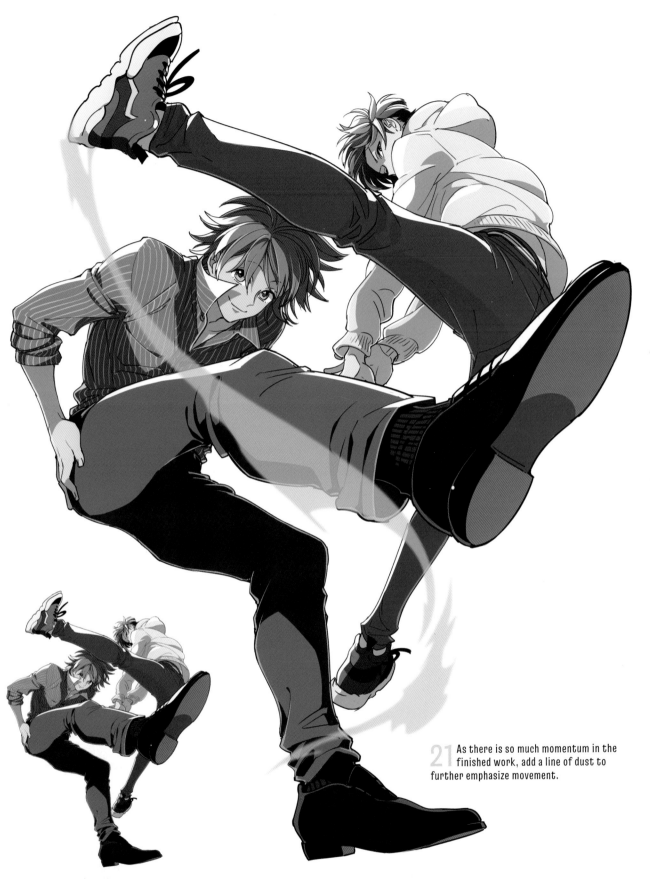

21 As there is so much momentum in the finished work, add a line of dust to further emphasize movement.

20 The completed work.

Paint in a Color Scheme that Expresses Personality

Example of a work that uses a grid to bring out depth: depicting backlighting

Refer to the instructions on page 154.

1 Paint all colors for all three figures in the same layer. It's common to put everything in the same layer when producing a work.

2 Decide on the base colors. Figure 1 (center) is in dull, calm tones, Figure 2 (right) is in mainly clear, pale shades and Figure 3 (left) is in bright, feminine colors. Think not only of the balance of the composition but the characters' traits and personalities in order to choose color schemes.

3 A new layer is used to color everything blue (temporary color) in multiplication mode. In the case of backlighting, shadow covers a large area so it's easier to get an idea of the work as a whole by painting everything in first and then using an eraser to scrape out only the areas where light hits.

A little light on the situation

Key Point

Alter the amount of light that hits the joints and the uneven surfaces of the muscles.

4 Start by scraping shadow off the hair little by little. If you take off too much, the backlighting effect will not be as strong, so exercise moderation.

5 Next, scrape shadow off the skin. For even sections with no bulges or hollows, scrape off just the edges and increase the light on the finger pads and around the joints.

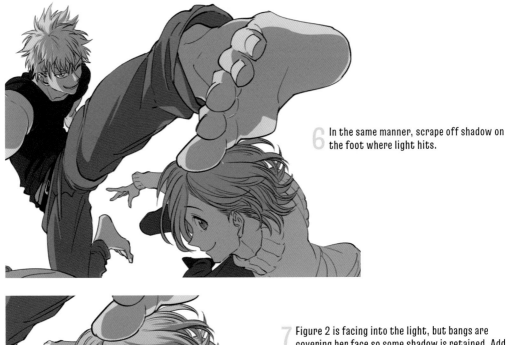

6 In the same manner, scrape off shadow on the foot where light hits.

7 Figure 2 is facing into the light, but bangs are covering her face so some shadow is retained. Adding light to the eye in shadow creates a more striking expression.

 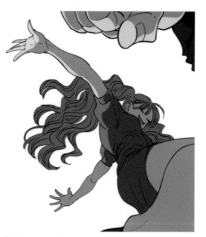 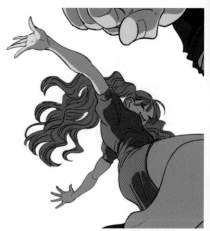

8 Direct light onto the boldly outstretched hand of Figure 3. There's no need to create the fine shadow in the finger joints as per Figure 1; simply scrape off shadow to leave a rough spot of light.

9 In terms of the overall picture, the hands are quite small parts at the very back. Extend a strip of light from the arms boldly over the back.

10 The buttocks and thighs are large, softly rounded body parts, so follow their form and scrape out shadow smoothly.

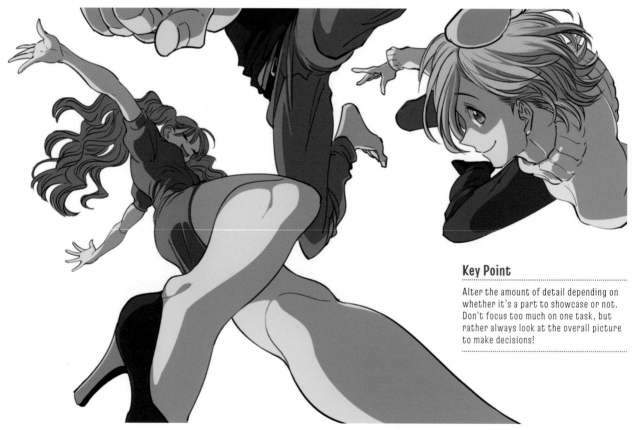

Key Point

Alter the amount of detail depending on whether it's a part to showcase or not. Don't focus too much on one task, but rather always look at the overall picture to make decisions!

11 As the legs are so large due to perspective and the use of an extreme angle, it is hard to capture their shape properly. Carefully finish off each part that was not incorporated into the line drawing, such as bumps and hollows in the knees, protuberances and indentations in the ankles and so on.

12 Unlike the limbs, the bundles of hair are irregular, so work in slightly detailed light over several stages. Start by removing shadow from the outer sections.

13 When adding light to the inner sections, look carefully at the flow of the hair and make sure the light follows it. Removing shadow at random lessens the backlighting effect in that particular section only, so work with care.

Look at the overall picture to check for bias in the light distribution

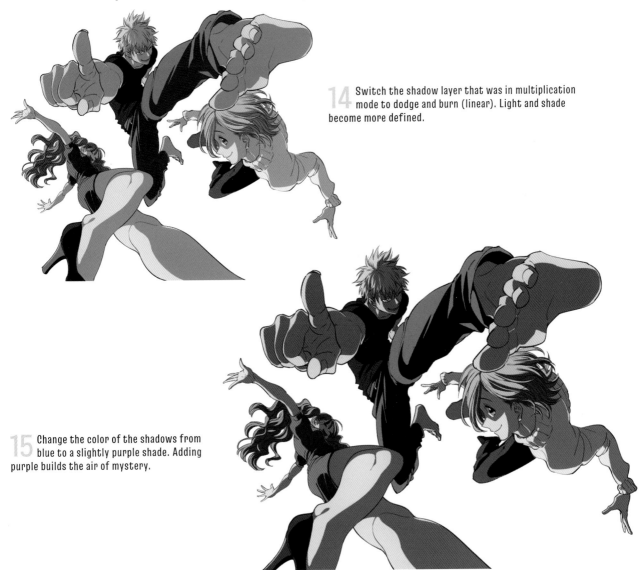

14 Switch the shadow layer that was in multiplication mode to dodge and burn (linear). Light and shade become more defined.

15 Change the color of the shadows from blue to a slightly purple shade. Adding purple builds the air of mystery.

Add blurring effects to soften the overall impression.

16 Hide the shadow and line drawing layers for a moment. Duplicate the base color layer and apply blurring.

17 After applying blurring, drop opacity to about 60 percent.

18 Switch straight to multiplication mode. Duplicate over the layer with the base color and the layer with the shadows and bring in the layer with blurring. This creates a relaxed impression overall.

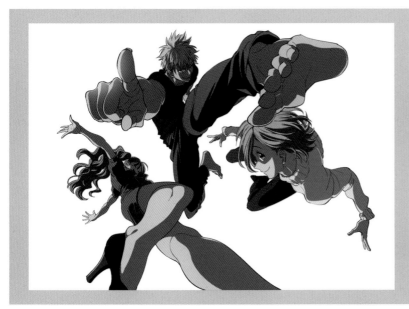

19 overall image with line drawing displayed.

19 Overall image with line drawing displayed.

Key Point

Example of expressing characters' traits and personalities through color schemes Figure 1 (center) is masculine in black and khaki. Figure 2 (right) is in a pale sweater to suit her androgynous facial features and hairstyle. Figure 3 (left) is in bright red that matches her cheerful expression. The purple of the shadows blends in well with the skin. Purple is a neutral shade in that it is neither a cool or warm color, and it is surprisingly versatile so I use it often.

20 Join all the layers except for the line drawing layer and create a screen layer over the top. Use the airbrush to lightly add white light to match the colors of each part in the well-lit areas marked with red circles. This creates an even more gently backlit look.

Color wheel

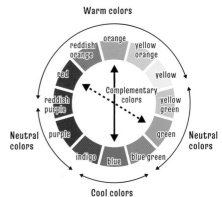

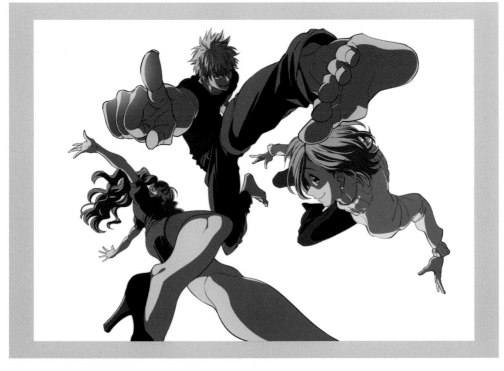

21 The sections where light was applied with the airbrush are made paler, making the pure black lines of the line drawing stand out a little, so soften the color in those areas only.

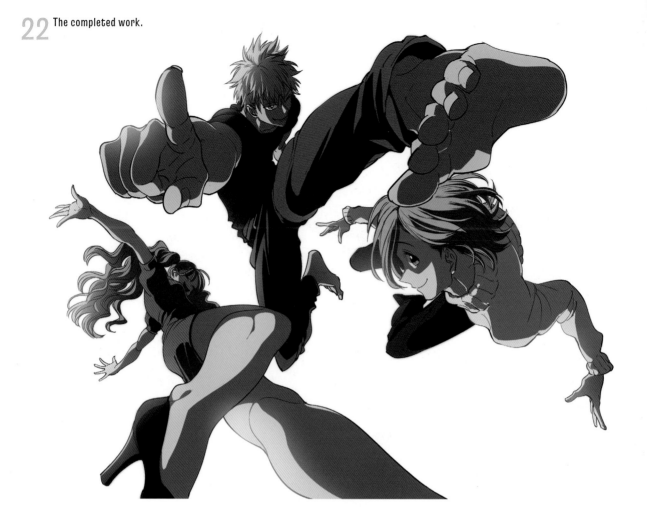

Closeups of each character

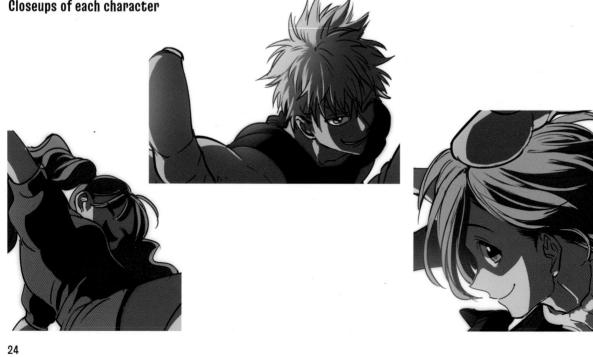

Blur the right hand of Figure 1 to look as if it is glowing with light. The left foot is also projecting out to the front, but in terms of posing, it is the finger pointing straight up on the right hand that we want the viewer to focus on, so it is here that light is focused to create a stunning result.

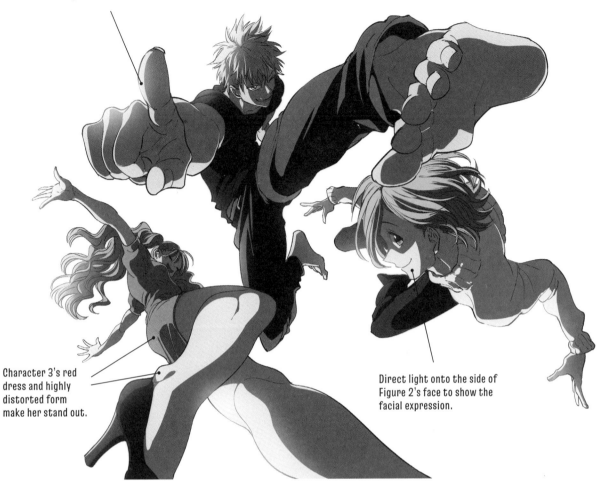

Character 3's red dress and highly distorted form make her stand out.

Direct light onto the side of Figure 2's face to show the facial expression.

▲ The work from page 24 transformed into monochrome. Viewed this way, it is clear that the purple shadows that indicate backlighting are not uniform, but rather the level of darkness is adjusted depending on the color scheme and positional relationship. Use backlighting effects to form edging around each character's outline, giving them the appearance of floating. Strong light directed from the left of the screen clearly sets out the parts intended for showcasing and making an impression.

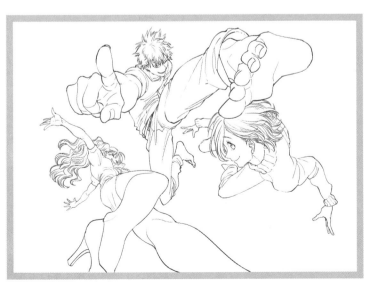

◀ Line drawing (see page 154). Use thick lines to draw the parts that are projecting out toward the front such as the hands and feet. For the flowing hair and detailed overlapping of creases in clothing, use fine lines.

To My Fellow Artists

In order to capture the movements of lively characters, it's not enough to simply learn the position of muscles and bones. It's important to connect each part so that you can draw without interrupting the body's flow. If you try to start by drawing the outline of the figure as it would look when completed, the form and movement will be rigid. Practice is the answer: Repeat the blocking-in and rough-sketching process over and over to get a handle on body mass and gradually produce accurate outlines. Here, the lines from rough sketches are used to offer approaches and practice methods for drawing free, realistic movement. Practice drawing lines that appear to flow, capturing the body's movement and creating attractive, appealing poses.

"Depth" is important for expressing movement

Examples of unnatural posing

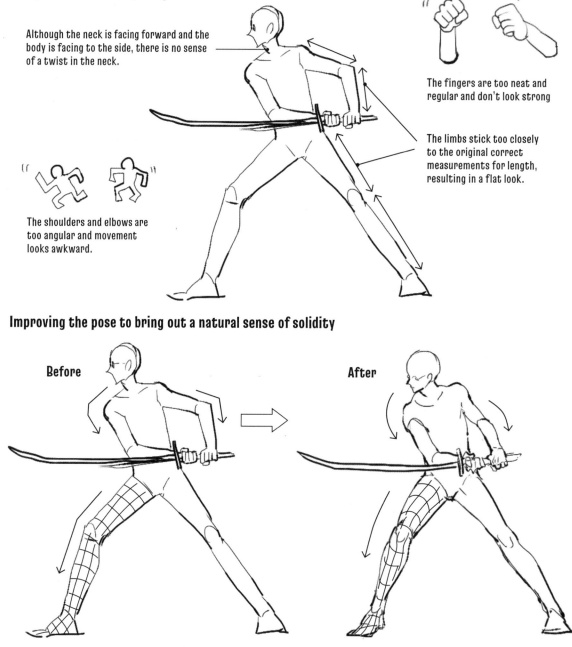

Although the neck is facing forward and the body is facing to the side, there is no sense of a twist in the neck.

The fingers are too neat and regular and don't look strong

The limbs stick too closely to the original correct measurements for length, resulting in a flat look.

The shoulders and elbows are too angular and movement looks awkward.

Improving the pose to bring out a natural sense of solidity

Before

After

Examples of posing with natural movement

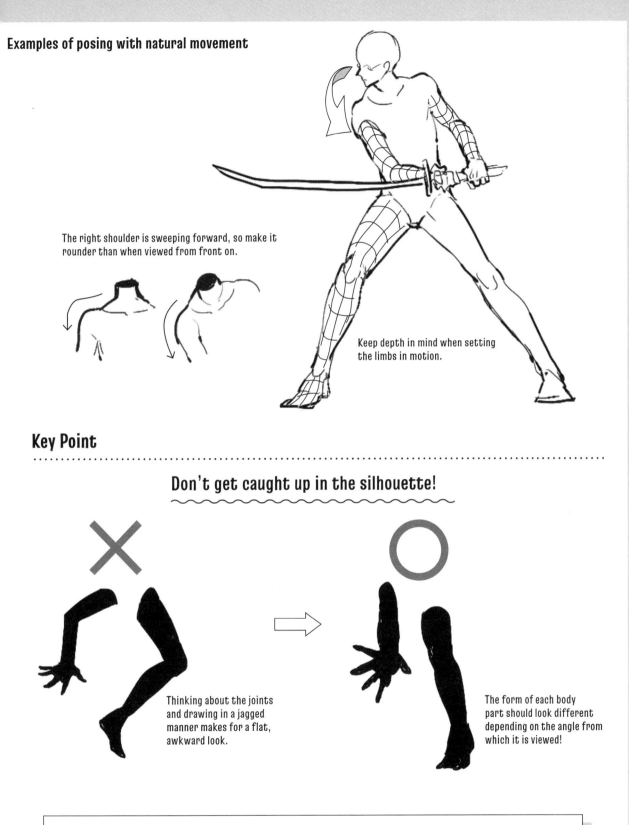

The right shoulder is sweeping forward, so make it rounder than when viewed from front on.

Keep depth in mind when setting the limbs in motion.

Key Point

Don't get caught up in the silhouette!

Thinking about the joints and drawing in a jagged manner makes for a flat, awkward look.

The form of each body part should look different depending on the angle from which it is viewed!

"Body depth" is something that's obvious but depicted surprisingly badly. Being aware of it will make it easier to capture bold movements and dramatically improve your illustrating abilities! From Chapters 1 to 3, I will show you hints and tricks on how to do this. Going through this book with these basic concepts of depth in mind will improve your understanding!

For Educational Purposes

(Images already published as tutorials/educational material on the Web)
The images can be used for commercial purposes; distribution of the images, however, is prohibited.

The illustrations included in this book are hand-colored using mechanical pencil and computer.
The graphic software used was Paint Tool SAI. However, the examples can be produced using other drawing and illustration software such as Clip Studio Paint Pro or your preferred platform or method.

This material is copyright protected and is solely to be used for educational purposes.
Please see the above note in regard to restrictions on the material's use.
For works posted on pixiv, please see the notes and conditions posted on that site.
The copyright of the illustrations published in this book belongs to Ebimo.

Let's Start with the Basic Standing Pose

The basis of many poses are rooted in one of the body's most frequently assumed positions: standing. If you carefully observe the pose, it's clear that standing isn't stationary but actually fluid, with various muscles being used to maintain balance. Start with a strong standing pose with the feet planted on the ground. The front and rear views of the standing pose can be rendered in approximately five-minute manga sketches, though it will take a bit of practice before you sketch them with ease.

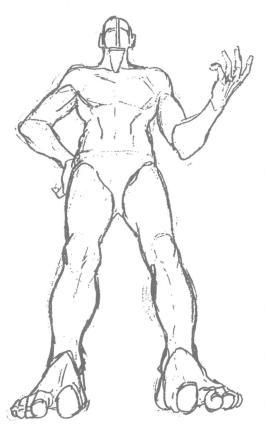

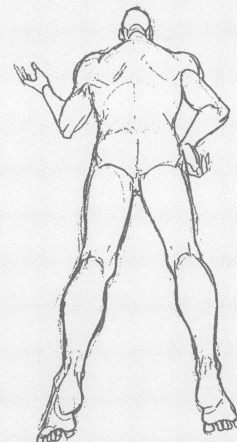

Use Patterns to Draw a Male Standing Pose

Start by using patterns to draw the male standing pose which forms the basis for this pose, in order to get a feel for the shape of the body and how to draw lines in.

① Head
When the pose does not emphasize other body parts, it's usual to start by drawing the head.

* This is the Ebimo way of doing things, so it's fine to start drawing from whichever point you like.

② Neck to chest
Movement in the neck and shoulder area has a tendency to become rigid, so use a smooth line to create flow down to the upper body.

③ Shoulders
Draw in the raised areas so that they connect at the back of the neck.

④ Shoulders to chest
Add the collarbone and neck tendons, rounding the shoulders to connect them to the collarbone and continuing the lines to below the pectoral muscles.

⑤ Torso
Continue the first lines for the neck to chest so that they connect to the torso.

⑥ Abdominal muscles
Draw in the abdominal muscles as extensions of the pectoral muscle lines in Step 4 (for a particularly muscular figure, make horizontal divisions also).

⑦ Arms and legs
Draw in the upper arms and thighs, making them slightly swollen and firm (adjust depending on physique).

The arms and legs are sprouting!

⑧ Arms and legs, continued
Continue drawing to form the wrists, hands and ankles, creating distinct tapering.

⑨ Feet
As a rule, feet point in the same direction as the knees, but making them point in different directions also works surprisingly well. This figure is about eight heads tall.

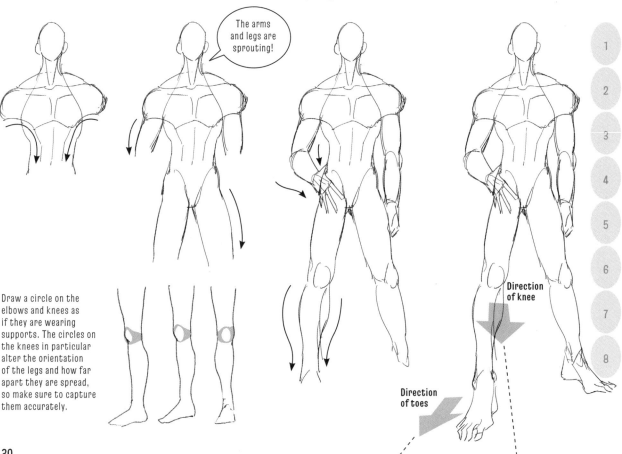

Draw a circle on the elbows and knees as if they are wearing supports. The circles on the knees in particular alter the orientation of the legs and how far apart they are spread, so make sure to capture them accurately.

Direction of knee

Direction of toes

Find the lines that indicate the flow of the body

The key point to quickly drawing a natural pose is to find the continuous body lines.

*For me, these lines are ironclad examples of continuous lines that connect body parts. There are many other examples of these lines.

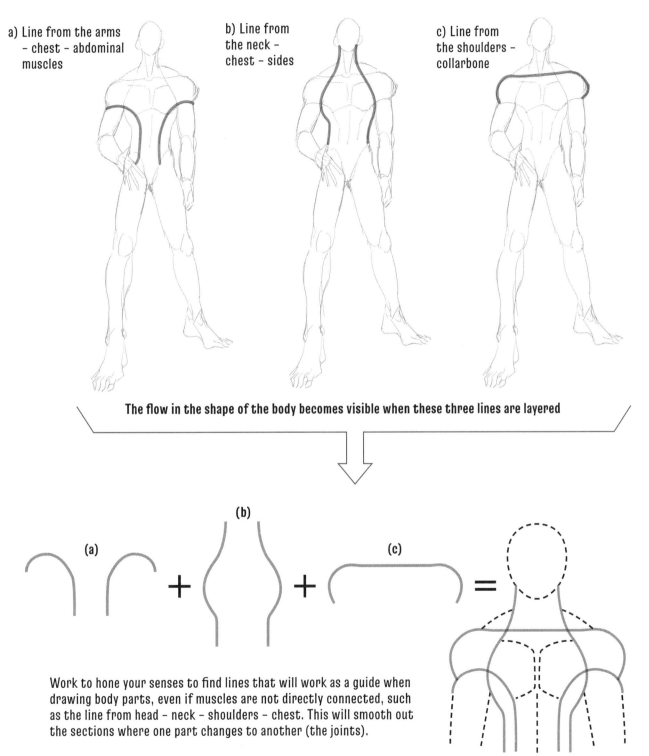

a) Line from the arms – chest – abdominal muscles

b) Line from the neck – chest – sides

c) Line from the shoulders – collarbone

The flow in the shape of the body becomes visible when these three lines are layered

(a) + (b) + (c) =

Work to hone your senses to find lines that will work as a guide when drawing body parts, even if muscles are not directly connected, such as the line from head – neck – shoulders – chest. This will smooth out the sections where one part changes to another (the joints).

Have a go at actual drawing from the next page onwards!

How to Draw a Male Standing Pose

Viewed from a position directly in front and level with the ground

1 Start with the head. This is a simple standing pose, so start drawing from the top down. The viewer's eyes are about level with the character's hips.

Progress after 1 minute

2 Adjust the width of the neck depending on the physique. Drawing the neck of a muscular male to be the same width as the head creates a cool look.

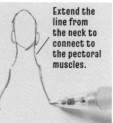

Extend the line from the neck to connect to the pectoral muscles.

3 Don't simply learn the position of muscles and bones, but draw so as not to interrupt the flow of the body where parts connect.

4 Add the shoulders as if fitting them onto the hollows created in the lines previously drawn from the neck to the pectoral muscles.

Connect the lines that indicate the flow of the body!

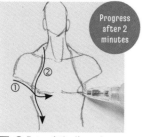

Progress after 2 minutes

5 ① Extend the line where the shoulder meets the upper arm to connect to the pectoral muscles. ② In the same way, make the line flow down to connect to the torso.

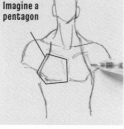

Imagine a pentagon

6 Joining the lines that extend from the shoulders and neck to the pectoral muscles makes it easier to draw pectoral muscles with a well balanced shape.

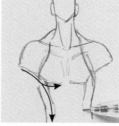

7 Branch out the line that extended from the shoulders to the pectoral muscles so that it forms the line outside the abdominal muscles.

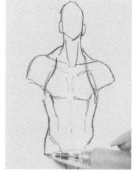

8 The line from the torso directly extends to the legs. Don't worry too much about the ratio between the torso and the legs, just go with what you think looks balanced.

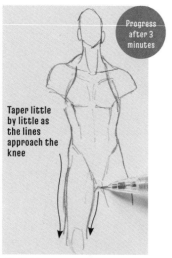

Progress after 3 minutes

Taper little by little as the lines approach the knee

9 Making sure the buttocks don't swell out to the sides, used smooth, curved lines to bring out tautness in the thighs.

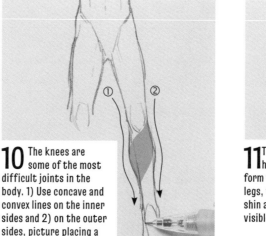

10 The knees are some of the most difficult joints in the body. 1) Use concave and convex lines on the inner sides and 2) on the outer sides, picture placing a mass of muscle on the gray section. Making the ankles narrow creates variance between the ankles and the calves to create firm, attractive legs (explanation of the legs continues in step 11).

11 The swells and hollows do not merely form the outline of the legs, they also form the shin and the calf muscle visible behind it.

For the foot, picture a triangular pyramid. The instep is higher on the big toe side than on the little toe side.

Keep drawing, adding in variations

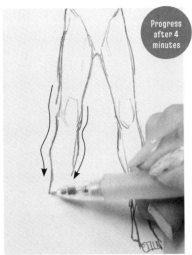

12 I drew the right leg with swells and hollows the same as the left leg, but somehow the outer side, which was meant to be smooth, ended up bumpy. I left it like this momentarily to continue drawing. I'll explain why later...

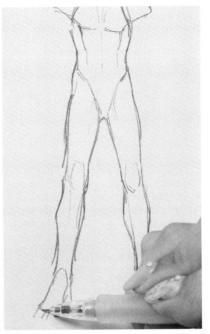

13 Draw the foot, imagining a triangular pyramid as for the left foot. Don't worry too much about symmetry between the feet.

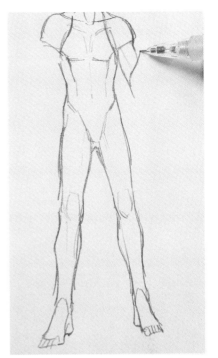

14 The foundation for the lower body is completed, so draw in the arms that were left out.

> Progress after 4 minutes

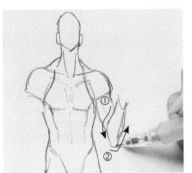

15 ① The arms are bent, so slightly broaden them to show the muscle is being pressed down. ② Make the elbow sharp and bony. The variance between 1 and 2 creates rhythm and, in the same way as for the legs, creates taut, cool arms.

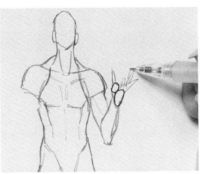

16 It's not only the fingers but also the palms that are often in motion. Clearly separating the muscles of the thumb and pinky sides creates the impression that the palm is tensed.

17 Follow the flow created up until now to draw the right arm. Slightly exaggerate the division created by the joint.

Completion of quick rough sketch

18 The rough sketch is complete.

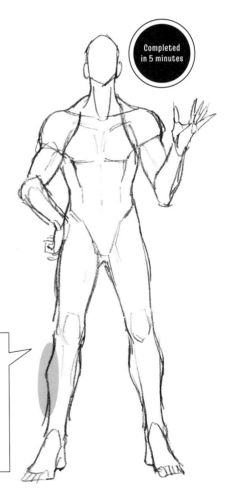

> Completed in 5 minutes

The reason for not correcting the right leg to look like the left leg in step 12

☆ I didn't want to interrupt the flow of the pen.

☆ Looking at the overall picture, it didn't bother me too much.

It's also because it is a rough sketch, but even if it were a line drawing, these kinds of judgments allow you to create flow in the body parts and the pen strokes and to keep drawing with a sense of rhythm.

Draw the rear view of the male example created on page 32

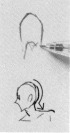
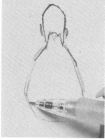

1 Draw the back of the head, imagining the skull firmly positioned on the neck.

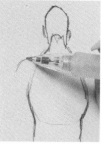

2 Start not with the muscles, but by lightly sketching the foundation for the back. Creating a foundation makes it easier to visualize a broad, masculine back.

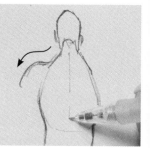

3 Draw in the taut waistline. The mass from the back to the waist forms the axis of the physique, so adjust it according to the type of character you have in mind.

4 Using the foundation of the back as a reference makes it easier to determine the position and width of the shoulders. Add in a line with inflections to show the bumps created by the spine to capture the median line that runs down the center of the body's surface.

Progress after 1 minute

5 For the join between the shoulders and upper arms, visualize an extension of the shoulder blades to create a fluid line. Be careful not to draw unnecessary lines of random muscle.

6 The elbow doesn't bend out directly to the side naturally, but rather slightly forward of the body. This is key for creating a sense of solidity.

7 Draw in the right arm as per the left, keeping the flow in mind.

Before completing the right hand, return to the back for a moment

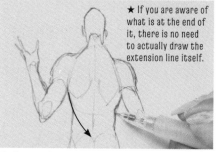

★ If you are aware of what is at the end of it, there is no need to actually draw the extension line itself.

8 Use the foundation for the back that you first drew and place the join of the buttocks at the end of the line that extends from the underarms along the outline of the body.

Progress after 2 minutes

9 Male buttocks are less ample than those of women and have slight dimple-like hollows at the sides. Make sure they don't spread out to the sides.

10 The join at the top of the legs is hidden by the buttocks, so adjustments need to be made to create legs of a well balanced length. In order to achieve the same balance as in the front view, use the length from the hips rather than from below the buttocks as a guide.

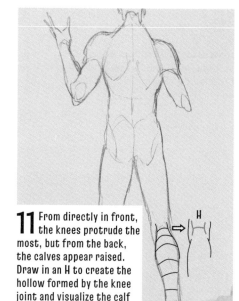

11 From directly in front, the knees protrude the most, but from the back, the calves appear raised. Draw in an H to create the hollow formed by the knee joint and visualize the calf as continuing down from the vertical lines of the H.

The Achilles tendon creates a cool rear view!

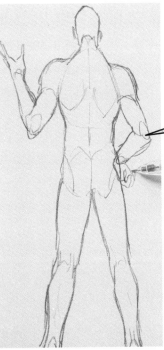

Progress after 3 minutes

12 Bring the curved line from the calf to the ankle slightly inwards and position the Achilles tendon above it. Don't simply sketch in lines randomly, but consider the flow as you draw.

What a randomly placed Achilles tendon looks like

✕

Just as for the shoulder blades, don't be sloppy when creating form.

13 Work directly down to the heel from the Achilles tendon. Capture adjacent sections of the body in a big lump rather than as individual parts.

14 The lower body is complete, so move on to the right arm. Be conscious of the sense of solidity formed when the elbow is bent not out directly to the side of the body but protrudes behind the back.

15 Draw the hand so it sits on the hollow at the hips.

Completed front and rear views

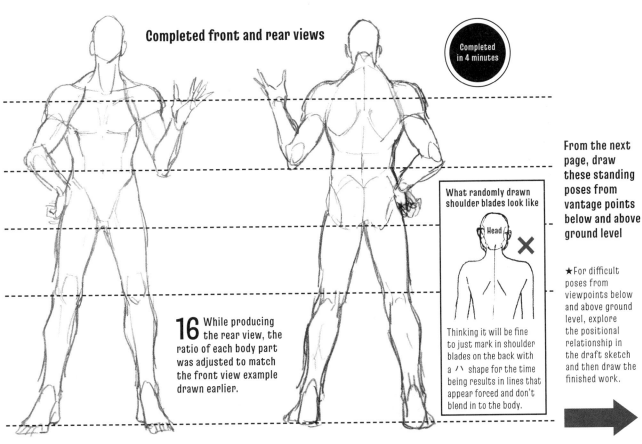

Completed in 4 minutes

16 While producing the rear view, the ratio of each body part was adjusted to match the front view example drawn earlier.

What randomly drawn shoulder blades look like

Head ✕

Thinking it will be fine to just mark in shoulder blades on the back with a ⌒ shape for the time being results in lines that appear forced and don't blend in to the body.

From the next page, draw these standing poses from vantage points below and above ground level

★For difficult poses from viewpoints below and above ground level, explore the positional relationship in the draft sketch and then draw the finished work.

A Manga Sketch in 5 Minutes: Front View, from Below

Time to produce: 7 minutes = **Draft:** 3 minutes +
Finishing touches: 4 minutes

*This sketch is actually completed in five minutes, including the draft and finishing touches. The time taken to stop work and photograph it is also counted, which is why slightly more time was needed.

1 Start from the head.

Draft sketch

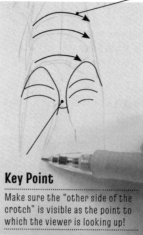

Run curved lines over the body to create depth.

Key Point

Make sure the "other side of the crotch" is visible as the point to which the viewer is looking up!

Progress after 1 minute

2 Roughly start sketching in the head and the body to get a broad understanding of their relative positions.

3 Smoothly connect the neck area.

4 Don't worry too much about the ratio between the upper and lower body while drawing in parts that indicate that the viewer is looking up.

5 Bring out roundness in joints such as the knees.

6 Making the area below the knee slightly longer than the area above it creates the effect of looking up.

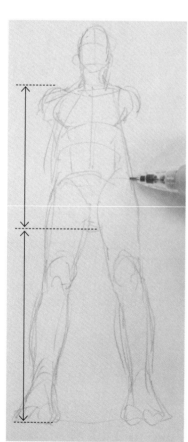

7 When drawing a figure from below, there is no set ratio between the upper and lower bodies, so just give it rough consideration—being aware enough of it to make the legs appear long is sufficient.

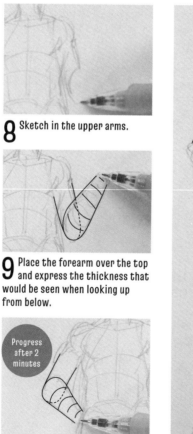

8 Sketch in the upper arms.

9 Place the forearm over the top and express the thickness that would be seen when looking up from below.

Progress after 2 minutes

10 It's easy to express thickness and angles in the joints. Be aware of roundness and depth when drawing them.

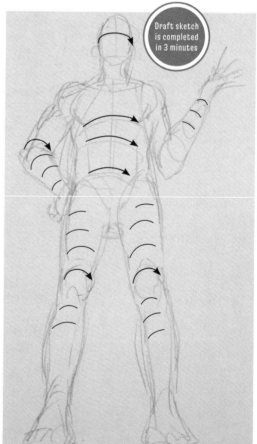

Draft sketch is completed in 3 minutes

11 Round out the entire body. Look at the overall figure to make sure no body part is overly long as you continue to draw.

1 Start with the head.

2 Decide on the position of the ears.

Key Point

Make sure not to trace over the draft sketch lines too much. Visualize the flow of the finished lines as you draw them, referring to the draft sketch lines purely as auxiliary lines that serve as guides. Being too careful about each individual part reduces the momentum in the line and tends to make for an unpolished overall impression.

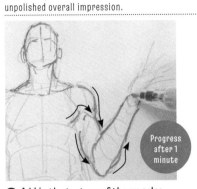

3 Add in the texture of the muscles which were not added at the draft sketch stage. Use curved lines so that the lines from each body part don't extend straight out and cross into each other.

Progress after 1 minute

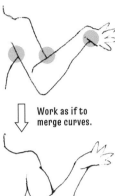

Work as if to merge curves.

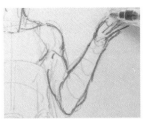

4 Flesh out the fingers that were sticks at the draft sketch stage.

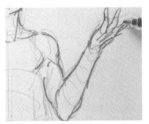

5 For detailed parts, drawing them as if "draft sketch = skeleton" and "finishing touches = adding flesh" will improve efficiency.

6 Work in the deltoid muscle on the right shoulder.

Progress after 2 minutes

7 Continuously checking that left and right are balanced, draw in the right side.

8 Make sure that the muscle quality and arm length doesn't turn the figure into a totally different character.

The area around the waist is an important point connecting the upper and lower body.

9 The legs don't sprout suddenly from the crotch, so as you draw, keep in mind the range of motion at the point where they join the body. This is also a trick for making the legs look long, so it's particularly important when drawing a figure viewed from below!

10 Be aware of the buttocks that can just be glimpsed beyond the crotch.

11 Pick out attractive lines from those that you roughly sketched in for the draft sketch. For the thighs, make sure to use one smooth stroke. Work so as not to interrupt the flow from the thigh to the knee and from the knee to the shin.

12 As the figure is viewed from below, the section of the legs from the knees down is on the long side, but make sure they don't look completely different from the section above the knees by drawing in each part such as the calves, ankles, ankle joints and so on carefully.

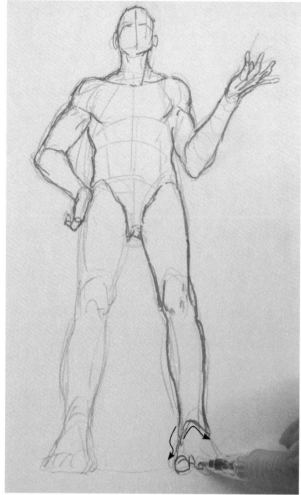

13 Make the instep bony to bring out thickness and rigidity.

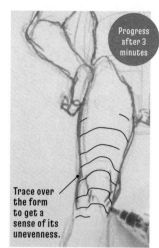

Progress after 3 minutes

Trace over the form to get a sense of its unevenness.

14 Take care when drawing the knee not to draw "lines" but rather "hollows" and "protrusions."

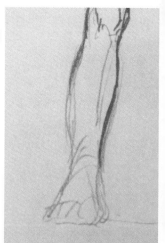

15 The right leg doesn't have to be drawn in complete symmetry with the left. As long as has the "qualities" of a leg and both right and left legs look like they belong to the same person, it's fine.

Completion of sketch with finishing touches (actual size

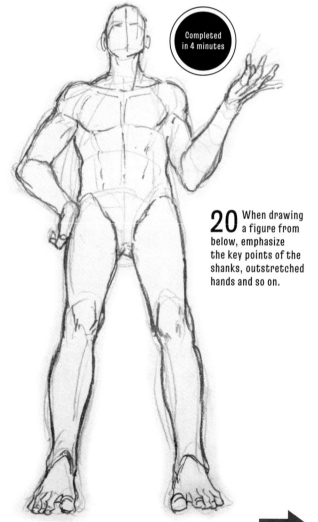

Completed in 4 minutes

20 When drawing a figure from below, emphasize the key points of the shanks, outstretched hands and so on.

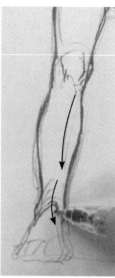

17 Toes are quite long. Drawing them in properly makes for strong feet.

18 Capture the outer ankle joint.

16 Draw the shank, keeping in mind that a bone runs through it. Make the shank and instep bony and rigid with only a light layer of muscle.

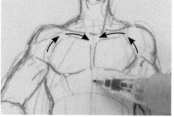

19 Add in the pectoral and abdominal muscles, again rendering hollows and swellings rather than using lines.

Next, draw this example from an even lower angle ➡

Front View, Extremely Low Angle

Time to produce: 8 minutes = **Draft:** 3 minutes + **Finishing touches:** 5 minutes

Exaggerate the balance of the body parts

Draft sketch

1 Start by drawing the head, then slightly exaggerate the width of the shoulders and tapering of the waist.

2 Even when balance is exaggerated, don't forget the presence of each individual body part.

Progress after 1 minute

3 Capture the litheness of the muscle form using curved lines.

4 When you want to create an imposing feeling, be bold with the legs that form the foundation!

Progress after 2 minutes

6 Add nuances of strength and weakness in the line from where the joint presses the muscle down to the wrist.

7 Emphasize both the boniness of the elbow and the fleshiness around the joint.

5 Draw the legs so that they both have the same sense of momentum. Go all out with the shanks so that the flow of the body is reflected despite the imposing appearance.

Draft sketch completed in 3 minutes

Make the head on the small side, elongate the neck and make the upper body appear to be breaking out from the lower body to create a sharp silhouette.

8 Take care when it comes to the shoulder width, the distance from shoulders to head, the size of the head and so on to bring out the sense of deformity created by the low vantage point.

9 Make swollen parts even more swollen and narrow down narrow parts! Make the body large overall! ... This alone won't create a dynamic look, so make sure that all the "areas that narrow" (neck, wrists, ankles) are depicted as being truly narrow.

1 In order to create a stronger sense of looking up at the figure, improve the flow from the shoulders – neck – head.

2 Make the collarbone quite horizontal so it seems the neck is just visible beyond it.

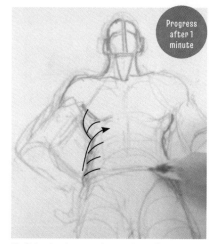

Progress after 1 minute

3 Bring in the tapering at the waist and emphasize the overlapping of the seemingly compressed torso.

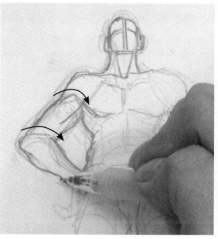

Progress after 1 minute

4 Round out the joints and areas where muscles connect.

5 In order to strengthen the imposing impression, rather than the hand on the hip, bring the hip itself to the fore.

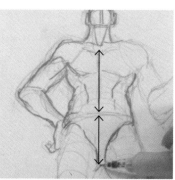

6 The ratio of lower body (crotch) to upper body is higher than for regular depictions from low angles. It is at around this stage that the difference between figures depicted from regular low angles and extremely low angles (overperspective) becomes apparent.

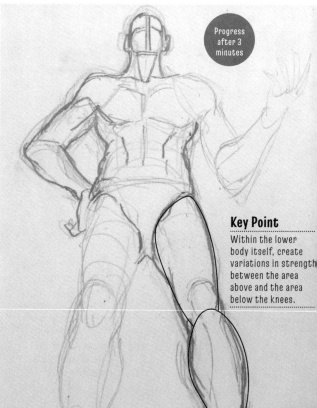

Progress after 3 minutes

Key Point

Within the lower body itself, create variations in strength between the area above and the area below the knees.

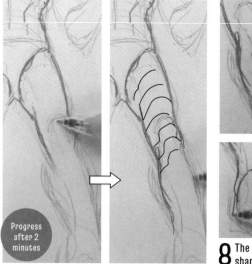

Progress after 2 minutes

7 Compared with the upper body, the legs take up a large area of the composition. Make sure to capture the sense of solidity in the legs.

8 The basic legs are the same shape as for a regular low angle drawing, but express things more strongly, ie narrow down the narrow areas and swell out the swollen parts.

9 Follow the basic concept when exaggerating perspective of making objects at the front larger and objects in the back smaller to draw the figure in stages. After creating distinction between the broad divisions of the upper and lower body, create distinction between the body part ratios in the lower body. Don't exaggerate everything equally, but create variation.

10 Use more pressure to draw the legs than for the upper body, creating thick lines.

11 Build up the instep and significantly thicken the toes.

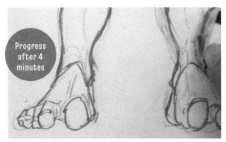

12 Along with making the instep high, broaden out the feet. Don't flatten them out, but adjust the size and distribution of each part, making only the big toe large, spacing out the gaps between toes and making them solid, for instance.

Progress after 4 minutes

13 Make sure that the toes on both feet are tensed to the same degree. As long as they are the same in this sense, it's fine for other small details not to match.

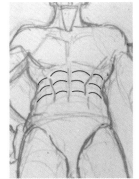

14 Looking only at this area, the parts from the ankle down seem way too large and out of balance. However, as long as it works when viewed as a whole, that's fine.

15 Add in curved lines of muscle to make the ridges and hollows of the abdominal muscles clear.

16 When drawing fingers, work with a fan shape so that each finger seems to connect to the wrist across the back of the hand.

17 The thumb is separate, but for the four fingers, keep the flow in mind and use a fan shape for a neat result. When the hand is relaxed, gradually spreading out the fingers from the pinky to the index finger makes for a natural look.

Completion of sketch with finishing touches (actual size)

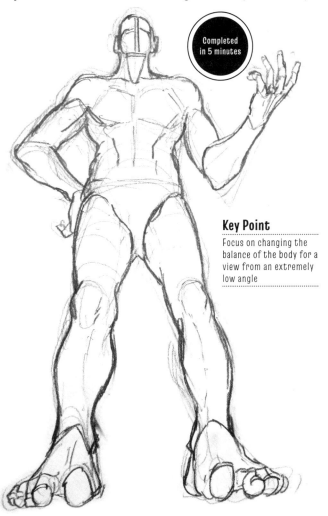

Completed in 5 minutes

Key Point
Focus on changing the balance of the body for a view from an extremely low angle

18 Looking at the overall picture, the upper body is not much different from that of a figure depicted from a regular low angle. When applying perspective, consider which areas to emphasize and how to emphasize them for effect.

A Manga Sketch in 5 Minutes:
Front View, from Above

Time to produce: 6 minutes = Draft: 3 minutes +
Finishing touches: 3 minutes

1 Start with the head.

| **Draft sketch** |

2 Roughly draw each part from the head – neck – chest.

Block

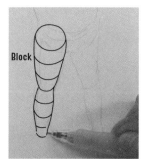

Block

3 Don't think about the outline, but rather consider the substance. Draw as if placing a large block on the screen.

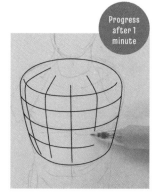

Progress after 1 minute

4 In order to bring out thickness and depth, visualize a grid over the body's surface when roughly drawing in the muscles.

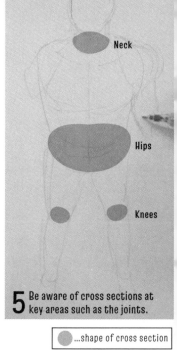

Neck

Hips

Knees

5 Be aware of cross sections at key areas such as the joints.

● ...shape of cross section

6 Firmly bent joints are difficult. If you're having trouble with them, Draw in round slice lines to visually understand how the flesh is compressed and so on.

7 As the figure is being viewed from above, adjust the angle so that the palm of the hand is slightly visible.

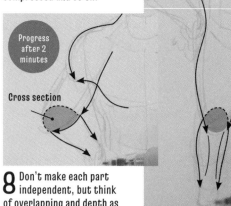

Progress after 2 minutes

Cross section

8 Don't make each part independent, but think of overlapping and depth as you work.

9 Confirm the position of the neck tendons, which are compressed and appear short.

Draft sketch completed in 3 minutes

10 If it's difficult to get a grasp on the angle or look of a figure viewed from above, draw in lots of round slice lines at the draft sketch stage. This makes it easier to draw the finished result.

Key Point

Visualize round slices and cross sections to create form.

Finished sketch

Key Point
The figure is being looked down on from above, so broaden the upper surfaces of the head and shoulders and the chest.

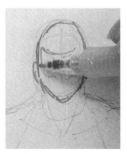

1 When angling the head, the position of the eyes and ears is important.

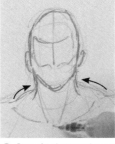

2 Draw in the muscles on the back of the neck in an arc, visualizing them connecting in order to express thickness.

3 In contrast to a figure viewed from below, draw the upper arm so that it laps over the forearm.

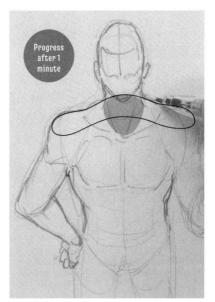

Progress after 1 minute

4 Use a relaxed curve for the shoulder area. Make sure the cross section of the neck from the center of the curve down to the hollow in the collarbone fits into the curve.

5 Think carefully about the swelling in the arms...

6 Completely overlapping the joints prevents the movement looking stiff, creating a smooth pose.

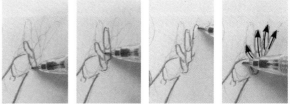

7 Don't make each finger move separately, but create regularity by lining them up in a fan shaped formation.

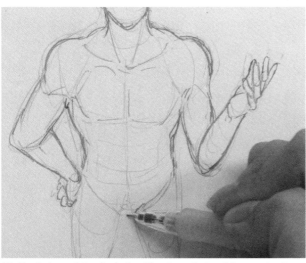

8 Check the positional relationship where the legs join to make the height of the crotch clear.

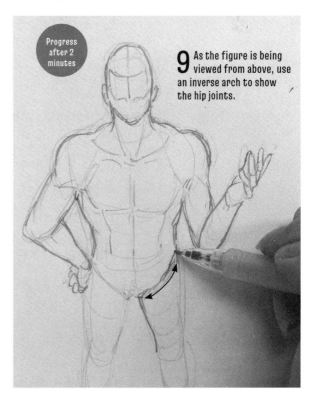

Progress after 2 minutes

9 As the figure is being viewed from above, use an inverse arch to show the hip joints.

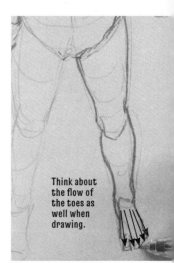

Capture the shape of the bone

Pay attention to how the shape of the inverse arch varies!

The heel is hardly visible, but as the legs are slightly spread, create the merest glimpse of them from the inside leg.

Think about the flow of the toes as well when drawing.

10 Bring out solidity in the knee joint.

11 Join inverse arches to clearly depict the boniness of the knee.

12 Follow the gentle curve of the shank to flesh it out.

13 Seek out the position of the instep and heel as you work lines in.

14 Consider the structure and flow of the skeleton to capture detailed shapes.

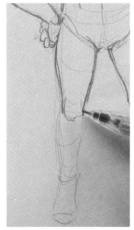

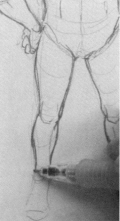

Completion of sketch with finishing touches (actual size)

Completed in 3 minutes

15 Draw the right leg in the same way.

16 The weight is evenly spread on both legs, so don't create any major differences in the legs.

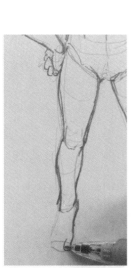

19 Make the left hand raised to nearly shoulder height large, and the right hand resting on the hip smaller. The palm of the left hand is at around the same position as the shoulder, but make it larger than its usual size. Apart from those parts, apply perspective so that parts gradually and smoothly get smaller toward the feet.

17 Refer to the left leg as you draw to check that the feet are spread equally.

18 Check the toes on both feet too as you draw.

Draw the same pose from an even more overhead angle

44

Front View, Extremely High Angle

Time to produce: 6 minutes = **Draft:** 2 minutes +
Finishing touches: 4

Draft sketch

1 Determine the sense of size for the head.

Progress after 1 minute

2 In line with the size of the head, make the shoulders narrower than for a regular overhead angle (to make the head appear larger).

3 The chest and hips are compressed and appear shortened.

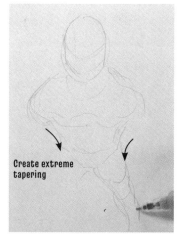

Create extreme tapering

4 Bringing the hips in also serves to emphasize the sense of presence in the shoulders.

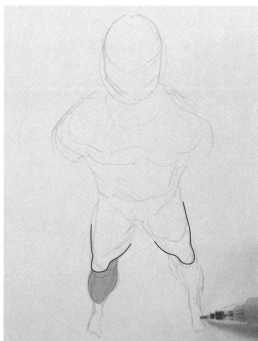

Emphasize the unevenness of the knees. From the knees down, clearly show the area behind the knees.

5 The area below the knees will appear thin, but make sure to capture muscle so they don't look spindly and delicate.

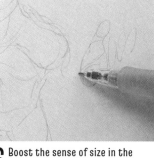

6 Boost the sense of size in the hands.

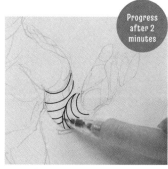

Progress after 2 minutes

7 Don't make the elbow too stiff, instead using depth to express the bend in the arm.

8 Consider depth to shorten the right arm also.

9 The elbow is tensed, so draw it on an angle. Narrow down the arm towards the wrist.

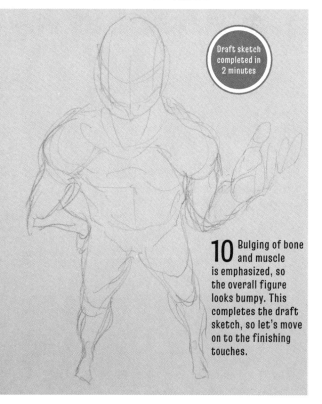

Draft sketch completed in 2 minutes

10 Bulging of bone and muscle is emphasized, so the overall figure looks bumpy. This completes the draft sketch, so let's move on to the finishing touches.

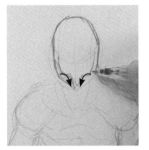

Finished sketch

1 Capture the bone structure of the face, working with momentum.

2 The neck is hidden by the head, so can hardly be seen. Use neck tendons to depict its presence.

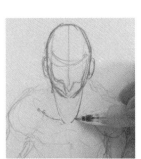

3 Bring out thickness in the area from the neck to shoulders. Make it fit into a rugby ball-like shape.

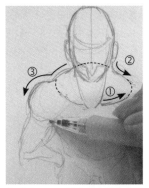

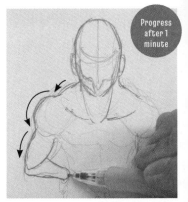

Progress after 1 minute

4 Use bumps to emphasize the outline.

5 Make the hands small to create a sense of distance.

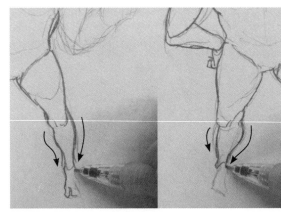

6 Slightly swell out the join of the legs.

7 There should be a sense of tempo in the outline of the body, with the join where the legs meet the hips being particularly dynamic. Make sure not to lose the sharp flow in the legs.

8 Make the ankles look quite narrow.

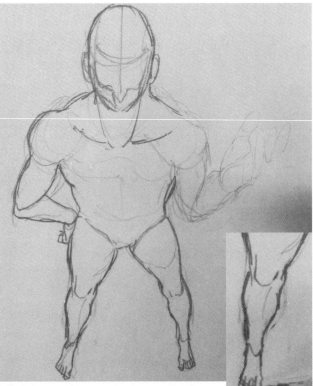

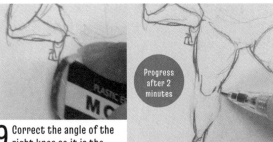

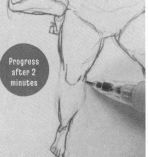

Progress after 2 minutes

9 Correct the angle of the right knee so it is the same as the left leg.

10 Adjust the feet to make them small, going all out with perspective to create the sense that they are far below.

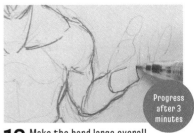

11 Be conscious of the swelling of muscle.

Don't forget there is a cross section

12 The flesh of the arm is compressed, crushing the muscle. As the figure is being viewed from overhead, the elbow comes to behind the arm. Don't create too much of an angle in the elbow.

13 Make the hand large overall.

Progress after 3 minutes

14 Decide on the knuckle positions and draw the fingers in. Draw from foreground to back.

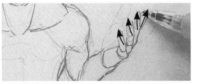

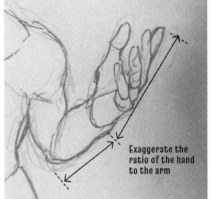

15 The fingertips gradually spread out towards the index finger.

16 Express strength by adding bounce to the line.

17 The completed left hand.

Exaggerate the ratio of the hand to the arm

18 Add the surface muscle. Broaden it out.

19 Bring out thickness in the hips.

20 The abdominal muscles gradually narrow.

Completion of sketch with finishing touches (actual size)

21 Emphasizing the area from the head and shoulders to the chest makes for a more dynamic bird's eye view. Divide the body into large portions to draw in the parts.

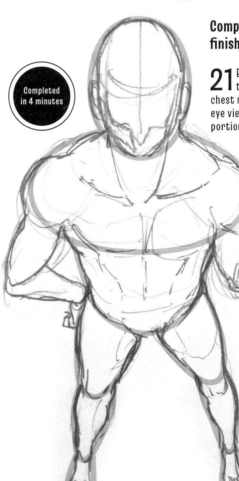

Completed in 4 minutes

★ Each portion is marked with gray lines.

A Manga Sketch in 5 Minutes:
Rear View, from Below

Time to produce: 5 minutes = **Draft:** 2 minutes +
Finishing touches: 3 minutes

1 Start with the large mass of the head, neck and shoulders.

Progress after 1 minute

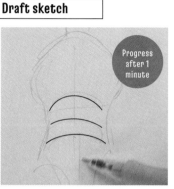

Draft sketch

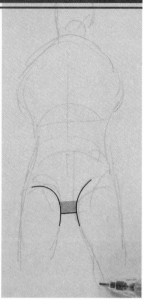

2 The back is very thick, so use a rounded shape to draw it.

3 Use arcs to divide the body, extending the torso down to the hips.

4 Work in the hip line and draw the legs extending down.

5 Making the crotch slightly visible in the gap between the legs brings out the sense of the low angle.

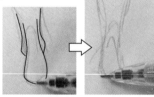

6 Keep the arcs in mind so as not to make any extreme changes in the line.

7 Join the Achilles tendon to the heel.

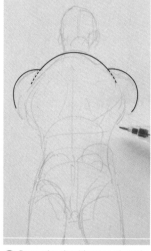

8 Draw the shoulders so that they seem to be slightly embedded into the mountain-shaped back.

Draft sketch completed in 2 minutes

10 Capture the overlap in the joint section.

12 It's mainly the angle of the joints that is altered to render the appearance of viewing the figure from a low angle. Now let's move on to the finished sketch.

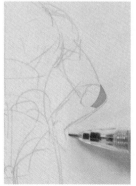

9 Clearly show the elbow to create the impression of looking up.

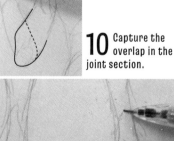

11 Add in low angle lines to the joints in the ankles.

48

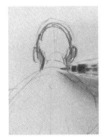

1 Smooth out the mountain shape drawn for the back.

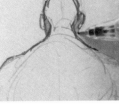

2 Show a glimpse of the outline of the face from behind the neck.

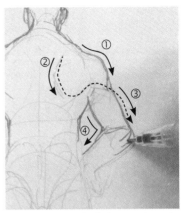

3 Firstly adjust the shoulders and neat line of the hips, as it is easy to create balance in those areas.

4 Continue drawing body parts in such a way as to avoid messy filling in of protruding tendons and bones.

Key Point
Capture hollows and bulges to express texture.

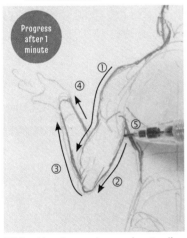

Progress after 1 minute

5 Combine the roundness and protruding elbow of 2 with the sharp line of 3 and so on to bring out the feel of the arm.

6 Draw in bumpy lines for bony joints.

7 Angle the hand so the back of the hand is slightly visible.

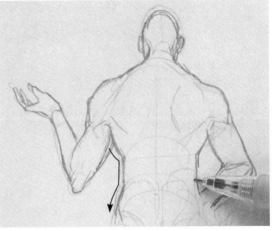

8 Start drawing in the swell towards the buttocks.

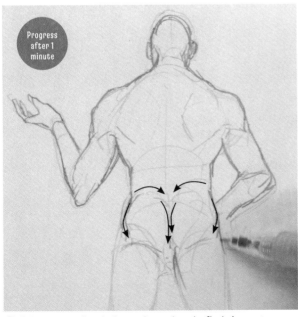

Progress after 1 minute

9 Take care to raise the buttocks to that the flesh does not spread out to the side.

10 Create variance in the line of the right thigh.

11 Distinguish where flesh is thick and where skin is thin. Make the outline of the back of the knee bony.

Tauten the calf.

12 The firmness of the calves changes depending on whether the figure is seated or standing. When drawing, considering which muscles are being used in that posture will allow you to distinguish between different qualities and textures.

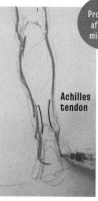

13 Bring in the ankle to make the rigidity of the Achilles tendon stand out.

Achilles tendon

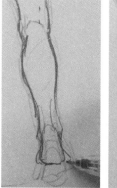

14 Make the front of the foot protrude so it is slightly visible from the heel.

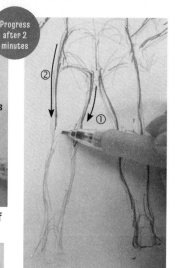

Progress after 2 minutes

15 In the same way as for the left leg, slightly swell out the leg, narrowing it towards the knee to bring out texture.

16 Slightly alter the unevenness of the lines on the inside and outside of the leg. Make the outside relatively smooth and the inside bumpy.

17 In the left leg as well, capture the section that protrudes out to the front.

Completion of sketch with finishing touches (actual size)

Completed in 3 minutes

18 Make corrections in the buttocks. Carefully use trial and error to correct them, as the join of the legs is a joint that stands out.

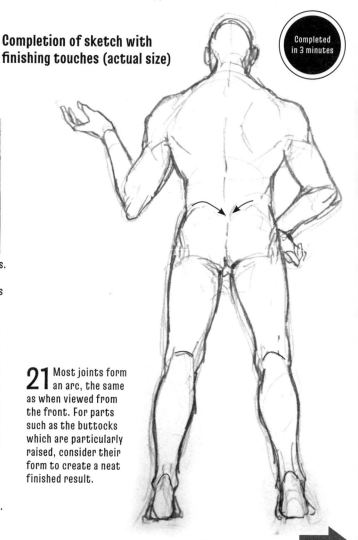

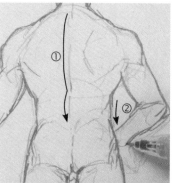

20 Add the right hand half concealed by the thickness of the hips.

19 Bounce out the line down the back so it doesn't end up becoming simply a straight line.

21 Most joints form an arc, the same as when viewed from the front. For parts such as the buttocks which are particularly raised, consider their form to create a neat finished result.

Try an even lower angle ➡

Rear View, Extremely Low Angle

Time to produce: 5 minutes = **Draft:** 2 minutes + **Finishing touches:** 3 minutes

Draft sketch

Make the head slightly smaller than for the low angle view on page 50, creating a size that is hidden by the back.

1 Make a round mountain shape for the back and determine the position of the head.

★Create significant changes from here

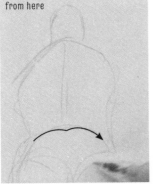

2 Shorten the torso and increase the presence of the buttocks.

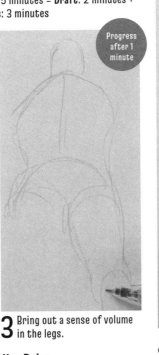

Progress after 1 minute

3 Bring out a sense of volume in the legs.

Key Point

Think of blocks being gradually layered one over the other.

Shorten the torso and create bold shapes for the section from the buttocks down the legs.

4 The legs are the longest part of the body and extend smoothly down. Rendering a view from below requires some innovation!

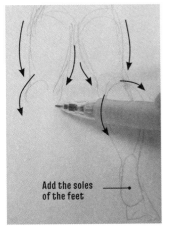

Add the soles of the feet

5 For an exaggerated angle, hollows and bulges are emphasized, so erase the smooth stick-like look and create bumps.

6 Capture where body parts are situated, working from the feet in the foreground through to the calves and thighs, in that order.

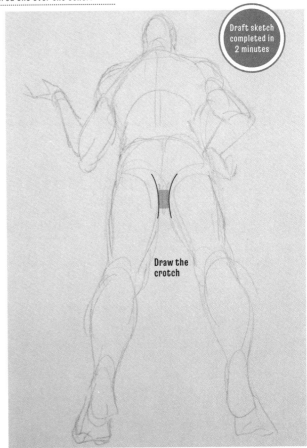

Draft sketch completed in 2 minutes

Draw the crotch

10 Draw in the visible areas of the downward facing surfaces, such as the feet and crotch, to strengthen the impression of looking up. Next, we'll work on the finished sketch.

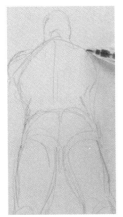

7 Add in the shoulders. Round them out to follow the mountain-like line of the back.

Progress after 2 minutes

8 The torso is drawn to make the position of the hips seem high, so the position of the hand is necessarily high too.

9 Make the raised left arm appear small.

1 The head is not just a circle, so finish it by properly connecting the hairline and the line for the neck.

2 Add in the shoulder blades. As they are being looked up at, make them a slightly flattened, crushed shape.

3 Clearly express where the shoulder starts.

4 Create a sense of muscles in the right arm and sketch in the boniness of the elbow.

5 Draw in the left arm, using a large mountain shape to form the shoulder line.

6 Narrow the upwardly extended wrist. Even in only the wrists, there is quite a difference between left and right.

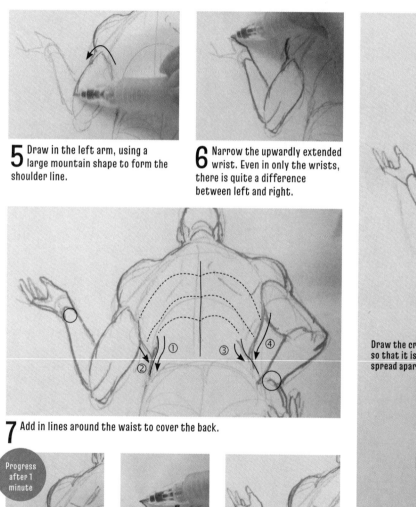

7 Add in lines around the waist to cover the back.

Progress after 1 minute

8 Correct the shape from the shoulder to the upper arm (bicep) to shorten it and capture its angle.

9 Bring the elbow to the foreground to heighten the impression of looking a long way up.

10 Check the sense of distance between the elbow and buttocks again.

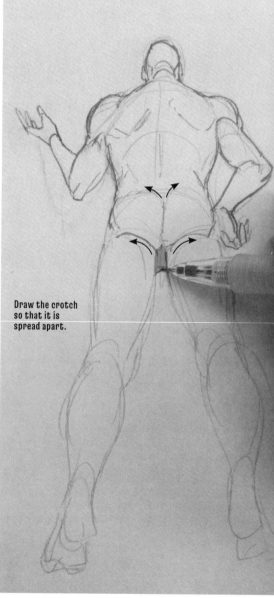

Draw the crotch so that it is spread apart.

11 Make large arcs in the swelling of the buttocks and raised flesh at the backs of the thighs.

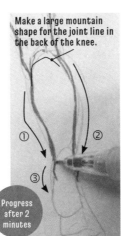

Make a large mountain shape for the joint line in the back of the knee.

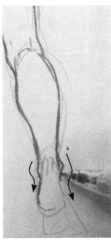

12 Quickly draw in lines...

13 Emphasize the bumps in the knee.

Progress after 2 minutes

14 Connect the swelling of the calf with the hollow at the ankle.

15 Make the protrusion of the ankle joints on the large side.

16 Boldly showing the soles of the feet makes for a stronger sense of viewing the figure from a low angle.

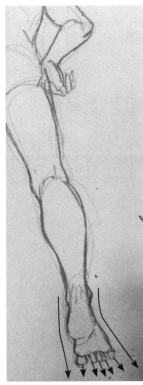

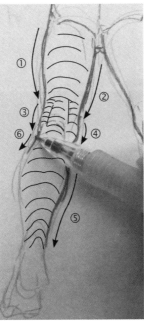

Completion of sketch with finishing touches (actual size)

Completed in 3 minutes

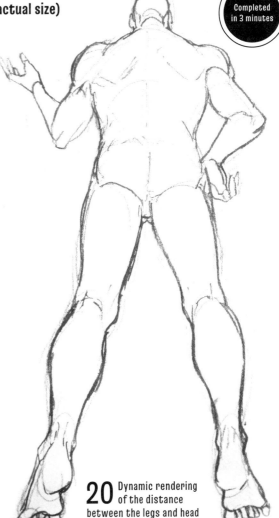

17 Make sure the toes spread out properly too.

18 Create detailed bumps and rises. If you touch your own leg, you'll clearly understand which areas form bumps and swells when muscles are activated. Keep this in mind to work uneven texture onto the figure.

19 Add nuance to the hollow in the sole of the foot, at the same time making sure both the right and left foot are in balance with each other.

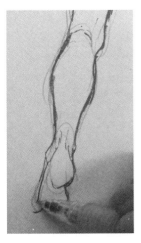

20 Dynamic rendering of the distance between the legs and head makes for a bolder result.

A Manga Sketch in 5 Minutes:
Rear View, from Above

Time to produce: 5 minutes = **Draft:** 2 minutes +
Finishing touches: 3 minutes

1 Start with the head, neck and shoulders.

Draft sketch

Progress after 1 minute

2 Work out the positioning of the thighs from the mass of the back, hips and buttocks.

3 Draw the calves to sit over the ankles.

4 Check the orientation of the seemingly compressed upper arm and forearm.

5 Crush the shape of the left arm.

6 Determine the position of the hand, considering the distance from the head and shoulders.

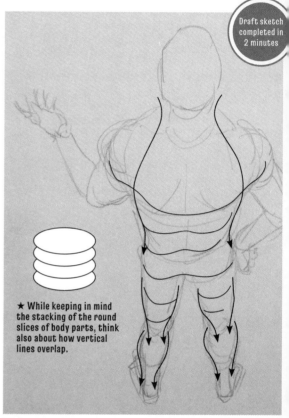

Draft sketch completed in 2 minutes

★ While keeping in mind the stacking of the round slices of body parts, think also about how vertical lines overlap.

7 Use smooth curves to separate the joints, overlapping them to create the rough draft.

Finished sketch

Determine where the neck and shoulders are situated.

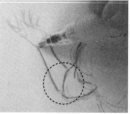

1 Make the head not completely round, but oval for a cool look.

2 Determine the shape of the section from the shoulder to the upper arm.

3 Cleanly separate overlapping joints to bring out thickness.

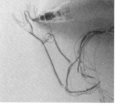

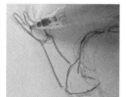

Progress after 1 minute

4 The section from the wrist to the thumb joint is quite thick. Carefully observe and touch your own hand to confirm the texture.

5 Don't forget to bring out thickness to show the presence of the muscles so that the back doesn't become rigid and flat.

54

Make it sharp

6 Keep in mind the latissimus dorsi that run from below the underarms down to the hollows in the buttocks. When drawing, consider which parts are connected to the lines you are adding to the body.

7 Retain about the same thickness as for the left side, but as the pose of the arm is different, create difference in the elbow via its position and how the bone is jutting out.

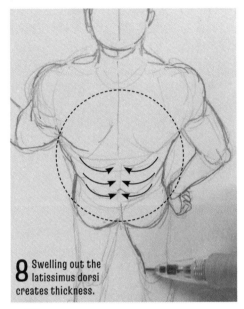

8 Swelling out the latissimus dorsi creates thickness.

From the front, the legs are thin, but from the side they are thick.

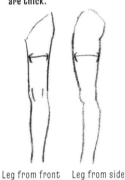

Leg from front Leg from side

Thickness

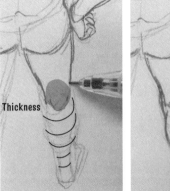

9 In an overhead view, create thickness vertically by deep, solid stacking of the knee joints.

Completion of sketch with finishing touches (actual size)

Completed in 3 minutes

Use a sharp angle to bring out the boniness where the elbow is sticking out.

Progress after 2 minutes

10 Depending on the angle when viewing from above, but you can go all out when showing the instep. The foot is large, so there is considerable length from the heel to toes.

The elbow is concealed in the background. Making the outline soft expresses this.

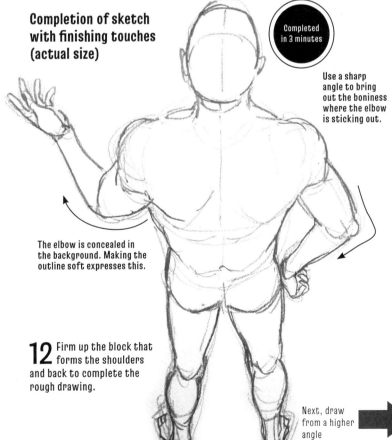

12 Firm up the block that forms the shoulders and back to complete the rough drawing.

11 Drawing the heels so that they stick out stabilizes the balance in a standing pose.

Next, draw from a higher angle

A Manga Sketch in 5 Minutes:
Rear View, Extremely High Angle

Time to produce: 5 minutes = **Draft:** 2 minutes +
Finishing touches: 3 minutes

1 Start with the head.

Draft sketch

2 Make the back from the shoulders to the chest appear bigger.

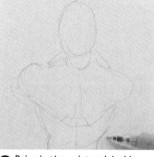

3 Bring in the waist and decide on the breadth of the buttocks.

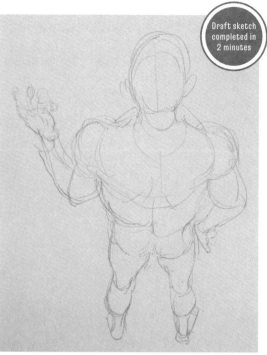

Draft sketch completed in 2 minutes

Finished sketch

1 Draw an oval for the head. Draw a median line down the center.

2 Follow the line of the shoulder muscles to form a short neck.

4 Use bumps to exaggerate the body's hollows, swells and tapering.

3 Form the outline for the body, considering the bumps of the bones and muscle joins on the skin's surface so as not to interrupt the line.

4 Divide the arm at the joints for emphasis.

Cleanly extend the arm. Round the upper arm.

Progress after 1 minute

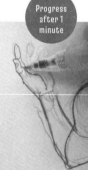
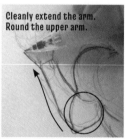
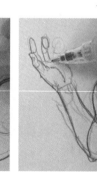
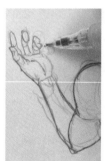

5 The palm of the hand is a small body part, so in a pose that doesn't emphasize the hands, don't exaggerate them.

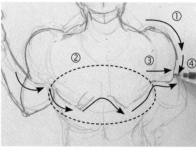

6 Position the shoulder blades so they connect from the shoulders.

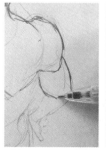

7 Rather than making everything exaggeratedly bumpy, alternately add and subtract nuances.

8 Shrink things down towards the ends of the arms.

9 Make tapering slightly more pronounced than for the regular overhead angle (page 55).

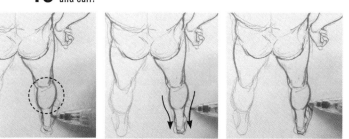

10 Work out the thickness of the knee joint by stacking the thigh and calf.

Progress after 2 minutes

12 After drawing the large mass of muscle in the calf, add in the leg extending straight down from beneath it.

Completion of sketch with finishing touches (actual size)

Completed in 3 minutes

Key Point

Creating a large distance from the neck to the shoulder blades immediately results in the sense of looking down from a great height.

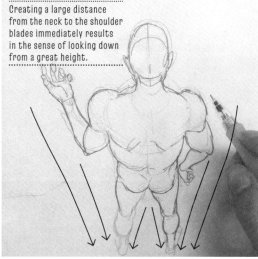

11 Make the overall silhouette sharp.

13 Making the silhouette of each body part such as the arms and legs sharp makes for a dynamic look when the figure is viewed as a whole.

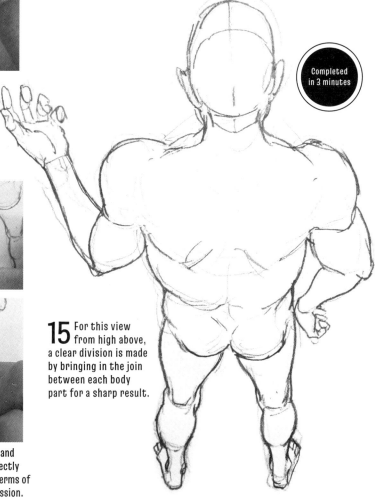

15 For this view from high above, a clear division is made by bringing in the join between each body part for a sharp result.

14 Check the right foot to adjust the shape of the left and make sure they are balanced. Don't make them perfectly symmetrical, but rather make them slightly different in terms of how strong they look to prevent a dull, bolt upright impression.

Take a Closer Look at Standing Poses

① Standing to attention

② At ease

③ Twisting

④ Leaning

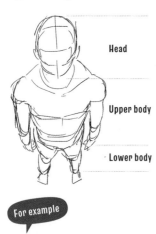

Head

Upper body

Lower body

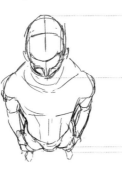

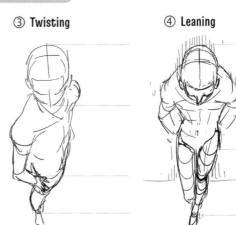

For example

If you vary where weight is centered when drawing from overhead...

① Standing to attention

② At ease

③ Twisting

④ Leaning

Even within a standing pose, the appearance of various body parts can be altered depending on where weight is centered or the figure's posture. Simply adding a twist to the torso enables "movement" to be rendered

Take care with the solidity of the head

It's surprisingly easy to overlook the sense of solidity on the sides of the face, and whether or not you are aware of this will alter its expressiveness. Whether viewed from below or above, the positional relationship between the eyes and ears is important. Check it by visualizing glasses to connect the corners of the eyes to where the ears join the head.

Consider how much of each body part is visible from the eye level of the drawer when drawing.

① Standing to attention

② At ease

③ Twisting

④ Leaning

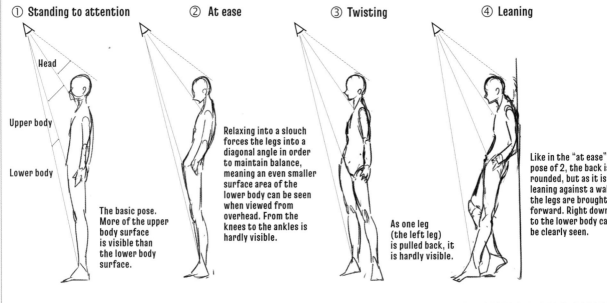

Head

Upper body

Lower body

The basic pose. More of the upper body surface is visible than the lower body surface.

Relaxing into a slouch forces the legs into a diagonal angle in order to maintain balance, meaning an even smaller surface area of the lower body can be seen when viewed from overhead. From the knees to the ankles is hardly visible.

As one leg (the left leg) is pulled back, it is hardly visible.

Like in the "at ease" pose of 2, the back is rounded, but as it is leaning against a wall the legs are brought forward. Right down to the lower body can be clearly seen.

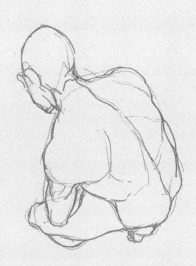

Chapter **2**

Poses with Movement and Changing Angles

Finally, we're moving on to capturing the movement of the entire body. Adding movement to a standing pose allows you to progress to a twisting pose. This chapter is overflowing with the sense of speed that is unique to quick drawing: the omnidirectional approach of drawing the same pose from different angles; sitting and sleeping poses that require rendering depth; changing angles to alter the viewing position to capture bold low and high angles; and intense expressions of movement involving multiple characters. That's a lot to cover, so let's get started!

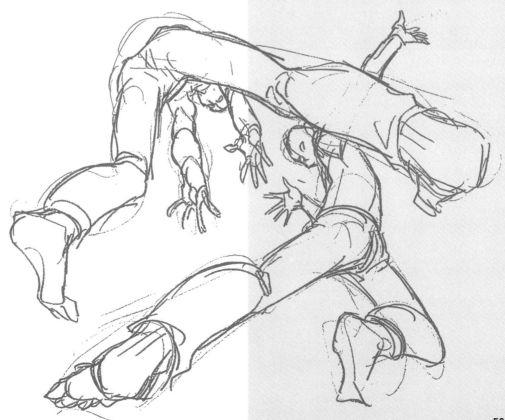

Add Movement and Expression to Standing Poses

Simply standing on two legs requires muscles in the entire body to create balance to prevent falling over, meaning that the exercise of "standing" is being carried out. However, in a figure standing straight, it's difficult to detect movement, so Try to add motion to convey a sense of "natural movement" in "standing poses."

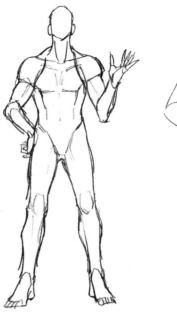

The height of the hips changes. In addition to this, creating a clear difference in the height of the left and right knees makes the shift in weight more obvious and makes for a natural pose. Creating a clearly unbalanced state is the key to a natural look.

The male figure from front on as drawn on page 32. This is a standing pose with weight resting on both feet.

A "center of gravity on one leg" pose with the weight resting on the right leg. The leg taking the body weight rises, making it possible to create a sense of movement in a standing pose.

1 First, tilt only the hips

Even for the same "weight resting on one leg" pose, try adjusting the amount of strength incorporated into the body depending on the scene and emotion. This allows for emotional expression to show not only in the face, but via the pose too.

Level
1
At ease

The expression is natural

For example:
"waiting for someone" "a scene where the character is glancing at something" etc.

Hints for the pose "weight resting on one leg"

The leg which is relaxed (the free leg) appears long from the hip joint down to the knee, so draw it that way. It's not that the length of the leg is actually different, but think of it in the sense that "that's how it looks, so draw it that way." Even if a figure appears to be an illusion when you observe it, I think "optical illusions" are the source of exaggerated expression, so it's a good idea to incorporate it into your work to a certain degree.

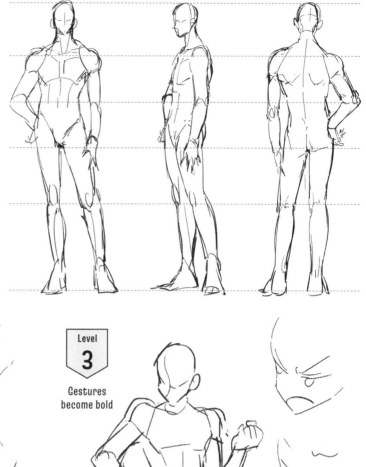

Level 2

Create the pose

Facial expressions full of emotion

For example:
Combined with expressions such as "showing off" or "gazing emotionally at someone," the pose can come across as being irritated or haughty and condescending.

Level 3

Gestures become bold

Powerful emotions can be conveyed

For example:
The legs spread wider apart. The shoulders rise in anger. Gestures are added to the hands. Emotions are heightened. "Standing in a victory pose from happiness" "unable to remain still due to anger."

2 Use a < shape to create balance

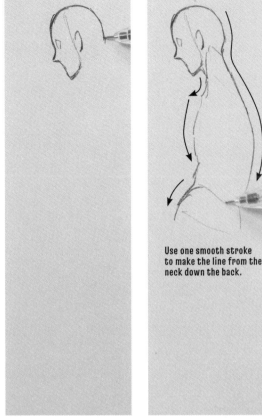

1 Draw the head as if viewing the profile from slightly behind.

2 In contrast with the line for the back, the front of the body has many uneven surfaces. Draw in lines to distinguish the collarbone, pectoral muscles and abdominal muscles. This area will be concealed by the arm, but it's important to clearly draw it in to get a grasp of the form!

Use one smooth stroke to make the line from the neck down the back.

3 For the arm, raise the shoulder position to create the look of viewing the figure from slightly below. Make it follow the smooth line of the spine. Next, determine the position of the hips.

4 As the upper body is significantly tilted, it is sturdily supported by the lower body. Unless the axis of the hips is stable, the pose will not firm up.

Work as if to create a slight depression in order to bring out the suppleness of the hips.

First, consider the center of gravity

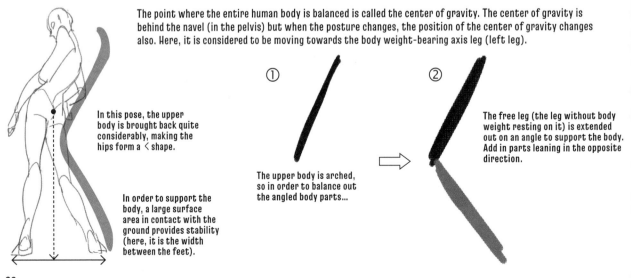

The point where the entire human body is balanced is called the center of gravity. The center of gravity is behind the navel (in the pelvis) but when the posture changes, the position of the center of gravity changes also. Here, it is considered to be moving towards the body weight-bearing axis leg (left leg).

In this pose, the upper body is brought back quite considerably, making the hips form a < shape.

In order to support the body, a large surface area in contact with the ground provides stability (here, it is the width between the feet).

① The upper body is arched, so in order to balance out the angled body parts...

② The free leg (the leg without body weight resting on it) is extended out on an angle to support the body. Add in parts leaning in the opposite direction.

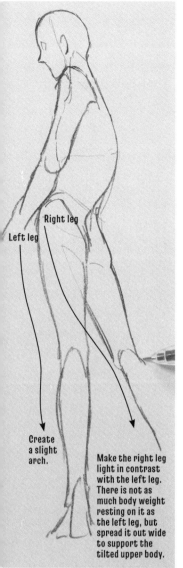

Right leg

Left leg

Create a slight arch.

Make the right leg light in contrast with the left leg. There is not as much body weight resting on it as the left leg, but spread it out wide to support the tilted upper body.

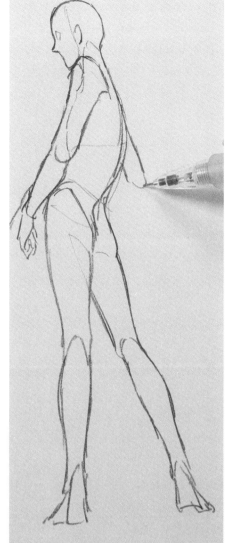

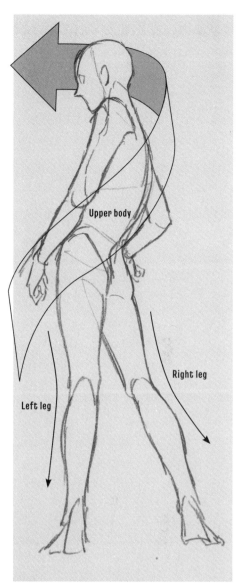

Upper body

Left leg

Right leg

5 The axis leg (left leg) is receiving the pressure of body weight, so create a slight arch in it for a realistic look.

6 Draw in the right arm in the background. In order to make the body appear twisted and to make the most of the line of tendons in the back, rather than drawing in a firm line from the shoulders down, lightly trace it in.

7 Representing the conscious flow of the body with arrows creates this result.

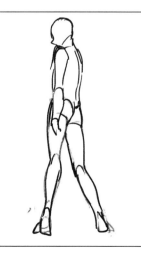

This way, I'm not standing

If the straight line extending from the center of gravity protrudes from the surface supporting the body (in a standing pose, the space between the legs) the figure will collapse.

As the right leg is quite a distance from the body weight bearing axis leg (left leg) and the hips are lowered, a straight upper body creates an awkward look. If the center of gravity is not on one side and the figure is drawn up to its full height in a "guardian" type pose, this is fine.

3 Next, lightly twist the body

Add a twist from a regular standing pose

① Upright pose ② Twist the upper body ③ Cross the legs The completed twisted pose

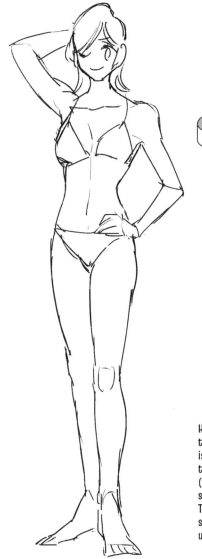

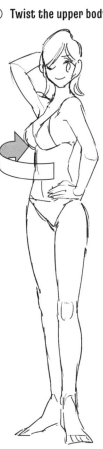

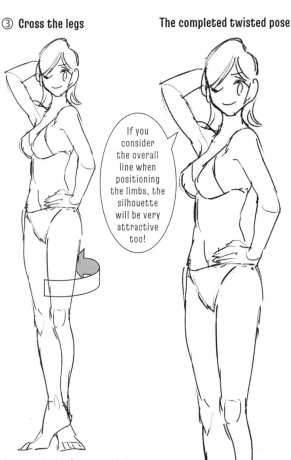

> If you consider the overall line when positioning the limbs, the silhouette will be very attractive too!

Here, I've tried twisting the upper body. The body is angled a little so that the center line of the body (median line) connects smoothly to the lower body. This makes for a slightly softer look than that of the upright pose.

In the lower body, I've crossed the right leg over the left to create movement on the opposite side from the upper body. The left leg, which forms the axis leg, is hardly touched, but when the upper and lower body face in different directions, it creates a "line that seems to flow" when the figure is viewed as a whole.

Think of an "upright pose with no twist" with the upper and lower body facing in the same direction as the base for this. Even if you make significant effort to add movement to both arms and create facial expression, the rigid body lacks appeal.

A hint for crossing the legs

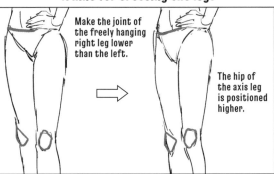

Make the joint of the freely hanging right leg lower than the left.

The hip of the axis leg is positioned higher.

As is clear from the raised heel, the crossed over right leg is not carrying the body's weight. In order to show that the body weight is mainly resting on the left leg, change the position of the hip.

Usually, the face is drawn first, followed by the upper and lower body, but if you try to create a twist right from the beginning, it may not be possible to achieve a standing pose. For a standing pose, decide on the positioning for the body's base, such as the axis leg, and then alter movement in the upper and lower body to create a natural pose.

Drawing twisted poses

To create a soft appearance, add variation so that the figure is not facing the same way from the head down to the toes. Drawing the figure from directly in front, from the side and from the back makes the differences in direction clear.

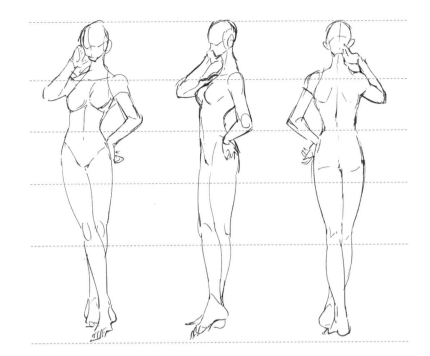

Use the arms and legs to create movement

In addition to the general flow of the upper and lower body, use the fingers and toes to add movement in opposing directions.

When bending the arms and legs, check carefully whether each joint is protruding out to the front of the torso or out behind it in order to position them (see page 26).

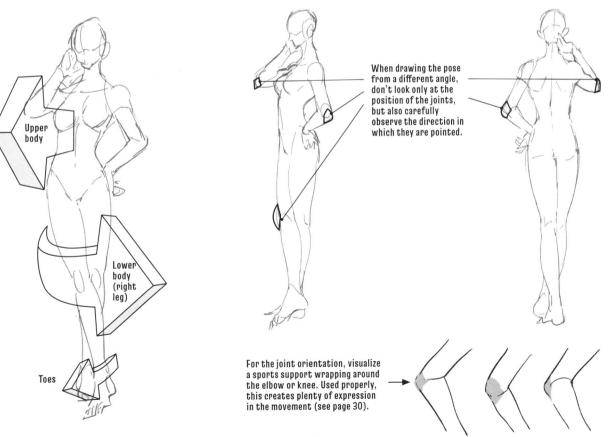

Upper body

Lower body (right leg)

Toes

When drawing the pose from a different angle, don't look only at the position of the joints, but also carefully observe the direction in which they are pointed.

For the joint orientation, visualize a sports support wrapping around the elbow or knee. Used properly, this creates plenty of expression in the movement (see page 30).

4 Try a deeper twist

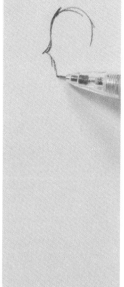

1 Decide on the orientation of the head (facing to the side) to start drawing.

2 Connect the body in order to get a grasp of the torso's axis.

3 Establish the join and work in the arm growing out from it.

4 Add in the chest over the sternal plate on the body's foundation. Don't curve the body in too much immediately beneath the chest as the ribs are there.

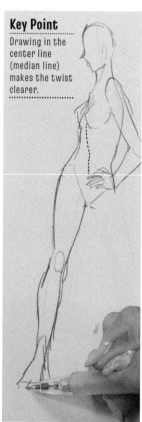

Key Point

Drawing in the center line (median line) makes the twist clearer.

Change the height of the hips and place the body weight on the right leg.

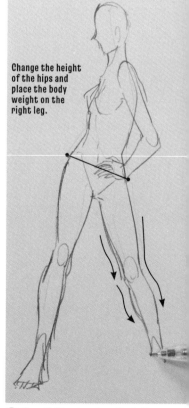

5 Make the lower body point forward to introduce a twist to the figure.

6 Draw the right leg which forms the axis leg to convey a sense of strength all the way through to the tips of the toes.

7 Make the left leg which is not supporting the body deviate away from the torso in a bold movement.

8 Use a lighter touch on the left leg than for the right to draw in curved lines.

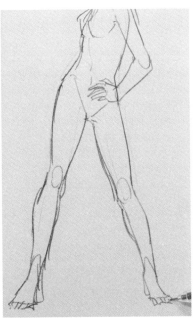

9 Bring out nuance in the pose to prevent it from becoming rigid, such as by directing the knees forward and making the area from the ankle down face outwards a little.

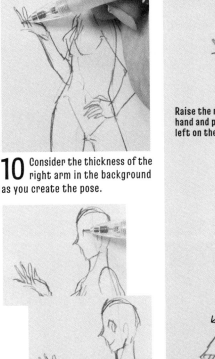

10 Consider the thickness of the right arm in the background as you create the pose.

11 Add facial expression to match the pose.

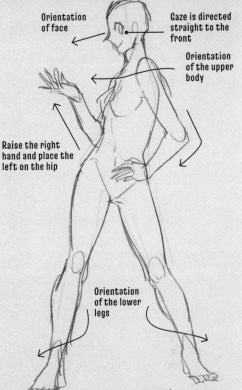

Orientation of face

Gaze is directed straight to the front

Orientation of the upper body

Raise the right hand and place the left on the hip

Orientation of the lower legs

12 The completed sketch of the twisted pose. Balance the figure so that the direction of force for each body part is not one-sided when viewed as a whole. The twist is an effective pose for bringing out movement in the body, so I'd like to introduce several twisted poses here.

Polishing the sketch with an omnidirectional approach

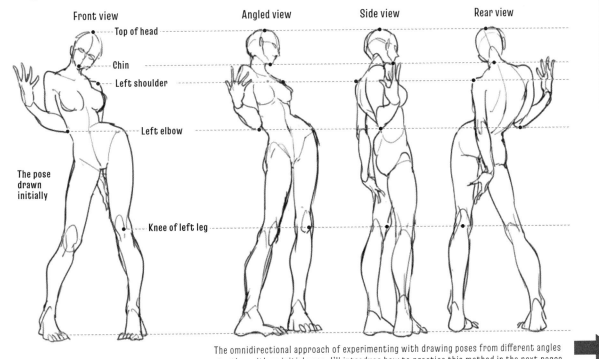

Front view — Top of head — Chin — Left shoulder — Left elbow — Knee of left leg

The pose drawn initially

Angled view

Side view

Rear view

The omnidirectional approach of experimenting with drawing poses from different angles starting with an initial pose. I'll introduce how to practice this method in the next pages.

Draw the Same Pose from Two Different Directions: Pose 1

1 Decide on the orientation of the head.

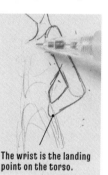
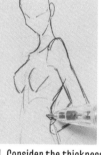

2 Decide on the axis for the torso and draw in the shape for the foundation, adding in depressions and swelling on the surface for the collarbone, chest, rise of the shoulders and so on. Explore the overall positioning in the draft sketch.

I call the practice of drawing an initial full body pose and experimenting with drawing it from different angles such as from the side or back an omnidirectional approach. Start with practicing drawing from two directions. The training of drawing a twisted pose from different angles is the first step in creating a boldly moving character.

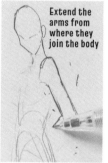

Extend the arms from where they join the body

The wrist is the landing point on the torso.

3 The wrist is the landing point on the torso.

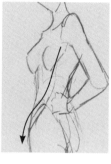

4 Consider the thickness of the sternal plate as you connect lines in a flowing manner.

5 I've twisted the hip to bring the buttocks to the foreground. Don't go overboard; think carefully about how far the body can twist naturally.

6 Make the left leg in the foreground straight. This is the leg that will bear the body's weight.

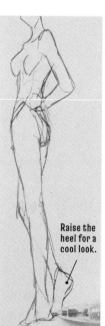

Raise the heel for a cool look.

7 The right leg in the background is not taking the body's weight, so bring out lithe movement in it.

8 There are a lot of elements you'll only notice once the whole figure is complete, such as fine balance, volume, distortion of parts and so on. Make careful corrections.

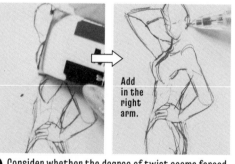

Add in the right arm.

9 Consider whether the degree of twist seems forced and make adjustments to the angle of the upper body.

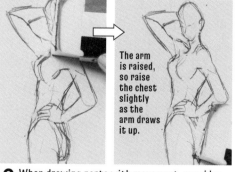

The arm is raised, so raise the chest slightly as the arm draws it up.

10 When drawing parts with movement, consider the parts that extend from them to depict changes in those parts too.

Preparation for drawing Pose 2

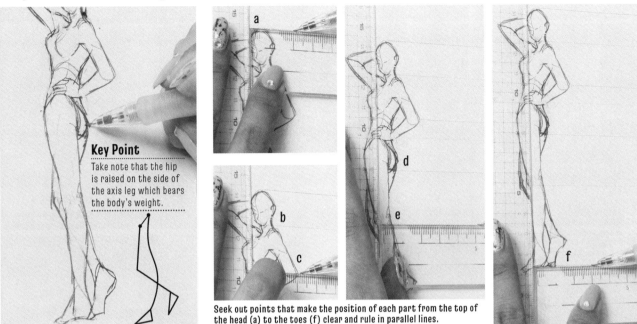

Key Point
Take note that the hip is raised on the side of the axis leg which bears the body's weight.

Seek out points that make the position of each part from the top of the head (a) to the toes (f) clear and rule in parallel lines.

11 Adjust the roundness of the buttocks to complete the first pose.

Rule in parallel lines at important body parts

In order to draw the differently angled Pose 2 from Pose 1, rule in parallel lines to serve as a guide.

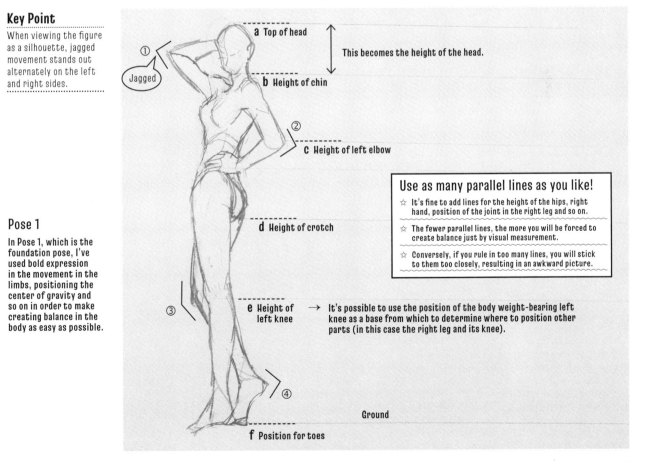

Key Point
When viewing the figure as a silhouette, jagged movement stands out alternately on the left and right sides.

① Jagged

a Top of head

This becomes the height of the head.

b Height of chin

c Height of left elbow

Use as many parallel lines as you like!
☆ It's fine to add lines for the height of the hips, right hand, position of the joint in the right leg and so on.

☆ The fewer parallel lines, the more you will be forced to create balance just by visual measurement.

☆ Conversely, if you rule in too many lines, you will stick to them too closely, resulting in an awkward picture.

d Height of crotch

Pose 1
In Pose 1, which is the foundation pose, I've used bold expression in the movement in the limbs, positioning the center of gravity and so on in order to make creating balance in the body as easy as possible.

e Height of left knee → It's possible to use the position of the body weight-bearing left knee as a base from which to determine where to position other parts (in this case the right leg and its knee).

Ground

f Position for toes

Pose 2: Draw the pose from a different angle (from behind)

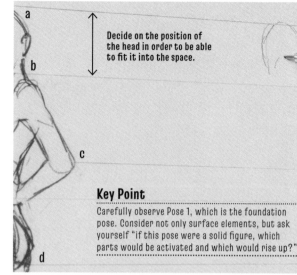

Decide on the position of the head in order to be able to fit it into the space.

Key Point

Carefully observe Pose 1, which is the foundation pose. Consider not only surface elements, but ask yourself "if this pose were a solid figure, which parts would be activated and which would rise up?"

1 Draw Pose 2, the rear view version of Pose 1.

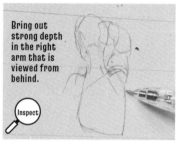

Inspect Connect the left and right deltoid muscles and confirm the positioning.

Make sure the chin does not stick out

2 There is a sense of the chin being pulled down, so draw the part from the neck to the back of the head stretching straight up.

Bring out strong depth in the right arm that is viewed from behind.

Inspect

★ As this is the first "omnidirectional approach", I have explained some of the matters derived from observing Pose 1; these are identified with a magnifying glass **Inspect** symbol.

3 The elbow of the raised right arm protrudes out to the front significantly more than the upper body, so don't bring it out to the side of the body.

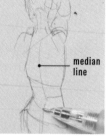

median line

Inspect

4 The left hip juts forward, contrasting with the upper body.

5 Mark in the median line to run down the center of the body's surface in order to make the twist in the waist clear.

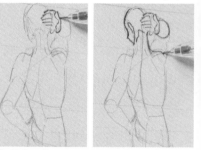

Ask yourself, "What part am I drawing now?" Then draw a solid finishing line.

9 Pick up lines to prevent various points noted when drawing the rough draft—such as the thickness of the flesh, body angles and so on—from being killed off.

6 The body weight-supporting left leg. This is a pose viewed from behind, but as the back is significantly twisted, the legs can't exactly be depicted as if viewed directly from the rear either. Carefully observe and read into situations such as this.

7 Don't make the right leg sharply bent as it would be if viewed from the side.

Incorporate the expression of depth into the left arm, slightly pointing the elbow out to create balance.

Use a sharp line ▶ to create shape.

8 The instep and heel of the foot are quite thick. Use a clear cut line to denote their form. This nearly completes the draft sketch.

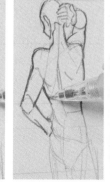

Don't worry about parts, but look at the entire figure

10 When expressing depth in the right arm, picking up only on that makes for a crisp way of drawing, but don't worry too much about it and prioritize drawing the entire body.

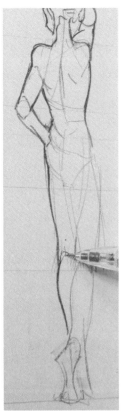

12 Differentiate the height of the hips, making sure the center of gravity does not shift from the left leg.

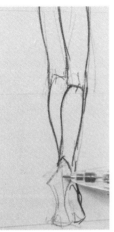

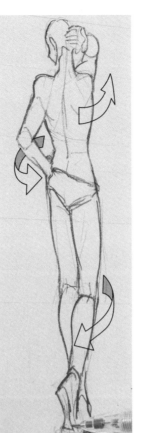

11 The way the back of the knees are rendered has a particular effect on the look of the legs. Be particular about bulges as you draw.

13 Looking only at the lower body, it resembles the form of a figure viewed from diagonally behind.

14 As I've paid attention to the median line and center of gravity while drawing, the twist in the body is alive and well.

15 Neatly correct the thickness of the legs and any parts you might have skipped over.

Inspect

16 As the join of the right leg appears to be pulled slightly into the foreground, take care depicting the overlap with the left leg.

17 Readjust the tilt of the left hip to complete the work.

Completion of the pose drawn from two directions

18 If the two figures are compared, there is misalignment in the positioning of the left hand, but as the purpose was only to get an understanding of how the pose is balanced and imagining it from a different angle, it's not a problem. Even if the position of the hand is slightly altered, it doesn't affect the foundation of this pose.

On the other hand, if the center of gravity is meant to be in the left leg but it's shifted to the right... or the positioning of the bend in the joints looks forced... that's due to a lack of observation.

Draw the Same Pose from Three Different Directions: Pose 1

The next "omnidirectional approach" practice is to draw a pose from three different directions. Try the challenge of a pose with limbs stretched and a twist and arch worked in.

1 Start from the head.

2 This time, make the head face towards the front.

3 Boldly arch the upper body out to the side.

4 Draw in the arm from the shoulder jutting out to the front.

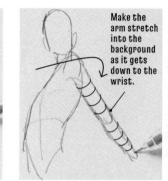

5 Add in movement to the arm from the foreground back to create an even bolder pose.

Make the arm stretch into the background as it gets down to the wrist.

6 Explore the angle of the leg from where it joins to the body.

7 Bring the median line to the foreground and make the lower body face forward in the same way as the head.

8 Work in the tautness in the thighs.

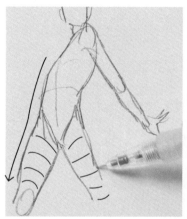

9 Make use of the flow of the right shoulder that cannot be seen in the background to pull the right leg into the foreground.

10 Mark in lines to make the right ankle look large.

11 Play up the bold flow of the leg and determine the direction of the toes.

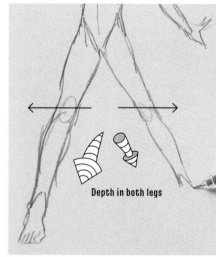

12 Make the legs open out not only to the side but from front to back, bringing out depth.

Depth in both legs

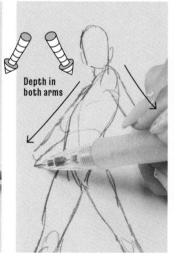

13 Spread out the arms wide to match the arch of the upper body.

Depth in both arms

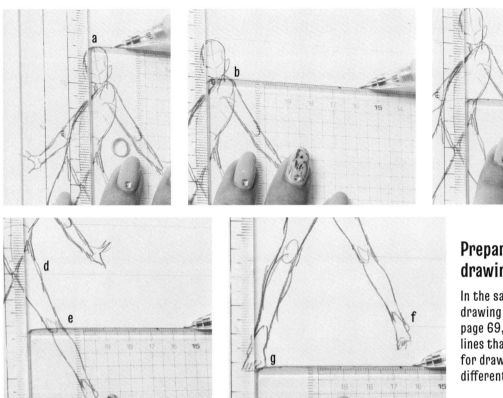

Preparation for drawing Pose 2

In the same way as for drawing the twisted pose on page 69, rule in the parallel lines that will form guides for drawing the figure on a different angle in Pose 2.

Pose 1 is finished!

Key Point

Pull the chin down in this simple yet boldly dynamic pose.

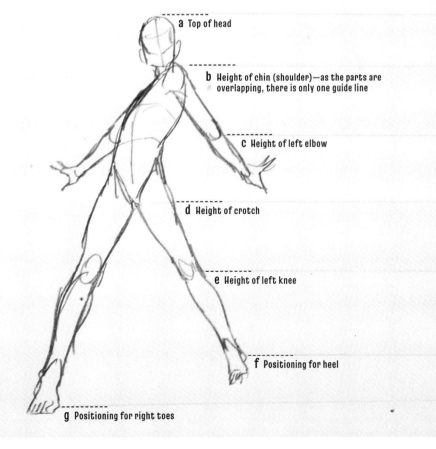

a Top of head

b Height of chin (shoulder)—as the parts are overlapping, there is only one guide line

c Height of left elbow

d Height of crotch

e Height of left knee

f Positioning for heel

g Positioning for right toes

Pose 2: Draw the pose from a different angle (from the side)

Draw Pose 1 (page 73) as seen from the side. After making the rough draft, use solid lines to capture the shape.

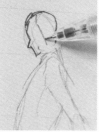

Direction of gaze

Pull chin down

1 Draw the silhouette of the face in profile.

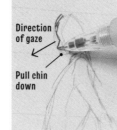

2 The chin is pulled down, so tilt the hairline as well.

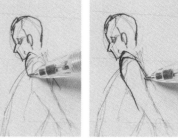

3 Bring the left shoulder more to the fore of the body than it would normally be.

4 Don't forget to express the depth when viewed from front on. Draw in the arm extending further into the background than where it joins the shoulder.

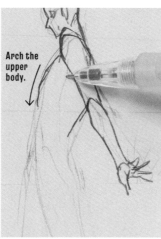

Arch the upper body.

5 Capture the thickness of the upper body.

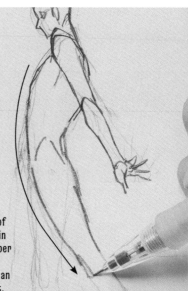

6 Make use of the curve in the arched upper body to draw the left leg as an extension of it.

7 Pay attention all the way down to the toes so as not to interrupt the flow!

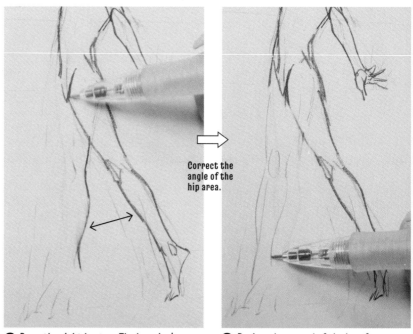

Correct the angle of the hip area.

8 Draw the right leg too. The legs don't seem to be quite far enough apart...

9 Review the spread of the legs from where they join the body.

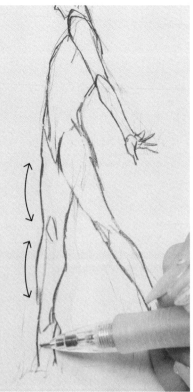

10 Rather than making them straight, raising up the thigh and calf results in activated legs that are stretched straight out.

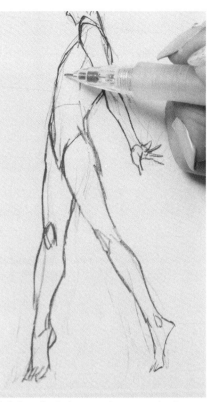

11 Draw in the knees and toes to point in the same direction as in Pose 1. Make the figure stretch up with plenty of strength in the toes.

Side line

12 As per the median line that runs down the center of the body, drawing in the side line (see page 160) makes it easier when drawing from the side.

13 Add in the right arm that can be seen in the background.

14 Finish off the toes.

Pose 2 is finished!

15 Simple poses can present difficulties. I struggled with the lower body in this pose.

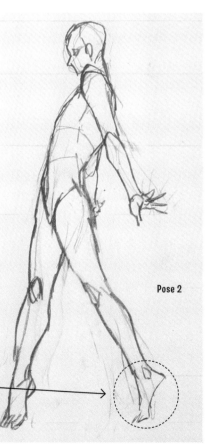

Pose 1

Key Point

The parts that appear small due to depth when viewed from front on may change in size when viewed from the side, as depth disappears. Consider the situation and make adjustments accordingly as you draw.

Compare the left feet!

Pose 2

Pose 3: Draw the pose from a different angle (from behind)

Using Pose 1 and Pose 2 as references, we'll draw the pose from yet another angle.

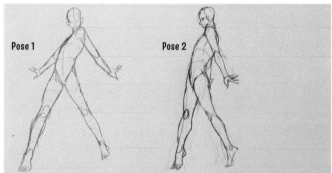

Pose 1

Pose 2

1 Measure out the positioning of each body part, relying on parallel lines to proceed with the rough draft.

2 Explore the shape while slightly exaggerating adding flesh to the form by considering whether the buttocks are lapping over the legs, whether the backs of the thighs are raised up and so on.

5 In order to render the pulled in look of the waist, make a curve for the line where the back and waist meet and broaden the back.

3 Keep experimenting with fleshing out the form until the pose feels right.

4 Adjust the line of the back, keeping in mind the flow of the S-shaped backbone.

6 Explore how the shoulder in the background should look.

7 As the figure is being viewed not directly from behind but from a diagonal angle, don't make the arms spread out symmetrically.

8 Adjust the appearance of the backs of the ears so the angle of the head is clear.

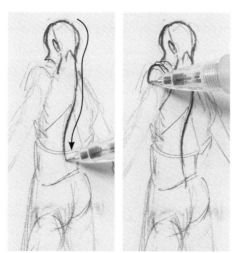

9 Be conscious of the connection from the back of the head to the neck and down the back.

10 Draw in the arms, checking the connection between the shoulders and back as you work.

11 Work in the elbow at the point where the upper arm and forearm join.

12 Draw in the hand to show the palm.

Use arches to indicate where the shoulders join the body, the elbow joint and so on to bring out perspective.

13 It's a pose in which the whole body is activated, so use strong lines to bring out tightening in the back, shoulders and around the neck!

14 Express depth in the right arm by using arches in the opposite way to those on the left arm.

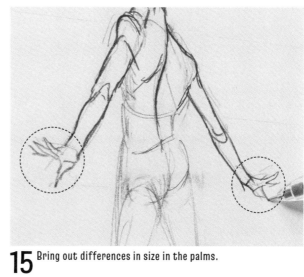

15 Bring out differences in size in the palms.

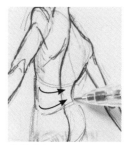

16 Raise the hips.

17 From here, correct the shape of the buttocks.

Pose 3 continued

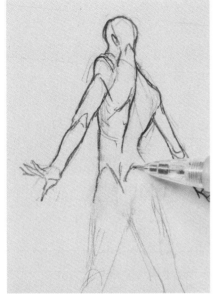

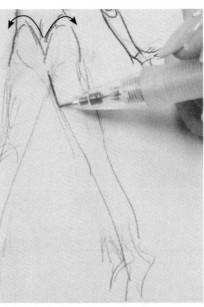

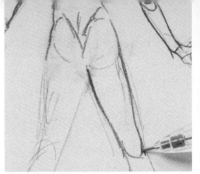

18 I asked myself "do the buttocks look like they are on a diagonal angle?" but they didn't... the body is twisted, so you need to work out which way the buttocks are facing and correct the shape.

19 Lift the buttocks so that they appear taut.

20 Get a grasp of where the left leg joins the hip, which is hidden by the buttocks, before drawing it.

21 Capture the points where parts connect to other parts, such as around the knees and ankles.

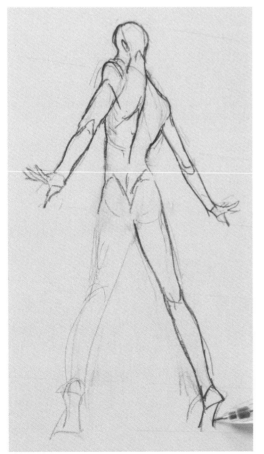

22 Compare this figure with Pose 1 to rethink the spread of the legs.

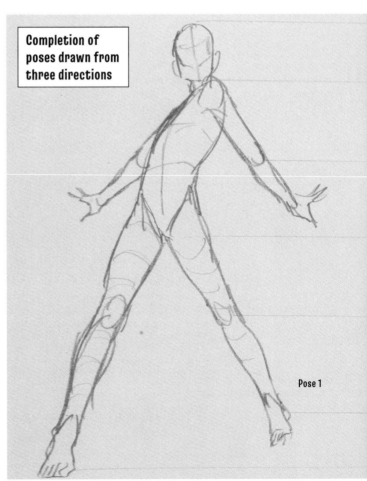

Completion of poses drawn from three directions

Pose 1

23 Raise the right heel to show the sole of the foot.

Use an arch shape to depict the rise of the thigh.

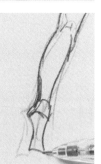

Mark in a line from the calf to the Achilles tendon.

24 The left leg is pulled back, so go all out to express the rise of muscle where the thigh joins the hip.

25 Pull up the heel to bring out a sense of strength.

⇩

Pose 3 is finished!

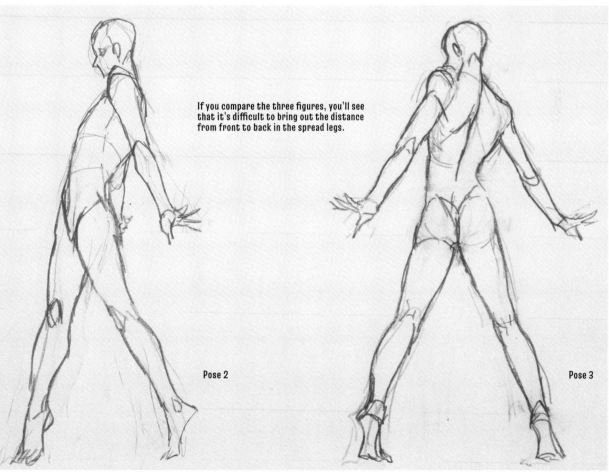

If you compare the three figures, you'll see that it's difficult to bring out the distance from front to back in the spread legs.

Pose 2

Pose 3

Draw Two Different Seated Poses

Key Point

Show the upper surfaces of the shoulders (lap them over the shape for the neck).

1 Draft in the positioning for the head down to the hips, using solid lines to draw in the torso.

Decide on the position for the buttocks.

2 As it is a relaxed pose, when seated deeply into the chair the body tilts forward.

3 Add in the surface of the seat to create the appearance of the figure being seated far back into it.

The perspective was too strong, so I corrected the seat surface.

A

Seated deep into a chair

It's possible to create movement not only in standing poses but in seated ones too. Let's take two different types of seated poses as the base into which to render motion, starting with a pose where a figure is seated deeply into the chair. We'll attempt to create various poses by adding arms and legs to a torso with only the hips resting against the back of the chair.

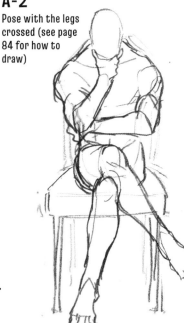

Advanced example: enclosed within a chair

Type A

A drawing of a torso seated on a chair and leaning forward. This is the base from which to consider variations in poses where the figure is seated deeply in the chair.

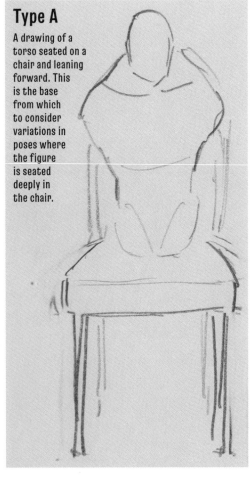

A-1

Pose with the legs apart (see page 82 for how to draw)

As the thighs are touching the seat, all the way up to the front of the figure's knees is firmly established in the chair. The heels tend to rise off the floor more easily than when seated on a chair's edge.

A-2

Pose with the legs crossed (see page 84 for how to draw)

Since the legs are on the seat, there is stability in the crossed leg pose. It's a pose that gives the impression of being firm and solid.

Key Point

Show the line of the neck (the upper surfaces of the shoulders are not visible).

1 Draft in the positioning for the head down to where the legs join the torso, using solid lines to draw in the torso.

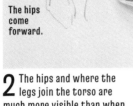

The hips come forward.

2 The hips and where the legs join the torso are much more visible than when seated deep in the chair.

3 The shape from the head down to the neck and the look of the shoulders affect the posture. Draw in the seat.

4 Slightly raise the shoulders and explore the line of the collarbone.

B

Sitting on the edge of a chair

Next, we'll draw movement in a shallow seated pose. For this posture, place the hips towards the front of the seat and lean the back against the back of the chair. Tilt the upper body back so the figure is facing upwards.

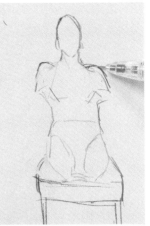

Advanced example: biting the Achilles tendon

Type B

A drawing of a torso seated in a chair, facing slightly skyward. As the figure is sitting on the edge of the chair, the hips are at the front of the chair. This is the base from which to consider variations in poses where the figure is seated on the edge of the chair.

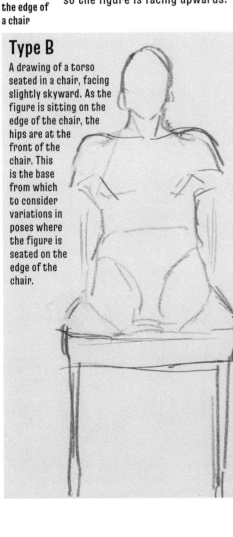

B-1

Pose with legs spread apart (see page 83 for how to draw)

The thighs are not on the seat surface, so it's easy to spread the legs apart. This creates space on the seat surface, so a pose with the hands on the seat to support the body is also possible.

B-2

Pose with legs crossed (see page 85 for how to draw)

The legs can be loosely crossed. This makes for a pose with no sense of tension. Resting the elbows on the chair arms heightens this impression.

Type A: Seated deep in a chair with legs apart

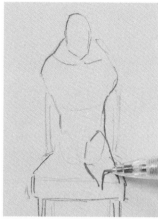

A

Draw using the "deep seated" pose as a base

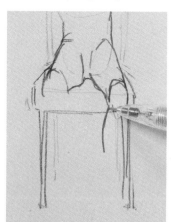

1 The hips are in the background, so the legs can't spread out very far to the sides.

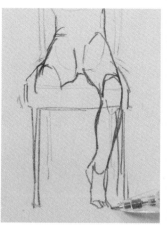

2 Match the knees to the edge of the chair and draw in the thighs.

3 Depending on the height of the chair, it becomes difficult for the heels to stabilize.

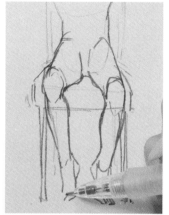

4 Adjust the direction on each side while drawing in the insteps.

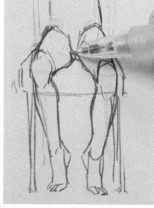

5 Raising the heels and flattening out the flesh in the thighs creates the sense of the figure being seated deep into the chair.

A1 is finished!

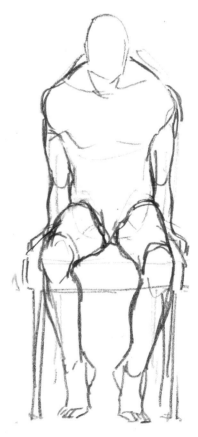

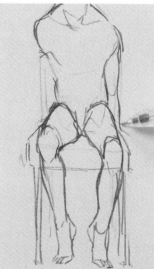

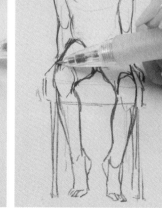

6 Make the figure grasp both sides of the chair so that the body is sandwiched in between the hands.

7 Completion. The tensing of the sides creates stability in this pose. The way the figure is holding himself gives the slight impression of nervousness.

Type B: Seated on the edge of a chair with legs apart

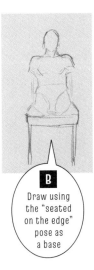

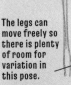

B
Draw using the "seated on the edge" pose as a base

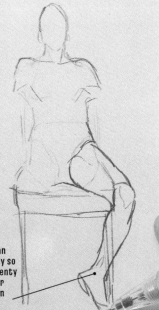

1 The position of the knees is lowered and the toes have a firm grip on the floor, so it's easy to create a laidback pose with the heels resting on the floor.

The legs can move freely so there is plenty of room for variation in this pose.

2 The flesh bulges up around the leg joints. Draw in the line of the right leg, comparing it with the left as you work.

3 Place the toes on the floor so that the soles of the feet face each other.

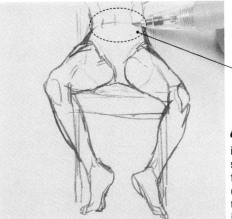

Key Point
Capture the shape of the abdomen.

4 The line of the abdomen is important for showing that the figure is on the edge of the chair. Indicate the sense of arching in the upper body.

B1 is finished!

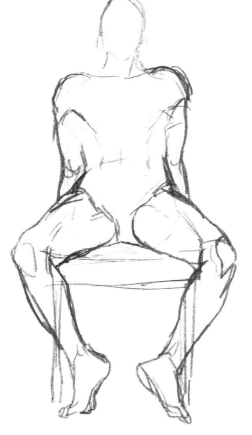

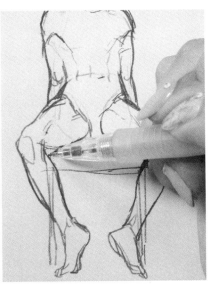

5 Capture the flattening out of the thighs and the change in their shape. The hips come forward, so if the hands are holding the chair, they will be behind the body.

6 Completion. The hands are placed in the gap between the back of the chair and the hips in this pose. Using the back of the chair when the figure is seated on the edge makes it easy to create impressions of "sloppiness," "being domineering" and "relaxing."

Type A: Seated deep in a chair with legs crossed

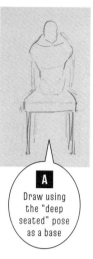

A
Draw using the "deep seated" pose as a base

Key Point
Get a grasp of the position and direction of the left knee.

1 Start by drawing the knees to meet the edge of the chair.

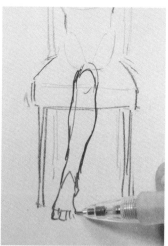

2 Connect down to below the knee. Angling the leg a little makes for an attractive look.

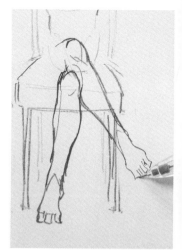

3 Cross the right leg over the left. Start with the knee here too.

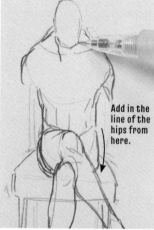

Add in the line of the hips from here.

4 Once you've captured the shape of the hips, start drawing in the hand attached to the chin.

5 Work in the position of the hand and forearm first.

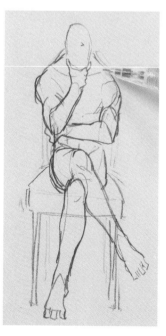

6 Use the same procedure in which you drew the legs from the knees down to determine the placement and draw in the arms from the elbows to the ends of the hands.

A2 is finished!

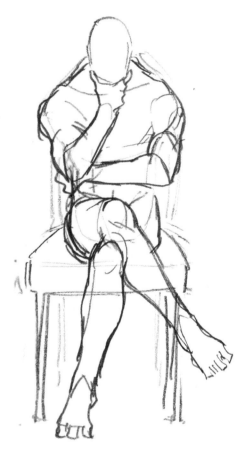

7 Completion. I brought the arms forward from a forward-leaning posture to form a pose of being deep in thought.

Type B: Seated on the edge of a chair with legs crossed

B

Draw using the "seated on the edge" pose as a base

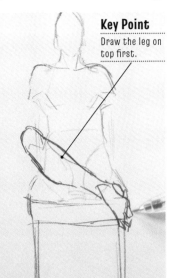

Key Point

Draw the leg on top first.

1 It's hard to get the balance right on the right leg which is on top, so determine its position first and draw in everything else to match it.

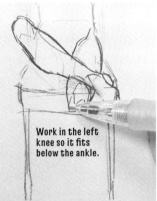

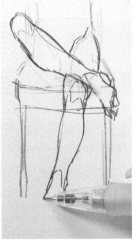

Work in the left knee so it fits below the ankle.

2 If care is not taken with the depiction of contact surfaces, the legs will not seem to be resting firmly on the chair, resulting in a sense of floating. Consider how the right leg laps over the left, placing it so it is caught by the left knee.

3 Bring the left leg slightly to the foreground to make it look like the figure is sitting with the leg thrust out.

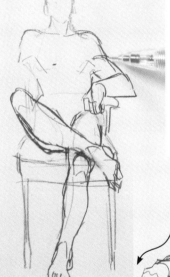

4 As per the legs, work different movement into the right and left arms.

B2 is finished!

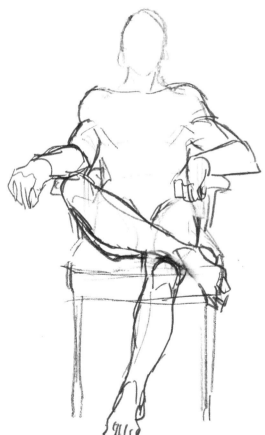

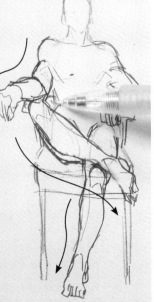

5 Orient the limbs differently to achieve balance.

6 Completion. The arms are placed on the armrests for a pose that conveys the impression of relaxing. Combining different ways of sitting and crossing the legs allows for the creation of multiple variations.

Using different ways of sitting to distinguish character types and scenes

In "Add movement and expression to standing poses" (page 60) I introduced examples of creating emotional expression by combining poses and facial expression. Seated poses and facial expressions can also be used to show a character's state of mind. In order to make it

Type B: seated on the edge of a chair with legs crossed; advanced example

☆ One hand is on the seat, not concentrating on anything in particular.
☆ Leaning back to relax.
☆ Not listening properly to what the other person is saying.
☆ Thinking about something at the same time ... etc.
☆ Behavior displayed towards someone to whose company the character is accustomed.

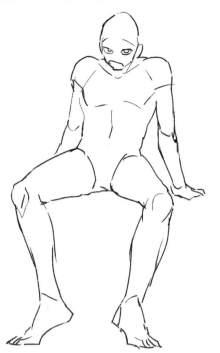

Type B: seated on the edge of a chair with legs apart; advanced example

☆ Sitting in a careless manner on the edge of a seat with the hands thrust behind.
☆ An irresponsible character or an attitude intentionally indicating no interest in listening properly.
☆ In a state of tiredness etc.

Type AB: seated either on the edge of or deep in a chair is fine! Pose with legs crossed; advanced example

☆ Intimidating posture with the arms spread wide to make oneself appear bigger.
☆ The style of a leader type figure or bad character.
☆ Attitude assumed towards someone the character believes is lower than himself.
☆ Or a posture to indicate power so the other party does not take advantage of the character.
☆ For postures that make use of the backrest, whether the figure is seated towards the front or back of the chair alters depending on the character's physique and the amount of sitting space.

Type A: seated deep in a chair with legs crossed; advanced example

☆ Stiffening the body with the arms crossed. A state of tension.
☆ Feeling intimidation, vigilance or some other less than positive feeling towards the other party.
☆ In a bad mood from feeling nervous, or the character is trying to show that they are in a bad mood.

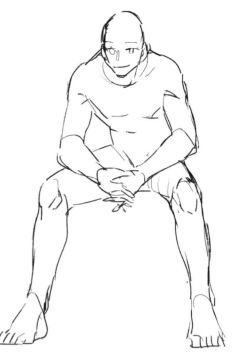

Type A: seated deep in a chair with legs apart; advanced example

☆ Leaning forward from deep in a chair. A posture that shows the character is listening carefully to what the other person is saying.
☆ Also for situations when facing the other person directly such as when trying to persuade them.
☆ This pose suits calm, dignified types.

Type B: seated on the edge of a chair with legs apart; advanced example

☆ Sitting leaning forward.
☆ In a forward leaning posture, interested in what the other person is saying.
☆ As sitting on the edge of the seat creates a restless impression, the pose can be used for characters with childish personalities.

Type B: seated on the edge of a chair with legs apart; advanced example

☆ The state of having slid down the chair with the buttocks only just clinging to it.
☆ A sloppy look with a rounded back. This was not the posture initially, but rather the figure gradually slid into it as would someone asleep on a train, someone having fallen asleep watching TV on the sofa at home etc.

★ The examples A "seated deep in a chair" and B "seated on the edge" were drawn as extremes to differentiate between them, but there are also intermediary postures and postures that draw on both types.

Challenge 1: Change the Angle in Crouching Poses!

1 ## Draw a crouching pose with the feet together

Try the challenge of redrawing poses from different angles.
Start with capturing a crouching pose from two directions.

1 Draw the base pose. Use soft, curved lines for blocking in to bring out the round form of the crouched figure.

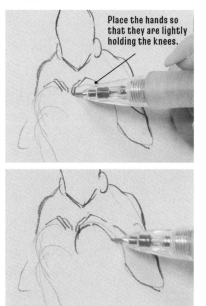

Place the hands so that they are lightly holding the knees.

2 Make the bend in the knees rounded as they are being viewed from front on.

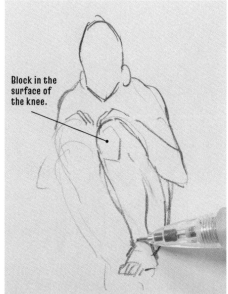

Block in the surface of the knee.

3 The sense of compressed flesh in the calf is key.

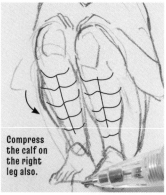

Compress the calf on the right leg also.

4 Get a sense for the shins and draw flesh sticking out in the gap behind them.

5 Connect the line from the thigh to the buttocks.

6 Draw in the expression too.

7 The completed pose. Round out the silhouette. Bring out thickness in the compact figure to complete the work.

➡️ **Draw the same pose from a low angle looking up from the feet**

Key Point
Don't forget the swelling out of the shin and calf.

1 Take on the challenge of the extremely low angle looking up from the soles of the feet.

2 Create the draft sketch in which only the legs can be seen and the body is nearly entirely concealed.

3 Make the legs huge. Don't forget to round out the overall silhouette.

The thigh is nearly entirely concealed.

4 Don't forget about the areas which you drew with care in the base pose!

Redraw the blocking in of the knees to make them viewed from below.

5 The hands which were nearly concealed by the thighs and knees can hardly be seen at all. Use the protruding elbow to clearly indicate the location of the hands.

6 Changing to the viewpoint of a low angle conceals the chin.

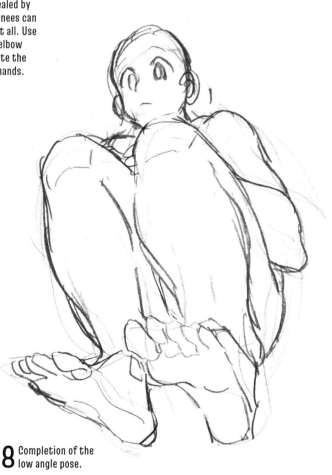

Facial expressions are readily altered so take care!

7 Draw in the face to match the expression in the base pose.

8 Completion of the low angle pose.

2 Draw a crouched pose with the legs spread apart

1 Start from the head.

2 Draw in the head on a slightly downward facing angle.

3 Sketch in the shoulders, making them rounded. Think of the neck as being behind the head, and the body being behind the neck.

We'll draw this crouched pose with raised heels from two angles. When crouching, the back rounds, directing the head slightly downward. Consider the characteristics of the posture when deciding on angles.

4 Sketch in the silhouette first so that the body doesn't tilt.

5 To create a slightly activated posture, draw the shoulders a little as if they were raised in anger.

6 Before drawing the hands, draw in the left leg opening out to the side. Place a hand on it.

7 Line up the direction that the knee is opening out on and the orientation of the instep.

8 In the same way as for the left leg, determine the position of the right arm.

9 The left leg is complete, so draw in the left arm so that it rests on the thigh.

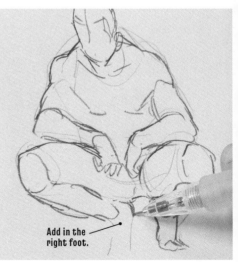

Add in the right foot.

10 The body weight is resting evenly on both legs, so draw them so as not to appear disconnected.

11 The body weight has shifted to one side, so I corrected the orientation of the face.

13 Add in a glaring expression to match the pose.

12 Make small adjustments so that the forms of the shoulders and face sit well together.

14 Draw in the pectoral and abdominal muscles. As the figure is crouching, squash down the abdominal muscles and make them not particularly visible.

The back is rounded, so compared with regular posture, the length from the shoulders to the hips is more compact.

15 While correcting the center of gravity, check for parts that have become misaligned and redraw them.

16 The feet have been corrected to be nearly symmetrical.

17 The completed pose. Take care when drawing the squashed down flesh around the stomach.

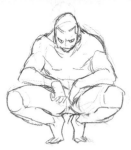

Draw the same pose from behind and overhead

Using the crouching pose from page 91 as a base, we will create a sketch from a different angle. In order to create an air of intimidation, make the back big and broad.

Don't simply join the head and neck to the back, but be conscious of following the roundness of the head to do so.

1 Commence the draft sketch.

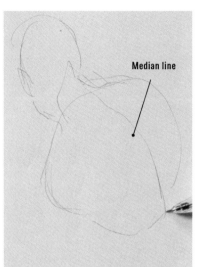

Median line

2 Mark in the median line down the center and determine the flow and orientation of the body.

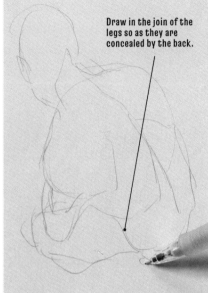

Draw in the join of the legs so as they are concealed by the back.

3 Add in the legs protruding out from beyond the roundness of the back.

4 Capture the orientation of the ears when viewed from behind. Adding in the hairline makes it easy to get a grasp of the angle of the head and position of the ears.

5 Make the join of the neck broad and use a fluid line to connect it to the back.

6 Taking care of unevenness at the shoulder blades, tapering at the waist and so on, draw in the body so that it looks like a curve when viewed as a whole.

7 Make the left shoulder in the foreground even broader.

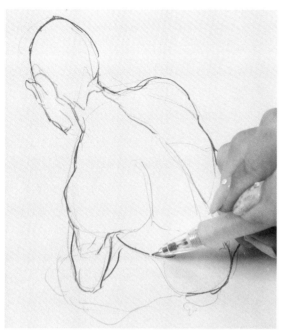

8 Taper in the body towards the waist. Don't make the line down to the hips drawn-out and sluggish but rather think of it as a large mass.

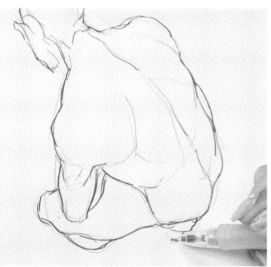

11 Consider how the shank and foot appear from overhead.

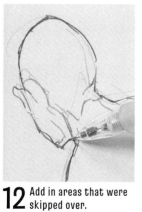

12 Add in areas that were skipped over.

13 Keep the heel and toe slightly visible.

9 The focus of this piece is the broad back, so keep the overall balance in mind and don't add too much detail.

Key Point

Use a clean line for the buttocks rather than working in hollows and bulges.

10 Clearly depict the squashed flesh in the thigh.

14 Completion of the pose viewed from overhead. Make the area in the upper body from the head to the middle of the back broad and make the lower body compact for a dynamic effect.

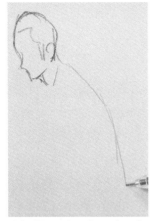

1 Decide on the orientation of the face and block in the line of the back.

3 Draw a crouching pose with one knee on the ground

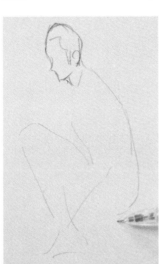

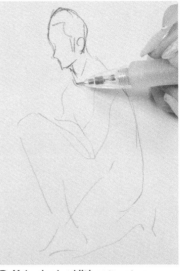

Capture a kneeling pose from two angles. For a pose whose shape is difficult to grasp, it's a good idea to explore positional relationships at the draft sketch stage.

2 Gently position each body part to get a grasp of how the pose will look.

3 Make simple additions to get an understanding of where the right hand will go, where the left hand will go, and so on.

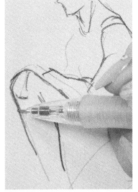
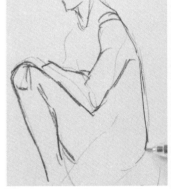

4 Create accent in the left arm as you draw.

5 The right leg is at the end of the left hand so draw it in next.

6 Work in the thickness of the bent knee as you draw.

7 Create a straight posture that extends down to the left leg.

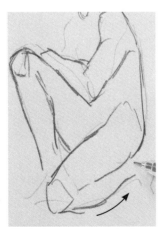

8 Lightly squash down the flesh in the thigh and do the same to the calf.

9 Give the instep a taut, angled finish.

10 Draw in the instep for the right foot and toes, creating a sense of rhythm.

11 Add in the join of the leg to establish the posture.

12 Correct the leg join section, making sure it's not on too much of an angle.

13 Half the right shoulder is hidden, so take care where the arm joins the body.

14 Even though it's hidden, don't lose the sense of continuity in the arm.

15 Capture the expression in the hand that is key to this pose. Draw it gently outstretched.

16 Separate the fingers to create a smooth flow.

Add in a facial expression that is in harmony with the pose

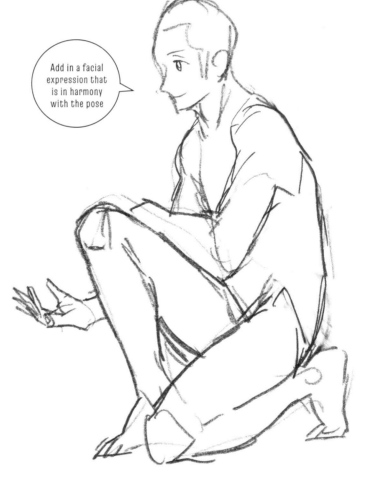

17 Completion of the base pose. Extend the fingers straight out and create an upright posture for overall cohesion.

[Change of angle!]

Draw the same pose from diagonally above

Use the crouching pose from page 95 as the base to draw a sketch from a different angle. Make sure to express the dynamism created by looking up from a low angle.

Line to indicate posture

1 Start the draft sketch with the line of the back.

Make a sharp bend at the knee to create an acute angle!

2 Determine where the right leg should be.

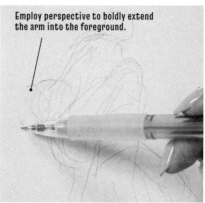

Employ perspective to boldly extend the arm into the foreground.

3 In terms of angles, the right hand is the key to the composition.

Make the jawline sharp!

4 In order to retain a gentle expression, don't overdo the angle of the face.

Don't stiffen the shoulders!

5 There's a tendency for things to become rigid when drawing a figure from a low angle, so consider the original pose to work in a moderate degree of roundness.

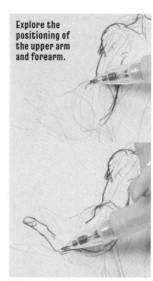

Explore the positioning of the upper arm and forearm.

6 Stretch out the arms and make the fingers long and attractive.

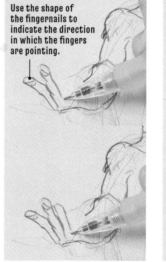

Use the shape of the fingernails to indicate the direction in which the fingers are pointing.

7 Compare the length of each finger as you draw them.

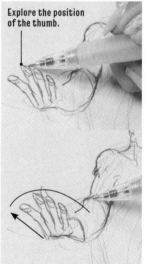

Explore the position of the thumb.

8 Adjust the fingers so that they form a fan shape.

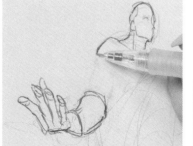

9 Correct the arm again so that it matches the position of the hand.

Key Point

Deftly alternate thicknesses along the arm to create attractive movement and prevent jaggedness in the joints.

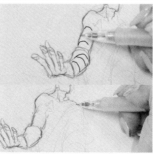

10 Neatly connect the tendons in the neck to the collarbone and down to the left shoulder.

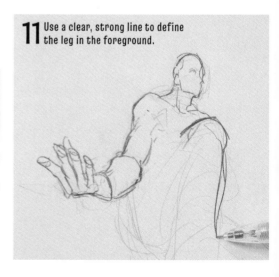

11 Use a clear, strong line to define the leg in the foreground.

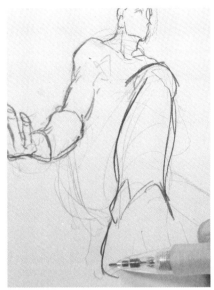

13 Significantly emphasize the height of the instep to convey a sense of presence. Thicken the toes.

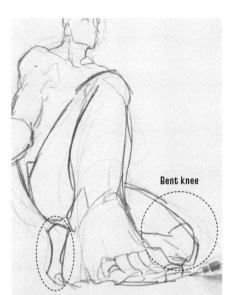

12 Increase the size of the foot from the instep down.

14 Create a glimpse of the left leg beyond the foot.

Bent knee

Position of foot

15 Ask yourself what kind of pose you are creating in order to properly show the parts that are key to the drawing.

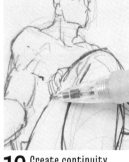

16 Add in hollows and muscle in the shoulder.

17 Capture the position and form of the elbow.

18 Create continuity between the left arm and hand.

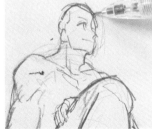

19 Adjust the size of the head little by little so that it matches the face.

20 Render the contact surface flat between the floor and foot in order to bring out the sense of space created when looking up at the figure from close to the ground.

21 Completion of the low angle pose. I considered how the pose would fit into the screen and used overexaggerated perspective on the movement in the right hand.

Challenge 2: Change the Angle in Reclining Poses!

1 ## Draw a reclining pose with the cheek resting on the hand

Capture this pose with the face resting on an upturned arm from two angles. As the upper body is arched and the shoulders are raised, the neck appears short, as if sunken into the body.

1 Draw the head and determine the position of the ears.

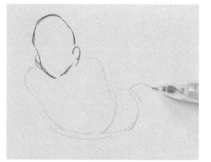

2 Once the angle of the face is decided, consider roughly how the figure will fit into the screen and draft a loose silhouette.

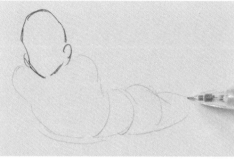

3 Capture the mass of the chest, hips, buttocks and thighs.

4 Explore the position of the right arm that is supporting the cheek.

5 As the elbow is poking into the ground, the right shoulder is raised. Start drawing from the position of the hand.

6 Use a sharp line for the forearm.

7 Determine the position for the loosely clenched left hand.

8 The neck is positioned lower than the shoulders and appears sunk into the body.

9 Slightly squash down the flesh in sections of the body that are in contact with the ground, such as the elbow and hip (stomach) to indicate the presence of the flat floor. Depict the load on the body.

10 Consider the thickness of the body as you work further and further into the background.

11 Dramatically alter thickness between the thigh and calf. Switching balance at the joints makes it easier to create a sense of perspective.

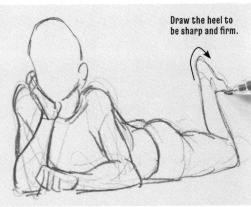

Draw the heel to be sharp and firm.

12 Take care with the angle of the foot to draw down to the tips of the toes.

13 Make the right leg small to create overall balance and bring out depth.

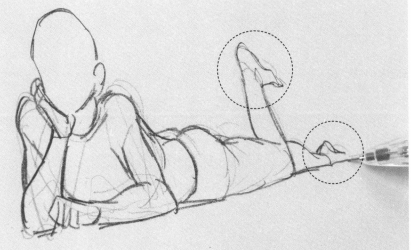

14 Differentiate between the size of the left and right feet. The legs should look as if they are swinging freely.

15 Make the facial expression fun and relaxed.

16 Use curved lines for the eyebrows and eyes. Simplify the mouth into a bowl shape.

17 The completed pose.

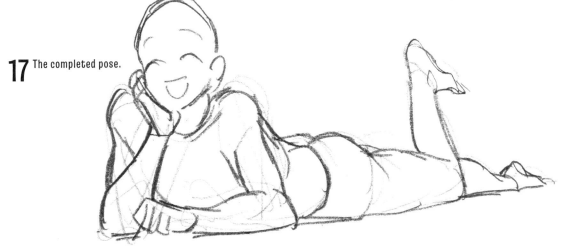

Draw the same pose viewed from the ground up

Using the reclining pose from page 99 as a base, sketch the pose from a different angle. As the viewer is looking up from diagonally below, there is the assumption that the arms, stomach and other parts in direct contact with the floor surface are visible.

1 Start the draft sketch. As it is a view from a low angle, the underside of the chin is visible.

2 Bring out the sense of the low angle by intentionally creating strong arch shapes for the joints.

3 As the view is not from directly below, make the upper body large. Maintain the sense of perspective by placing the lower body beyond it.

4 Use clear lines to draw in the head and hand.

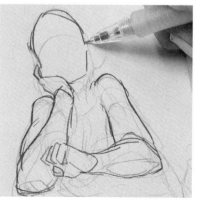

5 Make the palm of the hand cup the chin.

6 Alter the arm to exaggerate its thickness and strengthen the sense of perspective even within that single body part.

7 Enlarge the part of the left arm that is in contact with the floor too and bring out the sense of distance from the shoulder.

8 Check the shape of the head and position of the ears.

9 Showing a little of the back of the head from behind the ears creates the sensation of viewing the figure from a low angle.

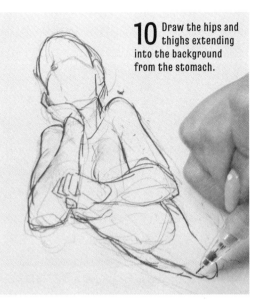

10 Draw the hips and thighs extending into the background from the stomach.

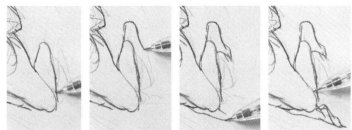

11 As the viewer is looking up from below, much of the area from the knees down is hidden by the thighs.

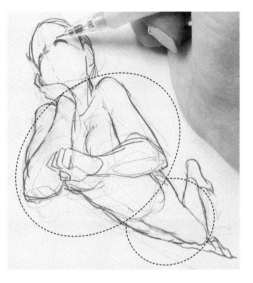

12 Creating a significant difference in the ratio between the upper body and the lower body brings out the impact of the low angle.

13 Round out the facial features. Follow the arched lines of the draft sketch to draw in the eyes and mouth.

14 Alter the shape of the mouth to make it seem to be being looked up at from below.

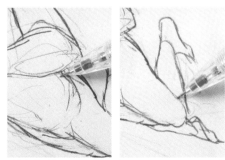

15 Add in the body surfaces that are squashed against the floor.

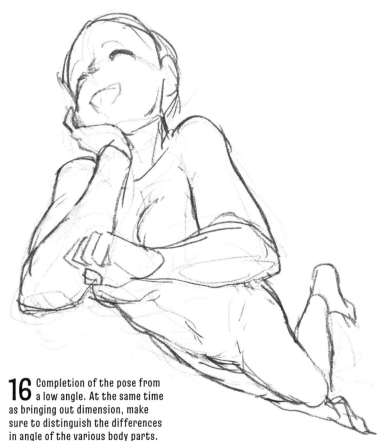

16 Completion of the pose from a low angle. At the same time as bringing out dimension, make sure to distinguish the differences in angle of the various body parts.

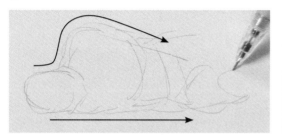

Make the head rest on the ground

1 Start from the head.

1 Draw a figure reclining on its side

Capture a sideways reclining pose from two different angles. As the head is resting on the floor, the shoulder and arm are significantly different on each side.

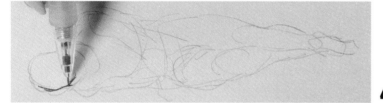

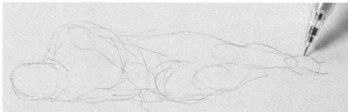

2 Roughly capture the silhouette with one side of the body pressed against the floor and the other with raised areas.

3 Visualise the foundation shape before adding in the squashed down shoulder and rounded form of the body.

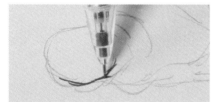

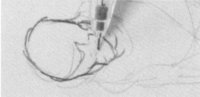

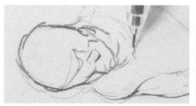

4 The draft sketch is complete, so start to draw in the final sketch starting with the head.

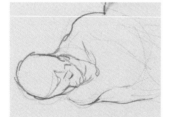

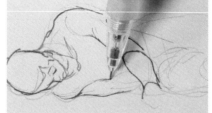

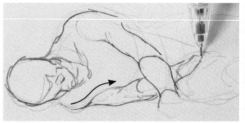

5 Start with the side touching the floor (this is a close-up of the head from step 4).

6 Angle the head slightly downward to bring out a sense of fatigue.

7 Use loose lines to make gentle curves around the neck.

8 The back is rounded, so round out the shoulders too.

9 In order to show that the hand is naturally thrust out, mark in a smooth curved line from the shoulder to the fingertips.

10 Render the sense of the arm beneath the body being "pushed down flat." Draw the flesh of the chest area being pressed down over the top.

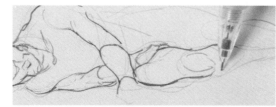

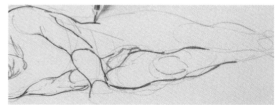

11 In a sideways reclining position, the legs are often bent. Don't draw them stretched straight out, but rather use more curved lines than in a standing pose.

12 While half the body is pressed flat against the floor, be aware of the tapering and hollows in the other half.

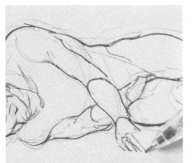

Key Point

Make the right leg sharply bent and bring the left leg to lie over the top.

13 Stack the legs so that they are in slightly different positions from each other in order for the bulges and hollows of each leg to fit neatly into the other.

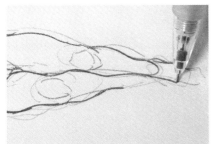

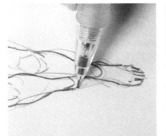

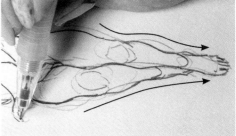

14 Make only the foot of the leg that is on top (the left leg) cover the right foot.

15 Draw the right foot tucked in beneath the left leg.

16 Adjust the silhouette so that when viewed as a whole, the body seems to get more relaxed towards the toes.

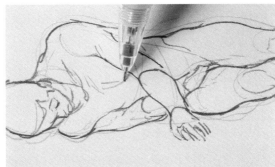

17 Use a soft touch when drawing the fingers so that they do not seem to be tensed.

18 Add in the muscles that are being squashed down due to the body being curled up.

19 Sandwich one hand between the legs to add subtle accent to the pose.

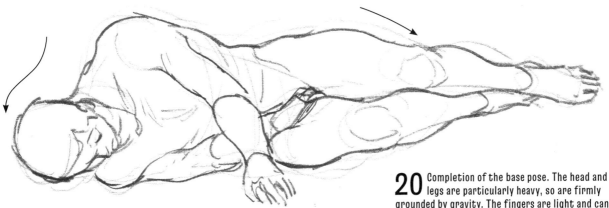

20 Completion of the base pose. The head and legs are particularly heavy, so are firmly grounded by gravity. The fingers are light and can be rendered to appear loose and relaxed. Consider the heaviness of the body parts as you draw them.

Draw the same pose viewed from the feet up

Use the reclining pose from page 103 as a base to sketch the pose from a different angle.

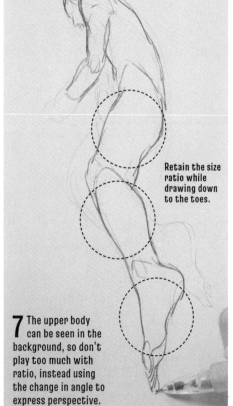

1 Draw in the overall silhouette, capturing the rounding of the back and bend in the legs.

2 The head is concealed by the shoulder, so start from the shoulder to draw in the lines that will remain unchanged in the final sketch.

3 Determine the position of the head beyond the shoulder.

4 Capture the continuity from the shoulder to the back.

5 Connect the large curve from the back down to the buttocks.

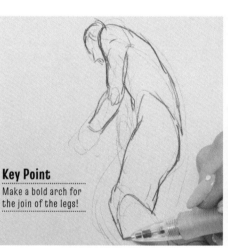

Key Point

Make a bold arch for the join of the legs!

6 Make the width of the legs considerable in comparison to the breadth of the back.

Retain the size ratio while drawing down to the toes.

7 The upper body can be seen in the background, so don't play too much with ratio, instead using the change in angle to express perspective.

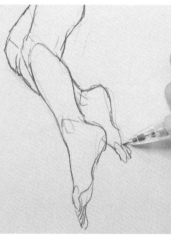

8 Pay particular attention to the thickness of the heels and separation of the toes to convey depth in the stacked feet.

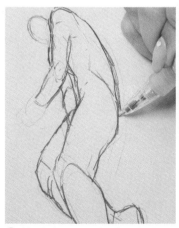

9 Check the connection from back to hips again. Retain the curve from the hips to buttocks as you connect the parts.

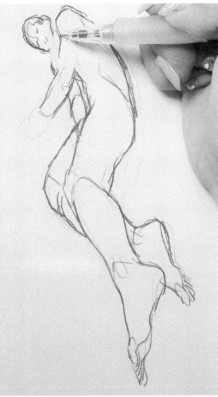

10 I redrew the angle of the head, adjusting it slightly so the facial expression is visible.

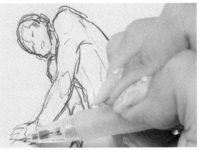

11 Leaving blank space to fill in the neck, bring out softness in the movement around the shoulders.

12 Direct the left elbow toward the viewer so that it's clear the figure is being viewed from a low angle.

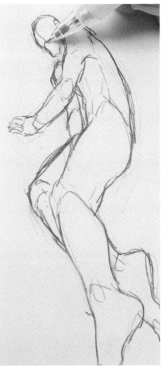

13 The position of the hand has been determined, so readjust the head and neck.

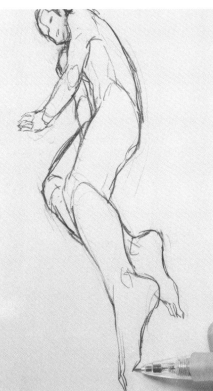

14 Here, I wondered whether too much of the sole of the foot was visible and slightly corrected it.

15 Completion of the pose from a low angle. Overall ratio and a sense of dynamic rhythm are used to effect. Retain roundness in the figure to avoid a stiff, rigid look!

3 Draw a figure reclining face-up

Respond to major alterations in the pose as you draw

This is an example of majorly altering the position of an arm or leg and proceeding to draw the changes in posture that result. We'll draw the base pose from two different angles.

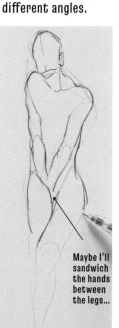

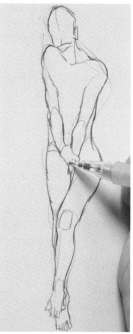

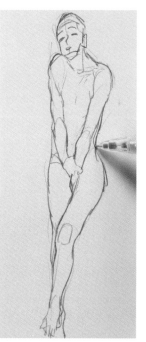

Maybe I'll sandwich the hands between the legs...

1 Sketch in the overall silhouette before marking in the solid lines.

2 Draw the pose with one leg on top of the other.

3 As the upper body is stretched out, the hands don't really fit in...

4 As I'm thinking of making the figure female, I want to emphasize the narrowing of the waist more. The area around the stomach is soft, so it tapers a lot more when a figure is on its side than when it is standing.

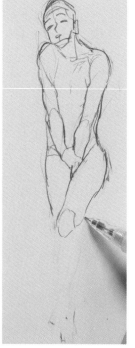

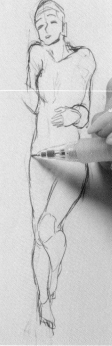

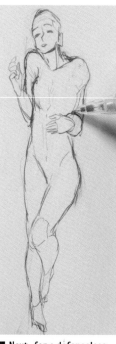

8 Completely change the lower body! Try orienting it in the opposite direction.

5 Try altering the way the legs are crossed.

6 This way, the X line forms, creating a sexy look. This might work too...

7 Next, for a defenceless look, I altered the hands, separating them from one another and placing them in a natural attitude.

Key Point
Don't make the legs stretch out straight, but let them fall out to the side due to gravity.

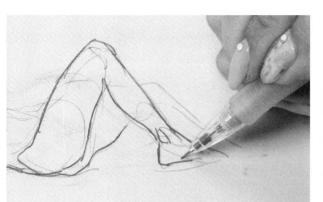

9 Use curved lines to softly draw in the thigh, swell of the calf and down to the narrow section of the ankle.

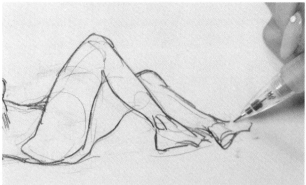

10 As the left leg in the background has dropped down more than the right leg, make the sole face towards the viewer. Take care with changes in subtle angles.

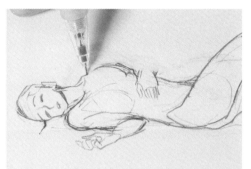

11 Make the shoulders flatter on the floor than for when the figure was facing to the side.

12 Create flow in the chest by flattening it out. After placing the hand lightly on the body, connect in the arm in the background.

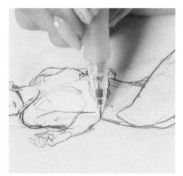

13 Adjust the elbow of the right arm in the foreground to sit close against the body.

Key Point

If you yourself can adopt the pose that you want to draw, give it your best shot. Instead of just relying solely on materials created by others, experiencing and analyzing the pose for yourself is effective as it allows it to stick in your mind.

14 Completion of the base pose. If something seems not to be working as you draw, locate the reason. Don't simply think "something's not right, but I don't know what it is" and keep working.

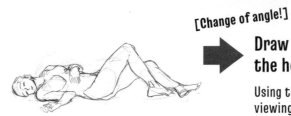

Draw the same pose viewed from above from the head down

Using the reclining pose on page 107 as a base, draw the sketch as if viewing the figure from a different angle.

1 Start the draft sketch from the head. Smoothly connect in the silhouette.

Key Point
Don't draw all the body parts; hide the ones that are covered up.

2 Focus on any eye-catching undulations as you draw.

3 Viewed as a whole, the silhouette nearly fits inside a circle.

4 Draw the facial features viewed from the top of the head, visualizing the angle of the head to determine it.

5 The shoulders are particularly smooth when viewed from overhead. Take care with the roundness of the chest which is being drawn down by gravity.

6 Place the hand on the torso before drawing the torso. Placing the hand on the torso will reduce its visible surface, although this is also due to the angle.

7 Proceed with drawing the leg, making it thinner towards the knee.

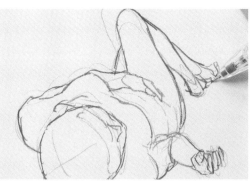

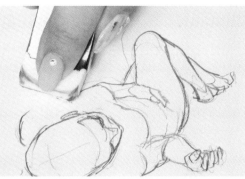

8 Pay attention to the positional relationship between the overlapping feet as you draw.

9 Correct any jagged areas.

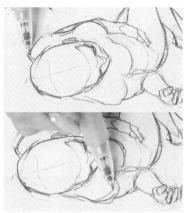

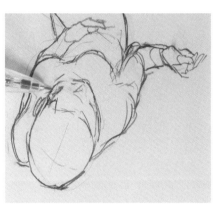

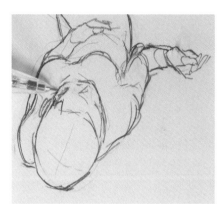

10 Correct the shoulders so that they both fall heavily to the floor. In a lying down pose, a large area of the body is in contact with the floor, and it is easy for the figure to become unbalanced, so make sure to consider the presence of the floor and proceed carefully when drawing each part.

11 Correct the shape of the head to be slightly elongated for a neat, smart look.

12 The head is not a perfect circle, so make alterations according to gender, age, personality and so on.

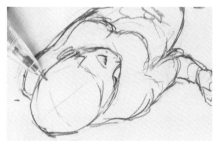

13 Correct the face and the line down the bridge of the nose, marking in a cross on the head to bring out the roundness of the head.

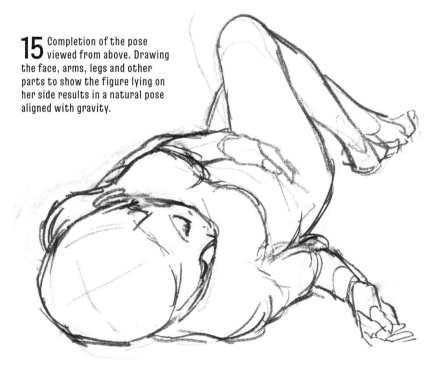

15 Completion of the pose viewed from above. Drawing the face, arms, legs and other parts to show the figure lying on her side results in a natural pose aligned with gravity.

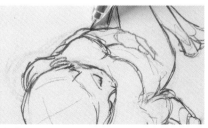

14 Check the positional relationship between the arm and chest.

Draw Various Movements from the Torso

Just as we drew "poses seated in a chair" starting from two types of torso on page 80,
Try practicing poses by first drawing the torso and then adding movement.

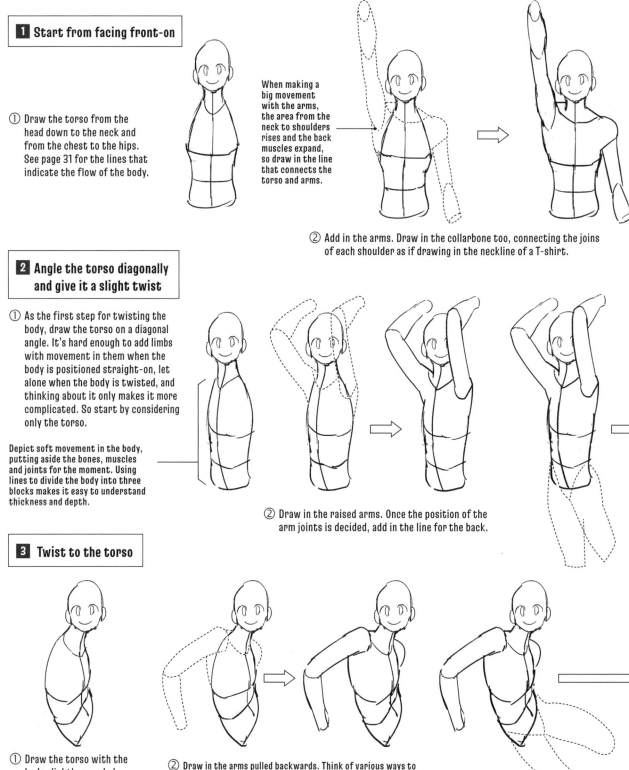

1 Start from facing front-on

① Draw the torso from the head down to the neck and from the chest to the hips. See page 31 for the lines that indicate the flow of the body.

When making a big movement with the arms, the area from the neck to shoulders rises and the back muscles expand, so draw in the line that connects the torso and arms.

② Add in the arms. Draw in the collarbone too, connecting the joins of each shoulder as if drawing in the neckline of a T-shirt.

2 Angle the torso diagonally and give it a slight twist

① As the first step for twisting the body, draw the torso on a diagonal angle. It's hard enough to add limbs with movement in them when the body is positioned straight-on, let alone when the body is twisted, and thinking about it only makes it more complicated. So start by considering only the torso.

Depict soft movement in the body, putting aside the bones, muscles and joints for the moment. Using lines to divide the body into three blocks makes it easy to understand thickness and depth.

② Draw in the raised arms. Once the position of the arm joints is decided, add in the line for the back.

3 Twist to the torso

① Draw the torso with the body slightly rounded. Make the face look straight towards the viewer.

② Draw in the arms pulled backwards. Think of various ways to orient the arms to suit the posture as you create the pose.

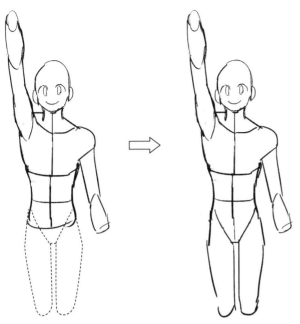

③ Add in the legs to align with the median line that runs down the center of the body. For ease of movement, make them sit over the hip section of the torso that has been divided into three parts.

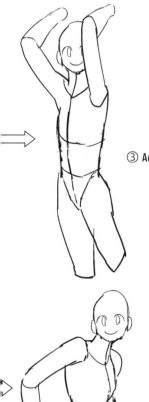

③ Add legs to the slightly twisted hips.

③ Add legs to the slightly twisted hips. Here, only the thighs are drawn in, but once the orientation of the calves is also decided the pose can be finished off with various movements.

Preparation for drawing four poses starting with the same head and torso

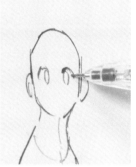

1 Starting with a face directed towards the viewer, add in a sideways-turned body. Capture the median line down the center of the body and divide the body into blocks to draw a natural curve.

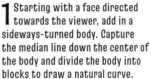
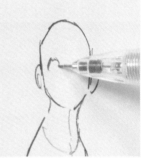

2 Add in facial expression to complete the base of the twisted torso.

Start

Draw Four Poses Starting with the Same Head and Torso

Characteristics of the four poses (A-D)

These are experiments in redrawing the arms and legs, using the same head and torso as a base. They allow various movements that make different impressions to be shown.

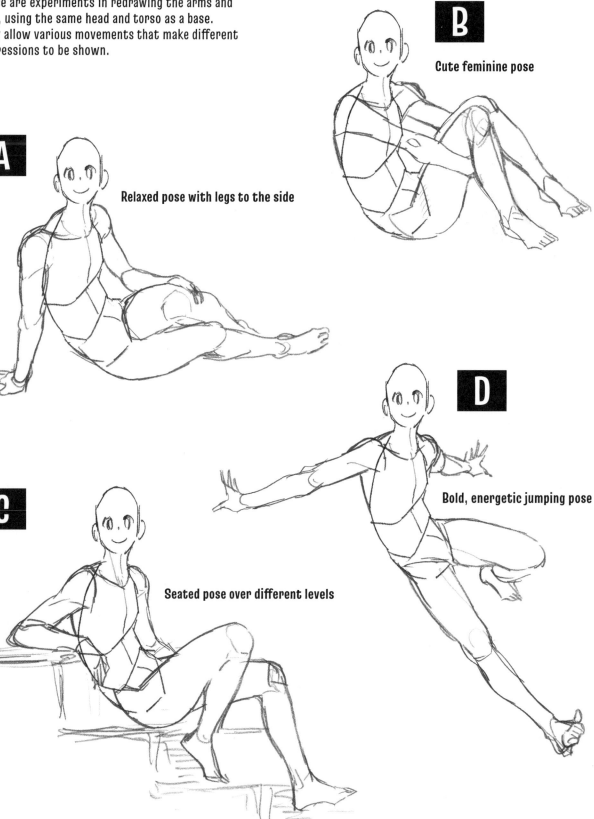

B Cute feminine pose

A Relaxed pose with legs to the side

C Seated pose over different levels

D Bold, energetic jumping pose

 A Draw Pose A

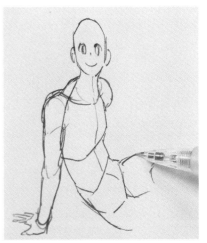

1 Start with the twisted torso from page 111.

2 Work in the width of the shoulders. The hand is resting on the ground, so create tension in the muscles around the shoulders.

3 Making the arm slightly arched rather than straight creates the sense that the body's weight is resting on it.

4 Bring the left leg into the foreground.

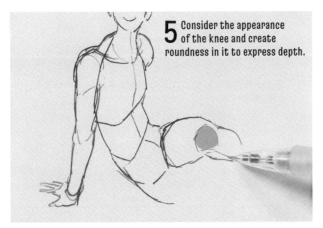

5 Consider the appearance of the knee and create roundness in it to express depth.

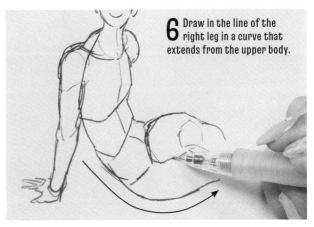

6 Draw in the line of the right leg in a curve that extends from the upper body.

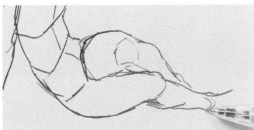

7 Shift the left leg away from the position of the right knee to bring movement to the pose.

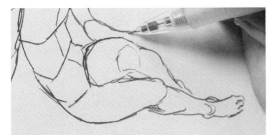

8 Depict the left hand lightly resting on the leg.

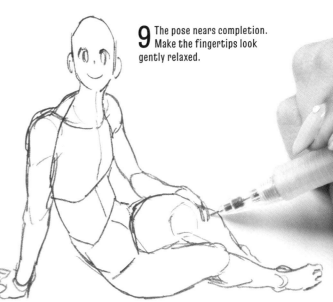

9 The pose nears completion. Make the fingertips look gently relaxed.

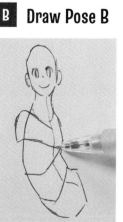

B Draw Pose B

1 Start with the twisted torso from page 111.

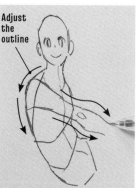

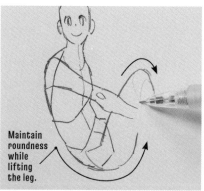

2 The figure is holding onto the knee, so bring the shoulder forward.

3 Create variation in the thickness of the arm, working with the position of the elbow as the key point.

Adjust the outline

4 Draw the knee on an angle.

Maintain roundness while lifting the leg.

5 Where the hand is sandwiched between the back of the thigh and the calf is soft, so make the flesh cover the hand.

6 The leg is not tensed, so mark it in with a curved, fluid line.

7 Connect the line down to the instep, making a clean line down to the toes.

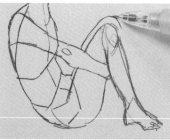

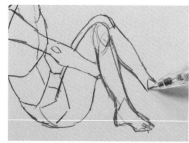

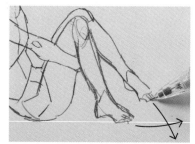

8 The leg in the background is also being hugged, so put the knees together to align the legs.

9 Slightly spread the legs out towards the toes to create a cute impression.

10 Set the toes on an angle so that lines extending from them would cross, creating a slightly pigeon-toed look.

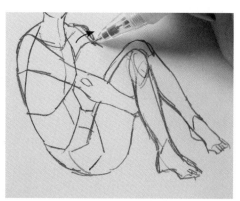

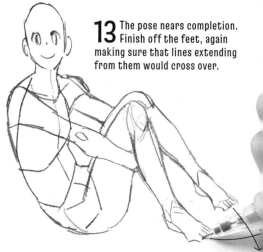

13 The pose nears completion. Finish off the feet, again making sure that lines extending from them would cross over.

11 Clearly raise the right arm too.

12 The line for the leg was rough and didn't look neat so I corrected it.

C Draw Pose C

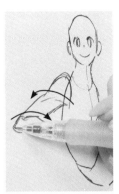

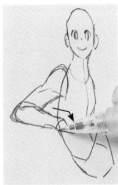

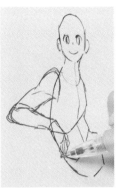

1 Start with the twisted torso. Draw in a scene where the elbow is resting on a different level.

2 Draw the shoulders to appear raised.

3 Be conscious of the rise of the muscles. Prevent the movement from becoming rigid.

4 Relax the area from the wrist down.

5 Smoothly connect down to the fingertips.

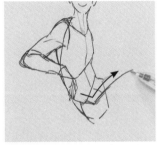

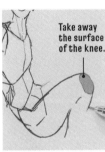

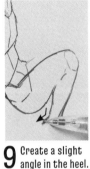

6 Create momentum from the hollow in the base of the leg to extend the line.

7 Neatly draw in a curve to capture the line of the buttocks.

8 Express the flattening out of the calf.

Take away the surface of the knee.

9 Create a slight angle in the heel.

10 Adjust the shape of the foot, working in variation.

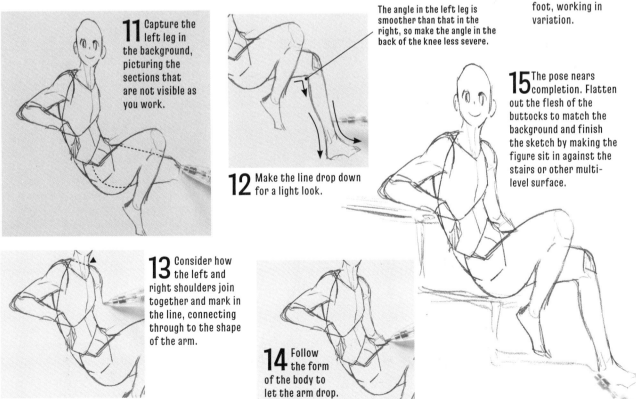

11 Capture the left leg in the background, picturing the sections that are not visible as you work.

12 Make the line drop down for a light look.

The angle in the left leg is smoother than that in the right, so make the angle in the back of the knee less severe.

15 The pose nears completion. Flatten out the flesh of the buttocks to match the background and finish the sketch by making the figure sit in against the stairs or other multi-level surface.

13 Consider how the left and right shoulders join together and mark in the line, connecting through to the shape of the arm.

14 Follow the form of the body to let the arm drop.

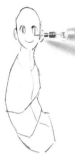

D Draw Pose D

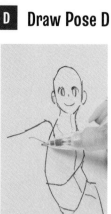

1 Start with the twisted torso from page 111. Draw the arms spread all the way out in this pose.

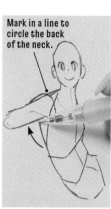

2 First of all, draw in the shape of the activated shoulders.

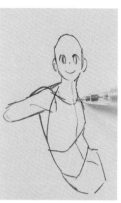

Mark in a line to circle the back of the neck.

3 Draw in the upper arm and add the line for the back muscle below it.

4 Make the line of the collarbone clear and connect it to the shoulder in the background.

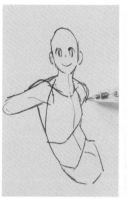

5 In order to create balance across both shoulders, clearly presume the presence of the sections that are hidden by the neck and cannot be seen.

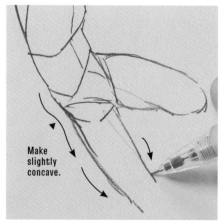

6 Work in firm flesh around the right leg to kick it up a little.

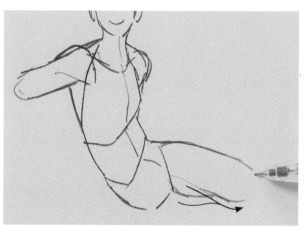

7 Create texture and thickness in the thigh.

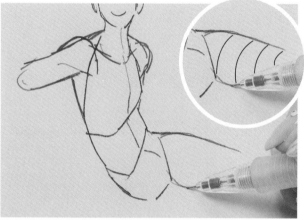

Make slightly concave.

8 The thigh is an area that is thick and activated, so create a sense of the presence of muscle.

9 Express the bent leg in a compact way rather than extending it out and thereby losing depth.

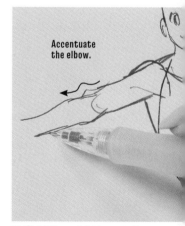

Accentuate the elbow.

10 Add in undulations at the same time as depicting the axis from where the arm extends.

11 Express the fingers arching upwards.

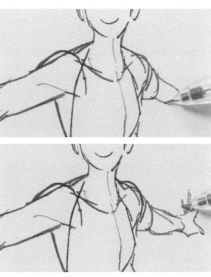

12 Draw in the left arm to create a strong sense of depth.

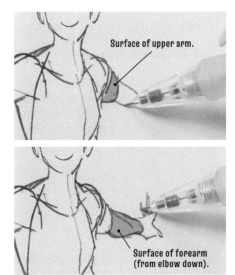

Surface of upper arm.

Surface of forearm (from elbow down).

13 Don't divide the arm into equal sections separated by the joints, but add in movement to show the degree to which it is bent and arched backwards.

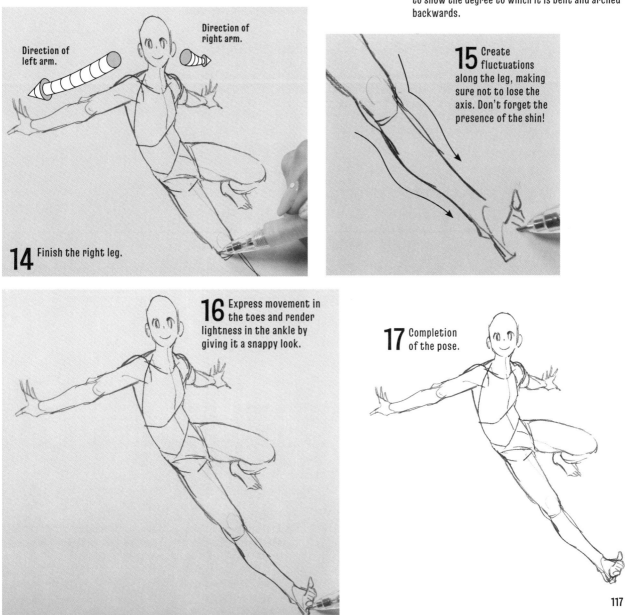

Direction of left arm.

Direction of right arm.

14 Finish the right leg.

15 Create fluctuations along the leg, making sure not to lose the axis. Don't forget the presence of the shin!

16 Express movement in the toes and render lightness in the ankle by giving it a snappy look.

17 Completion of the pose.

Draw Various Actions

Use the action of walking as a base to create poses

Cool poses, cute poses, sexy poses… when creating authentic movement in the body, think of the action of walking as the base. When the right hand is in front, the left leg is in front; when the left hand is in front, so is the right leg. It seems very obvious and simple, but considering this action as a base makes it easier to create well-balanced poses.

Walking action

Running action

> ### The more difficult the movement, the more important the base shape
>
> Even in the action of "running," which is an extension of "walking," the limbs on both sides of the body move separately. It's a quick movement that looks the most natural and is applied to determine the pose of the character.
>
> ☆ I want to draw a pose with dramatic movement but can't get the balance right.
> ☆ I don't know how to move the limbs so that they appear natural.
> ☆ There's something awkward about the movement but I don't know which part to fix.
>
> And so on… if you're worried about creating bold movement in characters, try starting with a walking action. The more complicated and difficult the movement, the more important it is to decide on the base and work step by step to move the figure. The three poses I'll explain here all have a different vibe, but all were created by applying the actions of walking or running and there is regularity in the way the movement has been formed.

Compare poses on the left and right for regularity of movement

① **Light pose** The examples on the left and right show a pose with light movement like that carried over from running. Looking only at the silhouette, there is not much difference between the drawings, meaning that they are well-balanced.

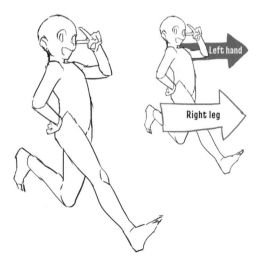

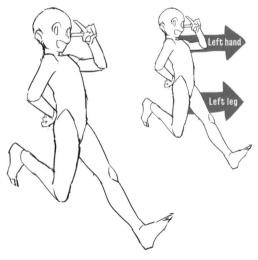

In this illustration, the figure is posed with the left hand brought up to make a peace sign, contrasting with the projecting right leg. There is a sense of power in both the left and right sides of the body progressing forward.

Although only the left side of the body is moving forward in this pose, the hand and leg on the right side are directed backward, so it can't be said that the two sides are balanced.

① **Slightly sexy pose**

While the limbs are not moving much in this low-key pose, there is movement in the shoulders as they advance together with the body, which is moving at a trot.

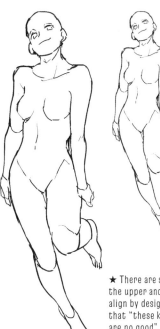

★ There are some poses in which the upper and lower body movement align by design, so it's not the case that "these kinds of illustrations are no good".

In this illustration the right shoulder is pushing strongly forward in contrast with the raised left leg, creating alternating movement for a pleasing effect.

Here, the left shoulder is activated, on the same side as the raised leg. It looks a little awkward and stiff.

③ **Kicking pose**

Compare these swift kicking poses. The twisted pose gives off more of a sense of stirring movement.

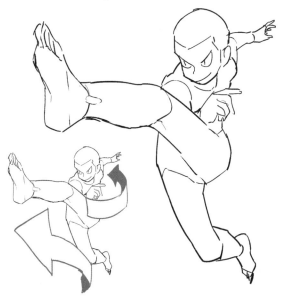

Key Point

When drawing the leg kicking up step by step, mark in lines to "alternate" to bring out movement.

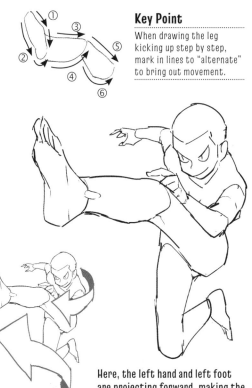

In this illustration based on the action of walking, the right hand projects forward in contrast with the left leg kicking up. The upper and lower body twist due to the momentum. The power in the upper body moves towards the right of the screen while that in the lower body moves towards the left side, allowing balance to be maintained without the loss of posture.

Here, the left hand and left foot are projecting forward, making the impression that the posture is starting to break down slightly. The upper body, lower body and left side are all coming forward, so it doesn't look very natural.

Drawing movement from a twisted body

Using the walking movement as a base, draw a pose from an extremely low angle.

1 Start by stabilizing the torso that will form the base.

2 Ignore the muscles and fine details at this stage.

3 Don't think about what the joints should look like, but decide firstly about positional relationships.

4 The hand projecting into the foreground. Angle it so a little of the palm can be seen.

5 From here, mark in the tendons that connect the shoulders to the chest and make the body look realistic.

6 Use the median line that runs down the center of the body to determine the twist in the torso.

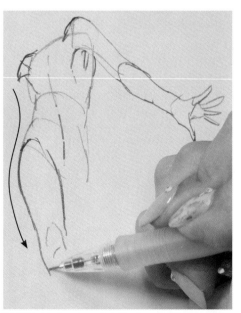

7 Fill in the legs to match the degree of twist. Make the outline of the body smooth.

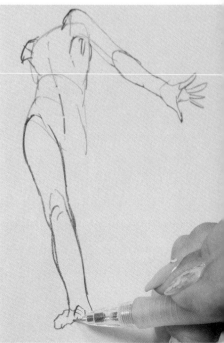

8 Just as for the left arm, make the right leg project into the foreground.

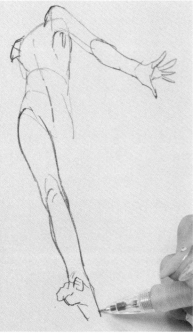

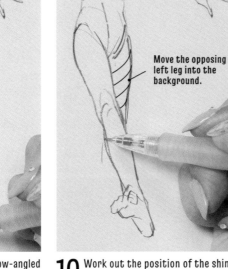

Move the opposing left leg into the background.

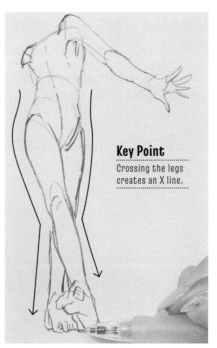

Key Point
Crossing the legs creates an X line.

9 Clearly show the heel for a bold low-angled composition.

10 Work out the position of the shin down to the foot on the left leg.

11 Use an X line to form a stylish silhouette.

12 Connect the shoulders to the collarbone and draw in the neck. Be conscious of using curved lines to prevent a rigid look.

13 The right shoulder is slightly in the background, so draw the arm growing from beyond the pectoral muscle.

15 Completion of the pose. For large movements, use the rhythm of the walking pose as a base. If both the right leg and arm come forward at the same time, the movement will seem rigid, so the principle is to create separate movement in the limbs of each side going forwards and backwards.

14 The palms of the hands are making the same movement, but due to the sweeping motion of the body they appear different.

Draw the dynamic movements of two people

Draw the figures from the low viewpoint of the leg coming into the foreground. As for the action of walking, separating the movements of the limbs on each side of the body brings out variation.

1 Mark in lines, visualizing the flow that will form the main feature on the screen.

2 Draw to prevent symmetry, at the same time maintaining a balance of left and right.

3 Draw in the shape of the legs. Visualize looking up into the background through the gap between the legs.

4 Position the two faces inside this circle.

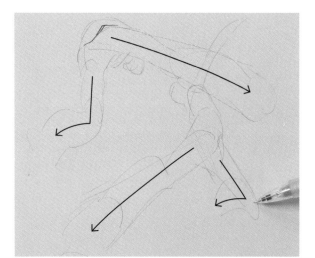

5 Bending one leg of each figure highlights the shape of the legs extended straight out.

6 In this two-person pose, give the legs dynamic expression by making the most of the shape of the clothing (pants) and creases.

7 The draft sketch is complete, so use solid lines, starting with the buttocks.

8 Use clean lines for the buttocks down to the knees, making a neat, trim shape that is not too thick.

9 Exaggerate the section below the knee (calf) so that it suddenly gets bigger.

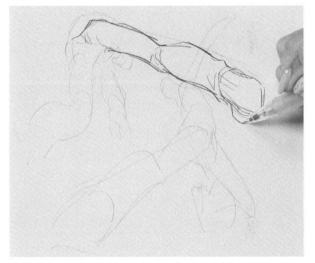

10 Make the heel bold too. Create the sense of fluctuations in tempo to concentrate power around the feet.

11 Bring out the same sense of balance in the right leg.

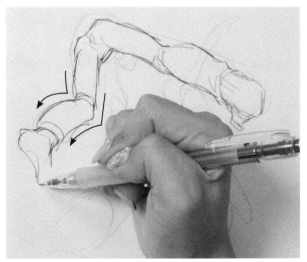

12 The right leg is bent, so arch back the line of the shin to accentuate that it is different from the left leg.

13 Move on to the second figure. The curved line continues from the upper body to the legs, so draw it in with a single stroke to bring out momentum.

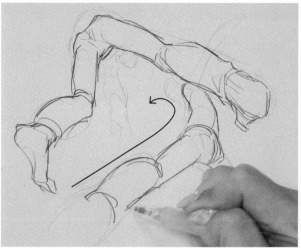

14 Emphasize the leg in the same way as for the first figure, but make it even tighter and exaggerated.

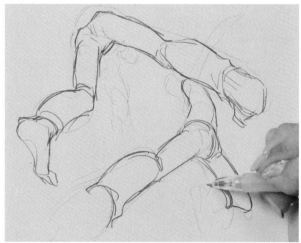

15 The right leg is further into the background than the left, so make it smaller.

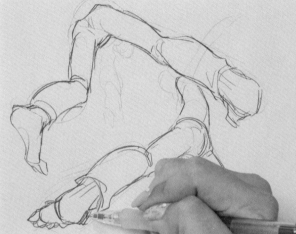

16 Make the heel look powerful.

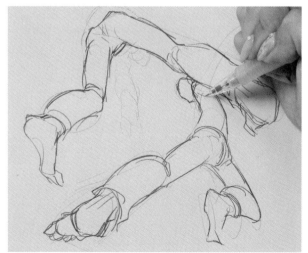

17 Draw in the small parts in the background.

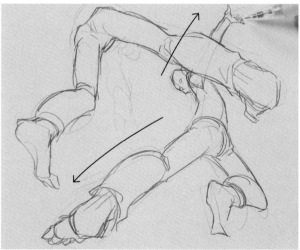

18 Draw in the hands as high as you can, stretching in the opposite direction from the extended leg to create a wide, sweeping screen.

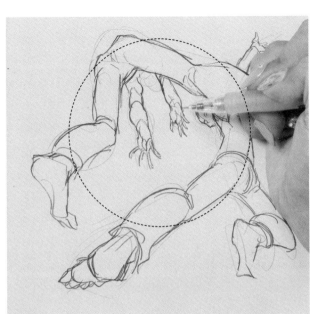

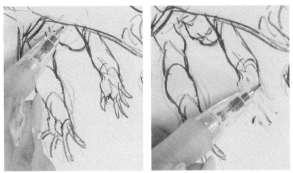

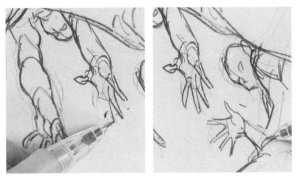

20 Arch the fingers straight back so as not to lose the sense of activation.

19 In contrast, extend both hands of the other figure into the center of the circle to prevent an empty gap forming in the center of the space.

21 Carefully observe your own hands to see how the fingers arch back when extended.

22 Completion of the pose. It's the force in the legs that draws the eye. Use the legs to form a frame inside which to place the facial expression and detailed parts of the hands. What is inside the frame (legs) will be noticed last. The legs bring power to the composition but also serve to guide the line of sight.

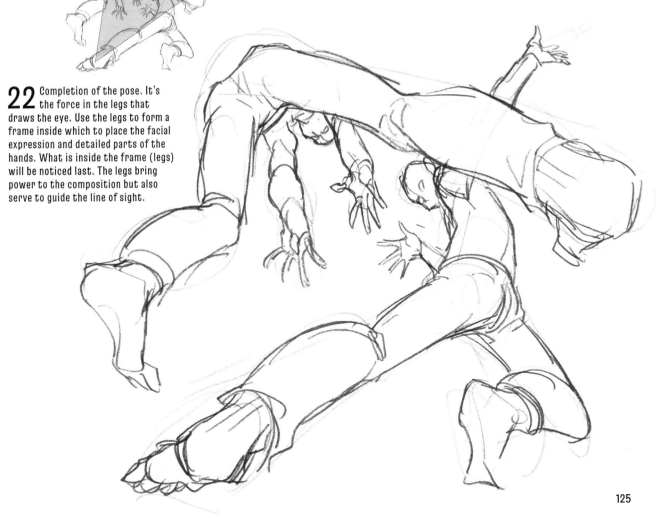

Draw the close movements of two people

Work from the heads, which appear large. The clasped hands are the highlight.

3 Work on the position of the face.

4 Mark in the median line running down the center.

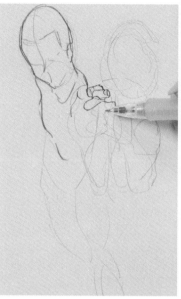

1 Draw the figures from an overhead angle.

2 Establish the entangled body parts and block in the figures in order to create an impression about the pair's relationship.

5 Make the pair clasp hands in the area between them.

Take care with the angle of the fingers.

6 This is a complicated entanglement, so when placed in the center it really makes for a focal point.

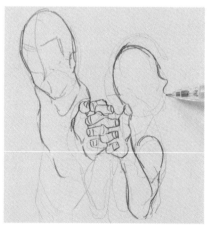

7 The back of the figure on the right is facing the viewer, so turn only his face so that it seems to be looking back in this direction.

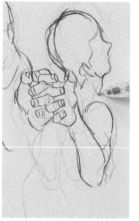

8 Draw in the line of the neck.

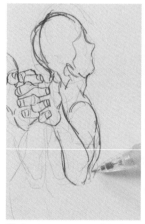

9 Create a posture with the chest pushed out.

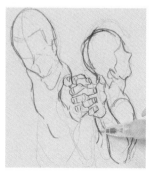

10 Draw in the parts that can be seen from between the arms. The chest is pushed out so make the back arched.

11 Narrow the legs towards the feet, creating a stylish standing posture.

12 Make the legs arch back slightly.

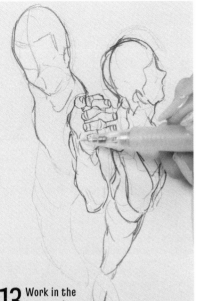

13 Work in the arm coming down from the palm of the figure on the left.

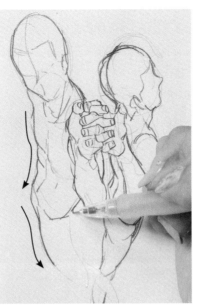

14 In contrast to the figure on the right, the back is curved in to create a posture with the hips taking the weight.

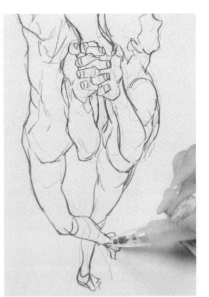

15 Bring out playful movement in the toes. There is a difference in the physiques, so slightly change the size of the feet too.

16 Make the feet exaggeratedly small to bring out a sense of perspective.

17 Adjust the figure on the right.

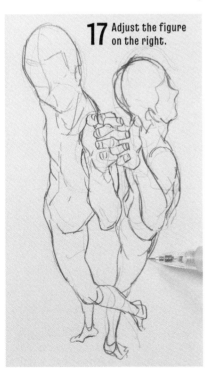

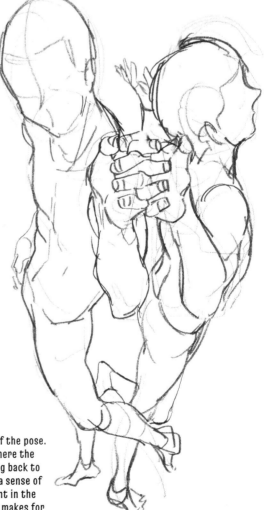

18 Completion of the pose. It's a pose where the figures are standing back to back, but bringing a sense of fun to the movement in the fingertips and legs makes for a pop-art style result.

Think of the Line of the Body Like Writing a Letter or Character!

Use smooth curves to draw the lines of the characters' bodies, just as you would to write letters, numbers or characters. As you draw, determine the order, considering which line connects to the next and which body part it will become. Even if it is a line that will be erased when the work is complete, at the blocking-in or draft sketch stage, keep the "flow" in mind to connect body parts.

The lines that make up hiragana characters are connected by unseen lines, like this.

Example of steps for a female sitting pose

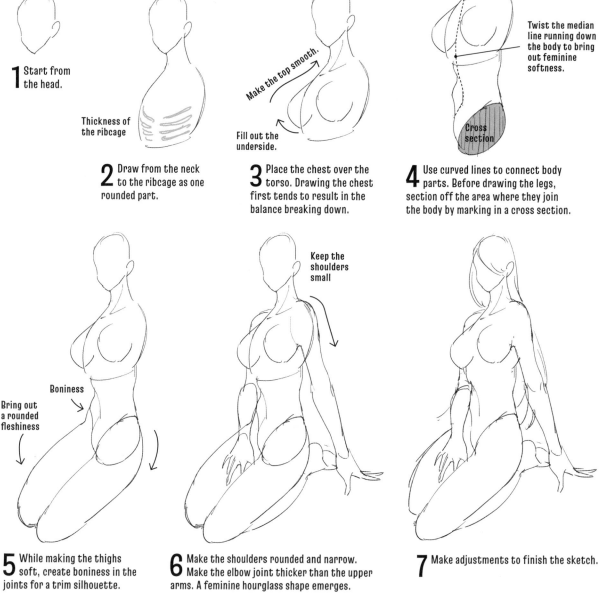

1 Start from the head.

Thickness of the ribcage

2 Draw from the neck to the ribcage as one rounded part.

Make the top smooth.

Fill out the underside.

3 Place the chest over the torso. Drawing the chest first tends to result in the balance breaking down.

Twist the median line running down the body to bring out feminine softness.

Cross section

4 Use curved lines to connect body parts. Before drawing the legs, section off the area where they join the body by marking in a cross section.

Bring out a rounded fleshiness

Boniness

5 While making the thighs soft, create boniness in the joints for a trim silhouette.

Keep the shoulders small

6 Make the shoulders rounded and narrow. Make the elbow joint thicker than the upper arms. A feminine hourglass shape emerges.

7 Make adjustments to finish the sketch.

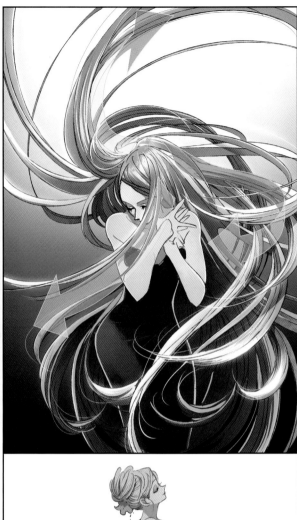

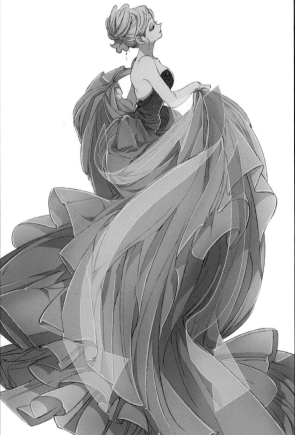

Chapter 3

Boldly Expressing Movement

In order to express action, dynamism and bold movement, it's not just the body but all the elements that require movement. The hair and clothes are obvious, but the space enveloping the character can also be manipulated to enhance and supporter powerful poses. Here, I'll carefully explain the thought processes and aims relating to creating compositions that I've posted on various websites and social-networking sites.

Move Elements Apart from the Body

Draw in bold movement for parts other than the body and limbs.

Move the hair in blocks

★ Thinking of the hair in three blocks makes it easier to visualize how to treat each section when adding color and shadow.

Front view

Take care with the shadow surface

① Place blocks of hair onto the figure in the same way as if they were fabric.

② Make this bottom block flutter a little.

③ Draw in the middle block.

④ Layer on the top block.

⑤ Draw in texture so it follows the inner and outer surfaces of the hair.

Side view

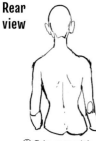

① Watch out for the hairline and position of the ear!

② Envelop the shoulders in the bottom block of hair.

③ Place the middle block on.

④ Make the top block flutter out.

⑤ Add wavy texture.

Rear view

I brightened the shadow surface

① Take care with where to position the bottom block!

② On average, the bottom block is not susceptible to being moved by wind and so on, so keep movement moderate.

③ Layer the middle block over the top.

④ Make the top block flutter and flip over.

⑤ Add texture to the blocks.

Create movement in the hair from the hairline and part

★ While some hairstyles can be considered with the whorl as the "point" from which to start, others are created from the "line" of the parting. Be flexible and change things according to the hairstyle you want to draw.

① Center part from the top (top of the head)

② The key point is to clearly bring out depth through the bundles of hair that flow to follow the roundness of the head.

③ Add texture to complete.

① Create a parting on the side.

② Try to make the bundles of hair flow out in a radial fashion.

③ Add texture to each bundle of hair. Changing the flow of hair depending on whether it is on the outer surface or underneath brings out dimension (as long as it doesn't go against the roundness of the head).

⑥ Add in bangs and adjust the shape, then apply color.

⑥ Add in bangs and adjust the shape, then apply color. Dividing the hair into blocks makes it easier to grasp "the hair in the background" "the shadow being cast onto the hair underneath by the hair on the surface" and so on.

⑥ Adjust the shape and apply color. Capturing hair in large chunks makes it easy to create natural movement.

Use parts and whorls to convey movement

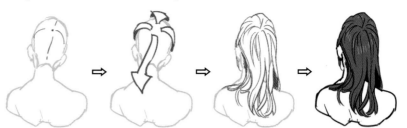

a) Create natural flow from the whorl.

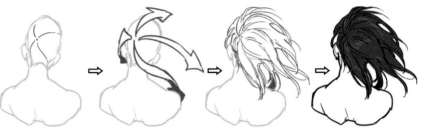

b) Bring out movement in a radial fashion from the back. I replaced the point that I was thinking of as the whorl in a) with "a point receiving wind."

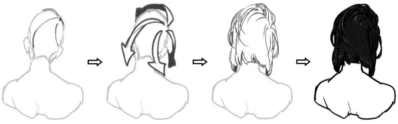

c) Move the bundles of hair from the side in a swirling fashion. With its swept up look, this style has a sense of solidity.

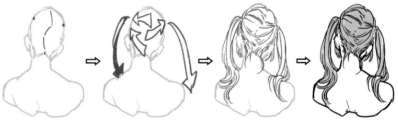

d) Create pigtails from a zigzag part.

① For a zigzag part.

② A slightly quirky but still becoming style.

③ For flowing or more tousled hair, use a zigzag part. The hair will appear to have volume and body. Easy to revise and rotate, it's a method that's used even for three-dimensional renderings.

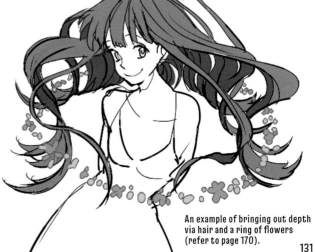

An example of bringing out depth via hair and a ring of flowers (refer to page 170).

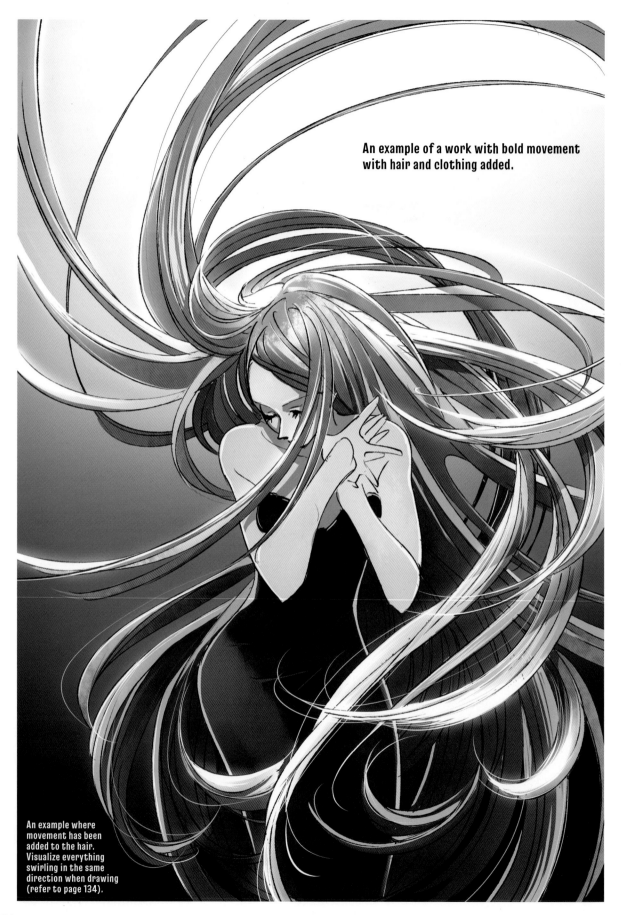

An example of a work with bold movement with hair and clothing added.

An example where movement has been added to the hair. Visualize everything swirling in the same direction when drawing (refer to page 134).

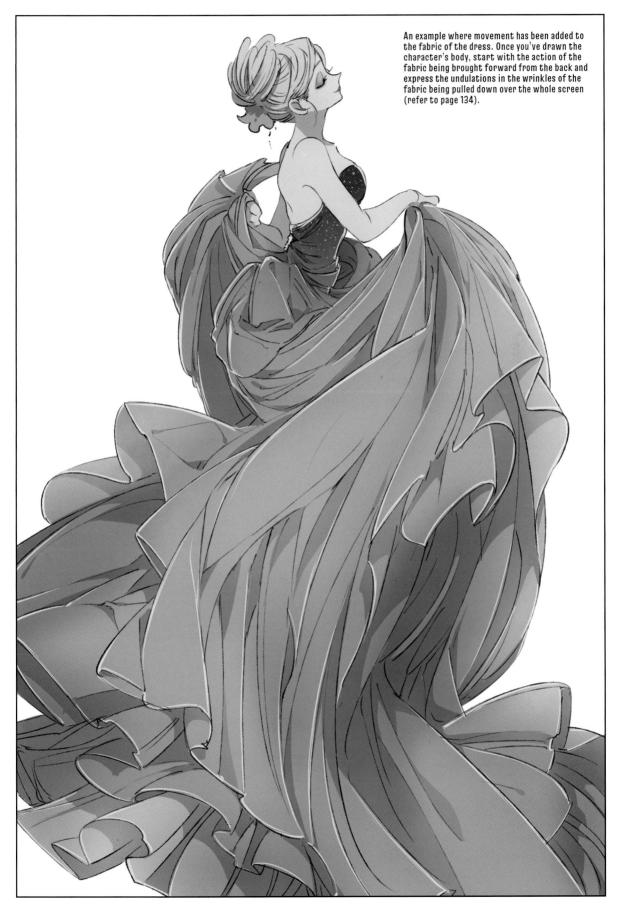

An example where movement has been added to the fabric of the dress. Once you've drawn the character's body, start with the action of the fabric being brought forward from the back and express the undulations in the wrinkles of the fabric being pulled down over the whole screen (refer to page 134).

Boldly moving a character with hair and clothing

Add hair and clothing to a character to express movement. Even if the body is not moving significantly, the undulations of the hair and clothing can create a lively impression.

▲ Completed work

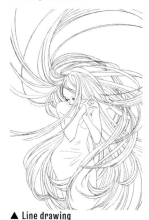

▲ Line drawing

The base colors are gradations of reddish purple.

The play of the hair also serves to express the character's emotions and inner side, so carefully render levels of light and depths of shadow to match the scene.

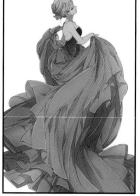

▲ Completed work

▲ Line drawing

Express that the fabric is moving from being pulled. Capture the fabric from behind being brought forward, with creases flowing slowly as they start to move with a slight delay.

So as not to interrupt the flow of the wrinkles, divide the fabric of the dress into three blocks and apply base color to each.

The bottom layer is in gradated shades of pale blue.

Blue base with purple gradation. Tone is added to make the recess of the shadows appear deeper.

The base color is blue. Reddish purple gradation is added around the edges of the fluttering fabric

134

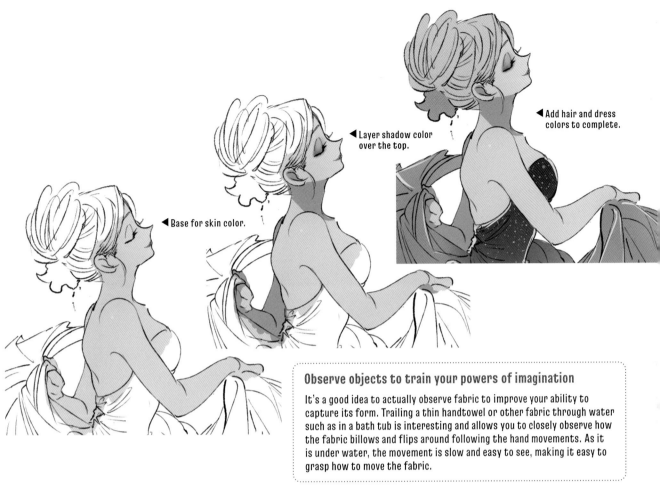

◀ Base for skin color.

◀ Layer shadow color over the top.

◀ Add hair and dress colors to complete.

Observe objects to train your powers of imagination

It's a good idea to actually observe fabric to improve your ability to capture its form. Trailing a thin handtowel or other fabric through water such as in a bath tub is interesting and allows you to closely observe how the fabric billows and flips around following the hand movements. As it is under water, the movement is slow and easy to see, making it easy to grasp how to move the fabric.

The expression of movement in the hem of the dress can be used in a couple's dance scene

Examples of an "omnidirectional approach" to capture a couple dancing. The way to move the hair as introduced on page 130, combined with the effect of the fluttering clothing makes for a dynamic impression. Express the hair and fabric moving as if they are following the turning actions of the bodies with a slight delay.

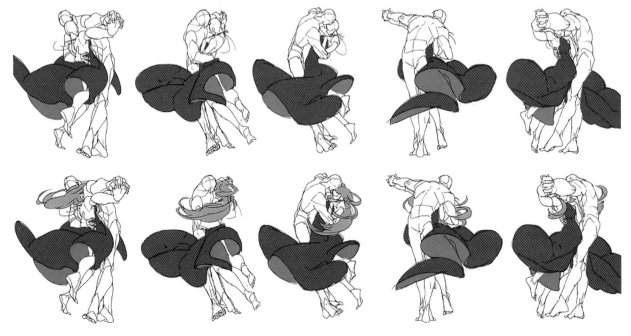

Expressing the bold movements of a fluttering garment

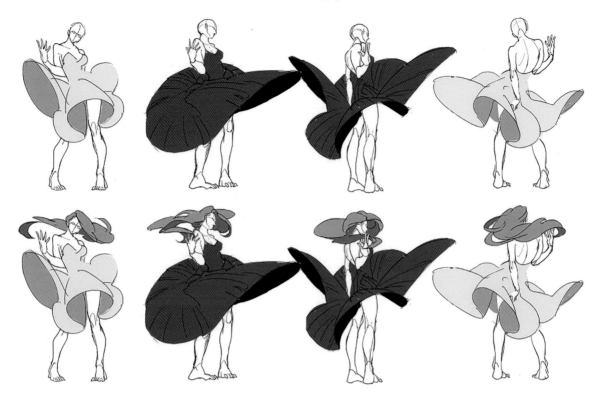

In order to convey large movement in standing poses, add in clothing and hair. The flipping up of a skirt takes up a large amount of space and brings out dimension. The specific approach and drawing instructions are explained from page 142.

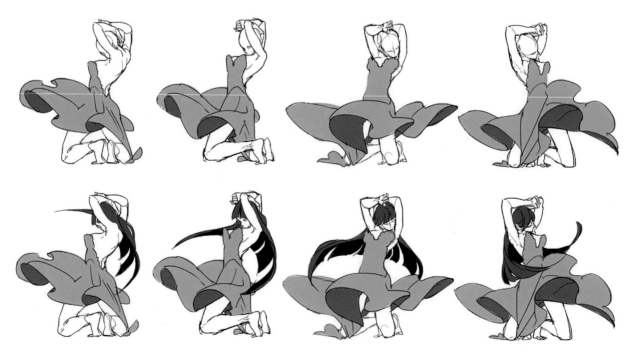

Even in a kneeling pose, hair and clothing flipping around makes for a dynamic scene. Render the skirt filling with air and swaying to and fro.

Adding elements such as clothing and hair to poses drawn from slightly different angles is practice for drawing scenes viewed from different angles, but it also has the advantage of making it easier to imagine continuous movement. It's the idea that it's because of the previous scene that drawing the movement in the current scene is possible, like watching a video frame by frame. I often draw imagining I'm excavating a scene from a movie, and this is like a simplified version of that.

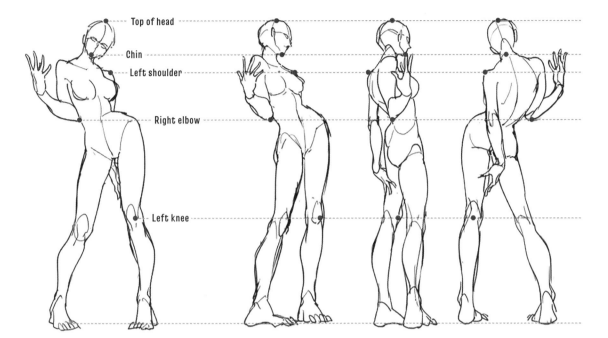

Top of head

Chin

Left shoulder

Right elbow

Left knee

An omnidirectional approach to a standing pose before the clothes and hair are added. Rather than the poses being cut from scenes with movement, it is as if they are standing poses positioned in place. Even so, make sure to firmly build on body parts that are key to movement such as the right hand with fingers reaching up and the left hand in the gesture of touching the leg.

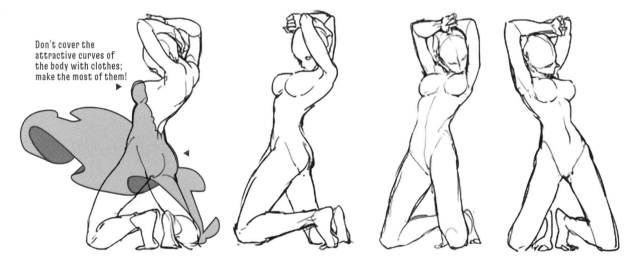

Don't cover the attractive curves of the body with clothes; make the most of them!
▶

An omnidirectional approach to a kneeling pose before the clothes and hair are added. Create appealing points of the body that you want to maximize, such as the emphasized chest and curved waist, and team them with clothing and hair.

Use a Loop to Bring Out Dimension

This method involves expanding on the idea of a "loop" to make it resemble a solid form.

Make a "loop" solid

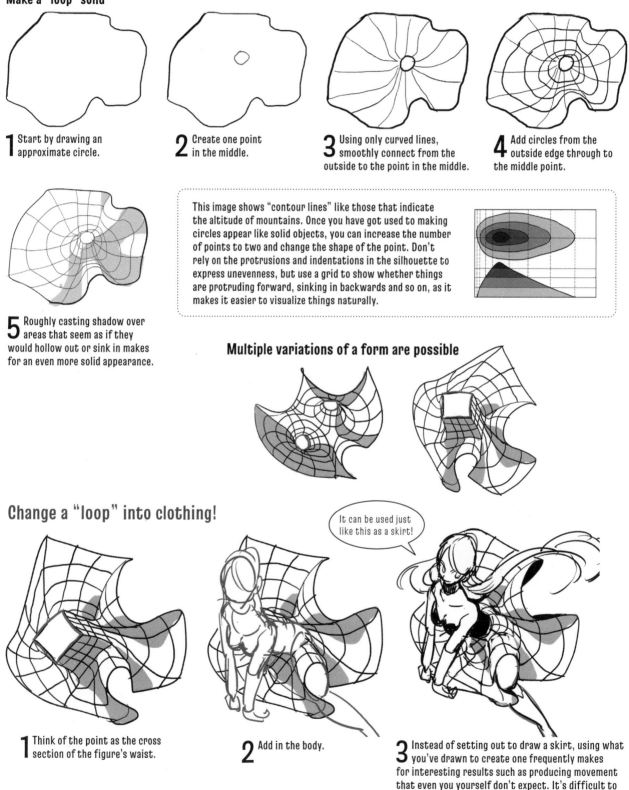

1 Start by drawing an approximate circle.

2 Create one point in the middle.

3 Using only curved lines, smoothly connect from the outside to the point in the middle.

4 Add circles from the outside edge through to the middle point.

5 Roughly casting shadow over areas that seem as if they would hollow out or sink in makes for an even more solid appearance.

This image shows "contour lines" like those that indicate the altitude of mountains. Once you have got used to making circles appear like solid objects, you can increase the number of points to two and change the shape of the point. Don't rely on the protrusions and indentations in the silhouette to express unevenness, but use a grid to show whether things are protruding forward, sinking in backwards and so on, as it makes it easier to visualize things naturally.

Multiple variations of a form are possible

Change a "loop" into clothing!

It can be used just like this as a skirt!

1 Think of the point as the cross section of the figure's waist.

2 Add in the body.

3 Instead of setting out to draw a skirt, using what you've drawn to create one frequently makes for interesting results such as producing movement that even you yourself don't expect. It's difficult to maintain flexible thinking, but it's very important!

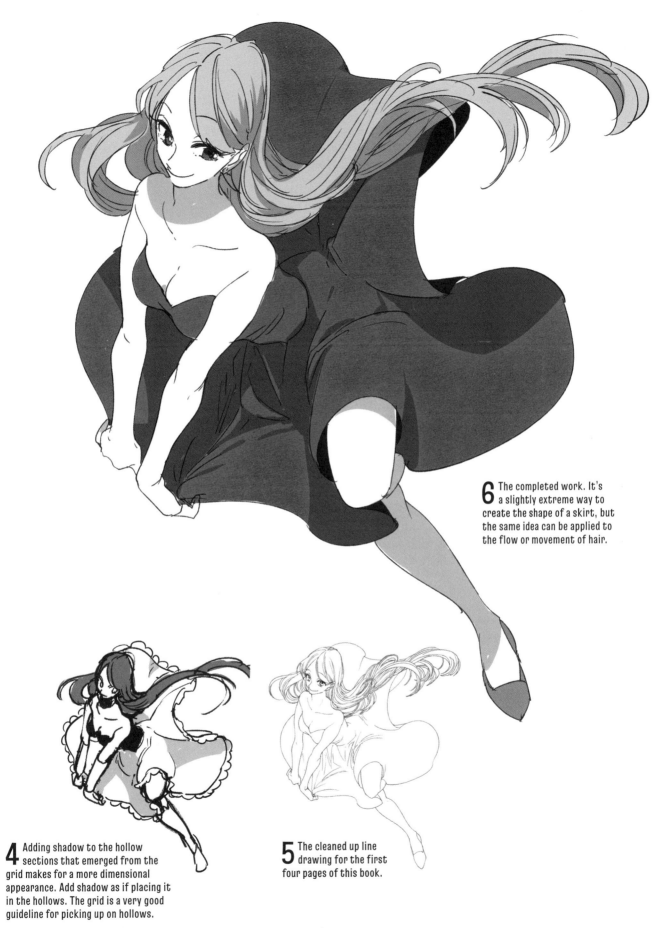

6 The completed work. It's a slightly extreme way to create the shape of a skirt, but the same idea can be applied to the flow or movement of hair.

4 Adding shadow to the hollow sections that emerged from the grid makes for a more dimensional appearance. Add shadow as if placing it in the hollows. The grid is a very good guideline for picking up on hollows.

5 The cleaned up line drawing for the first four pages of this book.

Develop hair and clothing from the same loop

It's possible to make the waist section from the example drawn on page 138 into the head (hairline) and the skirt hemline into the ends of the hair, with the irregularly strung grid as the hair. Similarly, it can be used in various situations such as to create the form of clothing, substitute for the flow in underwater scenes, express zero gravity conditions and so on. Just as you might look up at the sky and think "that cloud looks like a whale!", trust your sensibilities and draw freely.

Drawing other examples with a square as the base

1 Place the head (hairline) inside the point.

2 Make the outside of the loop the ends of the hair and the irregularly strung grid into the hair.

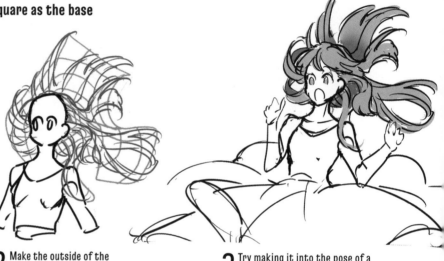

3 Try making it into the pose of a surprised girl.

1 Place the loop behind a figure in a crouched pose.

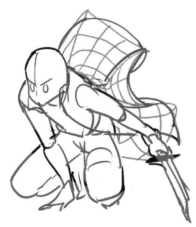

2 Fit it to the form of clothing (such as a jacket or outer garment) so that the grid becomes a garment for the upper body.

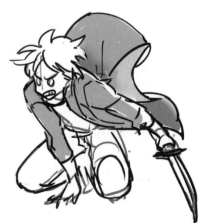

3 Create a crouching boy ready to wield a weapon as the wind blows.

The completed work. The loop has been used to depict the swelling movement of the upper garment. The leaning posture casts a large shadow from the neck down, and the character is looking straight ahead. Multiple points have been devised to draw the eye to the upper body despite the low posture, such as the boldly billowing upper garment, the light from directly in front, the sharp gaze and clothing in eye catching colors. While compact, it's a powerful composition that conveys the sense of the figure being about to fly into action to take on a challenger.

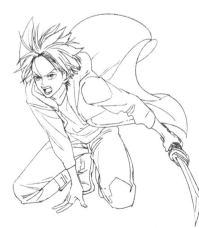

The cleaned up line drawing of the rough sketch of the boy.

Apply shadow to the skin, as if the light is hitting the figure from front on.

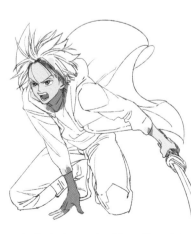

Add color to the clothing and sword.

Drawing a billowing skirt from a loop

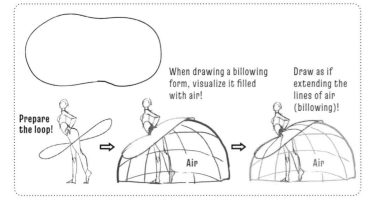

Prepare the loop!

When drawing a billowing form, visualize it filled with air!

Draw as if extending the lines of air (billowing)!

Air

Air

This method involves making the loop look like the hem of a skirt to form a dimensional look. The foundation for this is the concept of finding points in common and substituting the loop in for something else. Thinking of it as a skirt from the beginning makes it difficult to create movement in it as it sweeps out from the hips to hem and has creases. Focusing only on the hem as a "loop with one connection" makes it possible to create as much movement as you like simply by thinking about moving the loop. Drawing with momentum results in unexpected movements, making the final landing point very interesting. Substituting a circle in for "simpler objects with something in common" allows you to draw movement you wouldn't have thought of before and leads to many discoveries.

Drawing from a twisted loop

1 Draw a loop twisted like the number 8.

2 Place a figure inside the twisted section.

3 Use smooth lines to connect the hips and loop.

4 Erase the hips and thighs to form the skirt.

5 Overlaying the grid makes it easier to create dimension.

Drawing from enlarged loops

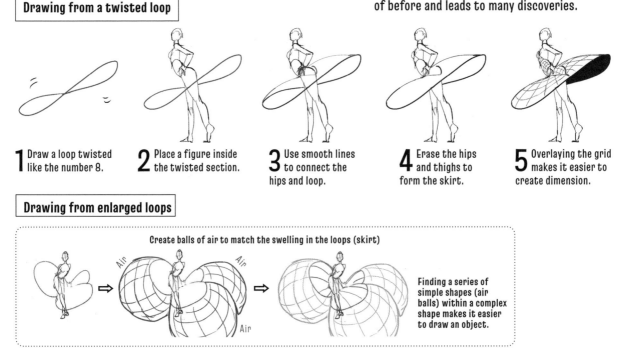

Create balls of air to match the swelling in the loops (skirt)

Air

Air

Air

Finding a series of simple shapes (air balls) within a complex shape makes it easier to draw an object.

1 Draw a loop.

Key Point

There are no rules to the shape of the loop, so it's good to pair tightly drawn-in sections with bold swelling.

Although it depends on the style and design of the picture, think of lines as outlines and omit any superficial wrinkles. Draw curved lines from the center out to uneven sections and hollows in the shape. Be aware of the presence of air inside the skirt to render it lifting in the wind. Drawing a grid on the surface will make it easier to view as a solid object and work in shadows when it comes to applying color.

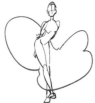

2 At the loop stage, it just looks like a squiggly line...

3 Connect soft lines over it to create the look of billowing fabric.

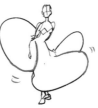

4 Retain the roundness. When adding wrinkles and movement, don't draw in unnecessary lines, especially if you want to add tautness to the fabric.

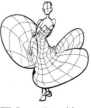

5 Draw the grid on.

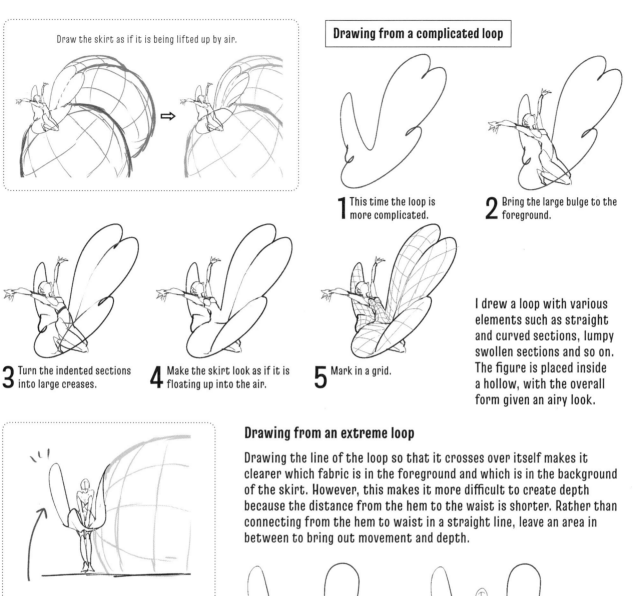

Draw the skirt as if it is being lifted up by air.

Drawing from a complicated loop

1 This time the loop is more complicated.

2 Bring the large bulge to the foreground.

3 Turn the indented sections into large creases.

4 Make the skirt look as if it is floating up into the air.

5 Mark in a grid.

I drew a loop with various elements such as straight and curved sections, lumpy swollen sections and so on. The figure is placed inside a hollow, with the overall form given an airy look.

In order to convey the sense of the hands holding down the billowing skirt, I used straight lines and didn't really mark in blown out grid lines on the skirt.

Drawing from an extreme loop

Drawing the line of the loop so that it crosses over itself makes it clearer which fabric is in the foreground and which is in the background of the skirt. However, this makes it more difficult to create depth because the distance from the hem to the waist is shorter. Rather than connecting from the hem to waist in a straight line, leave an area in between to bring out movement and depth.

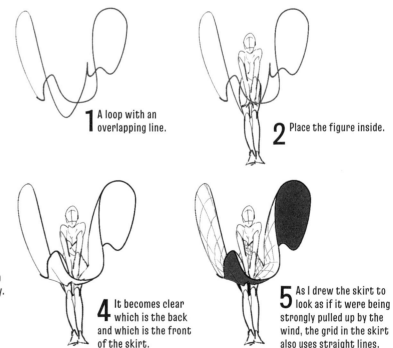

1 A loop with an overlapping line.

2 Place the figure inside.

3 Curve the line from the hem to the waist ever so slightly. Take care with the shape of the underside of the skirt so it's easy to tell which part the hands are holding down.

4 It becomes clear which is the back and which is the front of the skirt.

5 As I drew the skirt to look as if it were being strongly pulled up by the wind, the grid in the skirt also uses straight lines.

Drawing a pose where the loop is boldly moving

Start by drawing a more extreme loop

Cross the lines of the loop to add twisting and depth. As the pose includes the movement of the hand pulling on the fabric, use straight lines to connect to the hand to bring out momentum. Draw lines differently to express soft and vigorous movement.

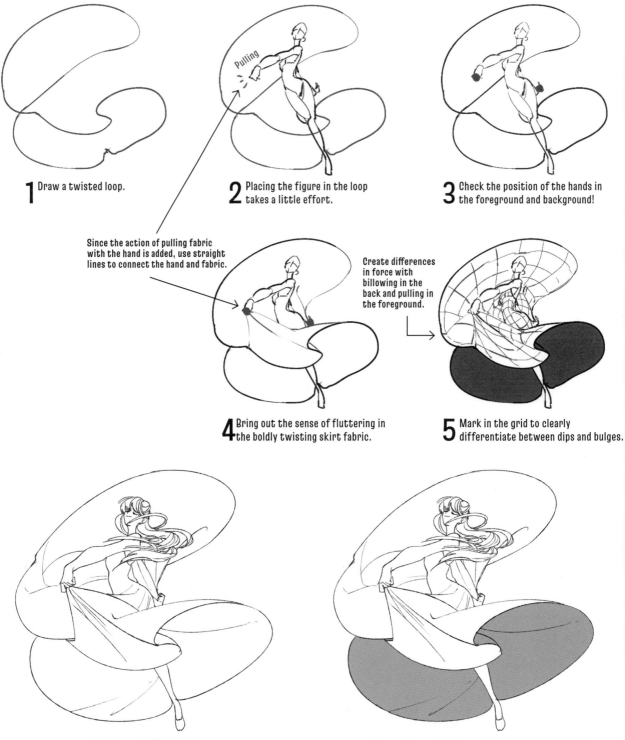

1 Draw a twisted loop.

2 Placing the figure in the loop takes a little effort.

3 Check the position of the hands in the foreground and background!

Since the action of pulling fabric with the hand is added, use straight lines to connect the hand and fabric.

4 Bring out the sense of fluttering in the boldly twisting skirt fabric.

Create differences in force with billowing in the back and pulling in the foreground.

5 Mark in the grid to clearly differentiate between dips and bulges.

Pulling

The cleaned up line drawing.

The section coming forward is the inside of the skirt.

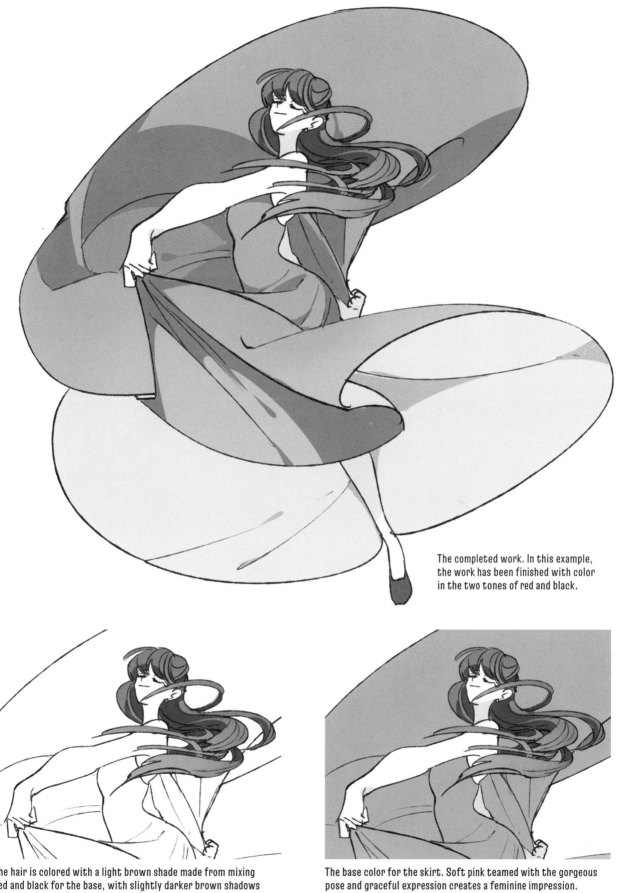

The completed work. In this example, the work has been finished with color in the two tones of red and black.

The hair is colored with a light brown shade made from mixing red and black for the base, with slightly darker brown shadows painted over the top.

The base color for the skirt. Soft pink teamed with the gorgeous pose and graceful expression creates a feminine impression.

Drawing starting with an intricate loop

Here, we'll start with an intricate loop with irregular form. There are no overlapping parts and many boldly billowing sections, so it is teamed with a big pose. Don't hold back with showing plenty of the inside of the skirt. The hands (red circles) connecting the lines that represent the wrinkles of the fabric are positioned close together, but the cloth in the center is slackened to retain softness and make the facial expression visible.

1 Draw a loop with lots of uneven sections.

2 Connect lines to the hands.

3 The hands are to the back of the torso. It's important to understand positional relationships including this depth.

4 Simply connecting lines like this would mean the facial expression and movement in the body were concealed, so slacken the fabric to create a gap and allow the face and body to be seen.

5 Add the grid over the surface of the skirt. The inside of the skirt that was the shape of the loop emphasizes dynamic, bold movements.

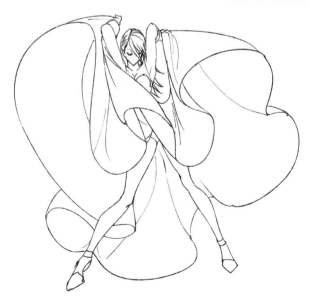

The cleaned up line drawing. Add in fine fabric wrinkles so as not to lose the large shape.

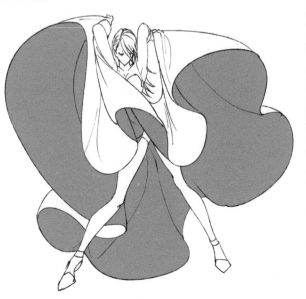

I tried making the inside of the skirt the highlight.

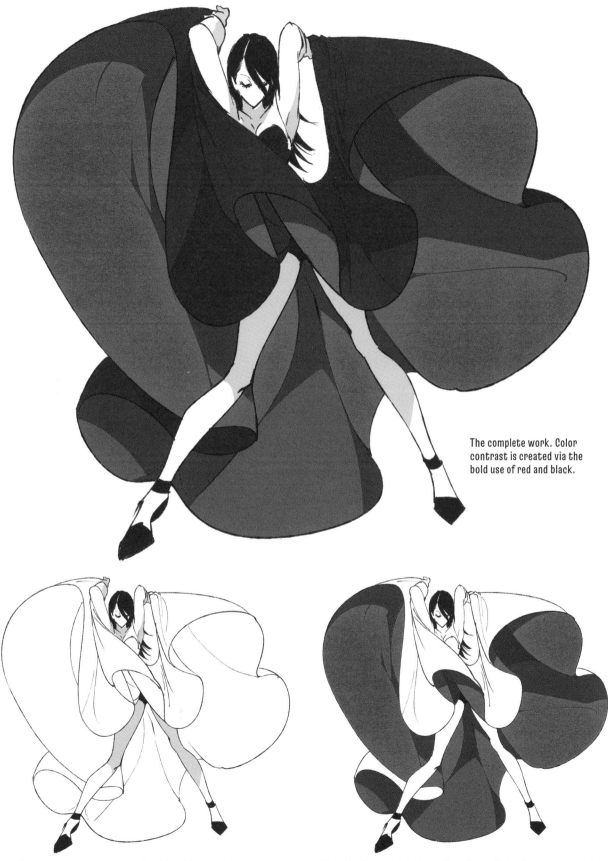

The complete work. Color contrast is created via the bold use of red and black.

Only pale gray shadow was used on the skin, which renders a monotone when combined with the black ground of the skirt. Making the red of the lining stand out more creates a vivid impression.

The skirt base and shadow colors. Apply shadow in two stages of shading in order to create sections of greater depth.

Use a Cylinder to Create a Sense of Perspective

Cylinder

Replace perspective with a cylinder

Use a cylinder to render movement from the background to the foreground!

Visualize the image as a series of cross sections cut into round slices. Sometimes it might be used to draw the limbs extending from the torso and sometimes, depending on the object you're trying to show, it might connect it from the hand or foot. Try various methods in order to draw in the way you want.

1 Draw the cylinder sweeping across the screen. Substituting in a simple shape like this makes it easier to create dramatic expression without getting confused by the set ratios for body parts.

2 Transform the stacked round slices into an arm and try putting a gun in the hand.

3 Draw in the rear view in the background. Try using a bold high angle that emphasizes the back!

4 Add in details to complete the work.

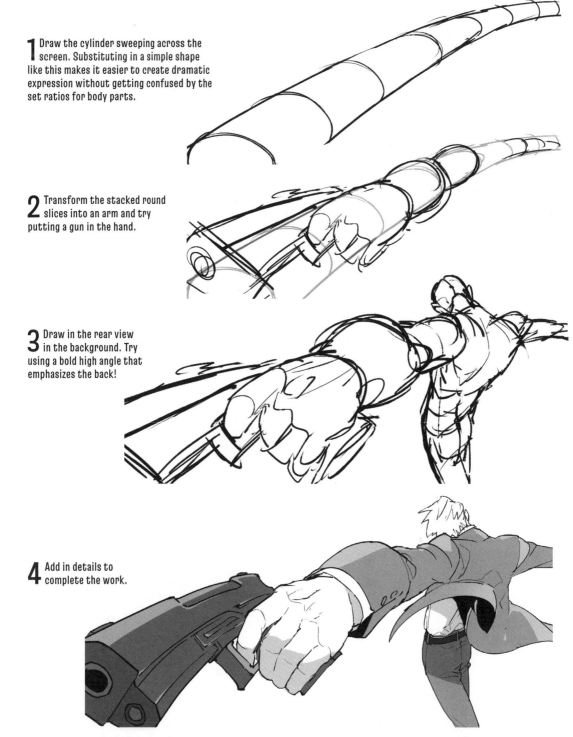

Use a cylinder to show movement from below to above!

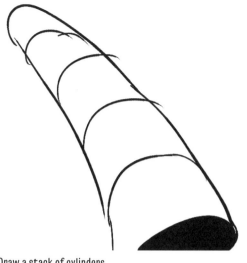

1 Draw a stack of cylinders.

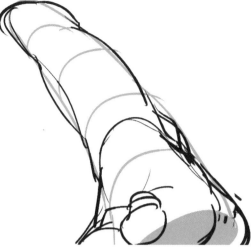

2 If you draw in a foot sticking out to the front, the cylinder will resemble a leg.

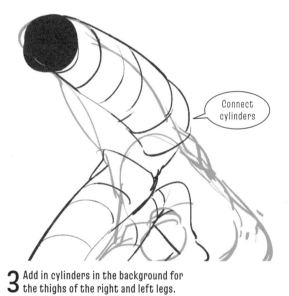

Connect cylinders

3 Add in cylinders in the background for the thighs of the right and left legs.

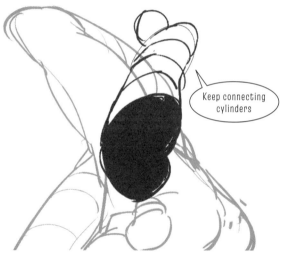

Keep connecting cylinders

4 Draw in the torso as a cylinder also and obtain depth.

This drawing technique doesn't consider the ratio of arm and leg length, so you can try altering thickness at the points where joints divide. Creating the impression of performance brings out originality and makes for a unique work.

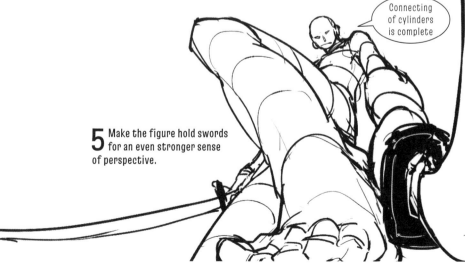

Connecting of cylinders is complete

5 Make the figure hold swords for an even stronger sense of perspective.

Use cylinders to produce two-directional movement!

This drawing method involves positioning the main parts first when fitting them into the screen, in order to produce the axis that creates a dynamic feel. Positioning them into an actual shape or letter, such as a cross or the letter S, achieves a neat result. I believe it's widely known that a composition that fits into a triangle is attractive. Try various compositions and positioning of your own such as combinations of triangles and letters of the alphabet.

Cross

1 Form a cross by overlapping two cylinders.

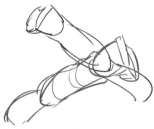

2 Start drawing from the section with which you want to impress. Here, I've started with the legs.

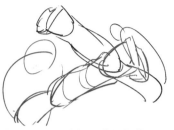

3 Explore the positions of the bodies.

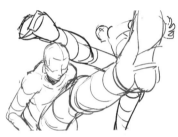

4 Check where the joints divide and fine tune things as you draw.

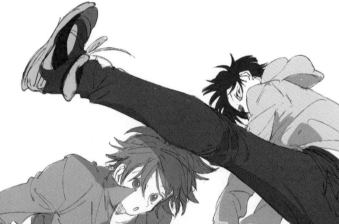

The overlapping and positional relationships have altered significantly from the cross formed in step 1. It's only a procedure for how to think about things, so if you come up with different ideas while drawing, keep making changes. (The production process for this work is published in full color on pages 12-13.)

5 The completed drawing, with two tones of red and black worked into the cleaned up line drawing.

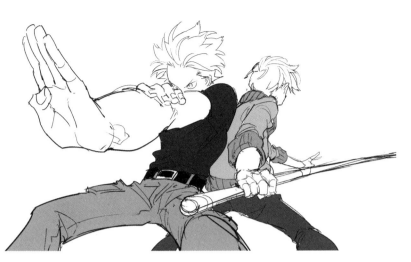

Moving in opposite directions

Here, force is directed towards the foreground and background. Create three-dimensional flow from background to foreground and foreground to background to bring out depth. Draw "things in which force is moving in different directions" at the front to create balance on the screen and convey power.

The arm sticking out to the front and the weapon extending into the background bring movement and depth to the screen.

Diagonally directed movements

Compositions where the figures are placed in reflection to one another either above and below or to the side make for symmetrical, slightly fantasy-like works. It's a convenient composition for making the screen gorgeous, but also tends to be used frequently. In order to tighten up the airy space and add power, I extended the arms right out to the front for a dynamic effect.

In this example, it is the diagonally outstretched hands of the two girls that serve to bring out power in the screen. Just as the arm of the girl on the right is extended to the left of the screen, the arm of the girl on the left is directed to the right of the screen. Shift power in different directions to create flow inside a limited space. Direct the characters' gazes in the same direction as their arms to create an even more powerful impression.

Use a Grid to Create Depth and Distortion

When drawing a picture on the screen, it's usual to position the character with regard to the vertical and horizontal white space, but Try a slightly different approach for when a strong sense of perspective is desired. Use a grid to add depth.

1 Rather than drawing the character first, launch straight into drawing the "space." Use curved lines to bring out the feeling of depth on the screen.

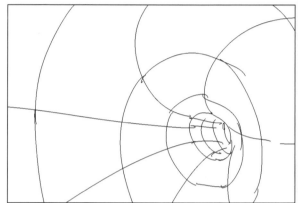

2 Adding ovals creates the look of a space inside a cylinder.

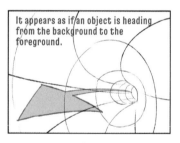

It appears as if an object is heading from the background to the foreground.

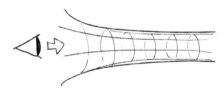

It's also possible to make it appear as if it is heading from the foreground to the background.

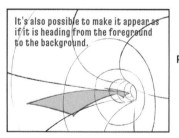

Draw the character to fit in with the space

Face

Back

Arm

Making the foreground large and the background small gives rise to the space.

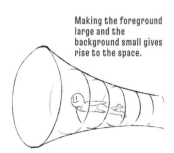

① Start drawing from the head.
② Chest.
③ Make the arms emerge from the shoulders in the foreground and background.

Key Point

When blocking in the figure, position it so the body and limbs follow the curved lines of the grid.

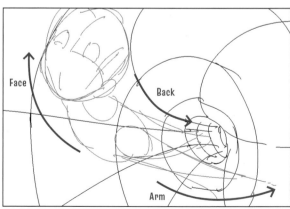

Face

Back

Arm

3 Roughly block things in. The order for drawing in the character differs significantly depending on the situation. In this example, when looking at the character as a discrete unit, it appears to be being viewed from an overhead angle, so start with the head. If the feet are in the foreground, you might start from the feet.

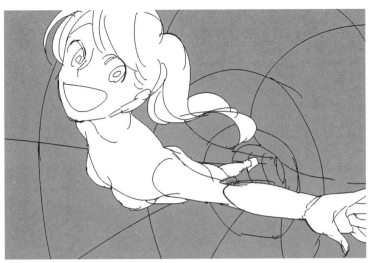

The aim is to make use of the freehand-drawn curved lines of the grid in the lines of the body. Even if you don't try to follow them too closely, if the space is made up of curved lines you will be visually aware of them, so I think you should naturally be able to draw the figure more smoothly than if you were drawing a figure on an empty screen. Try creating a space that you believe makes it easy to draw.

4 The body drawn in to match the curved space.

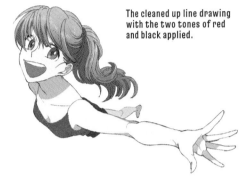

The cleaned up line drawing with the two tones of red and black applied.

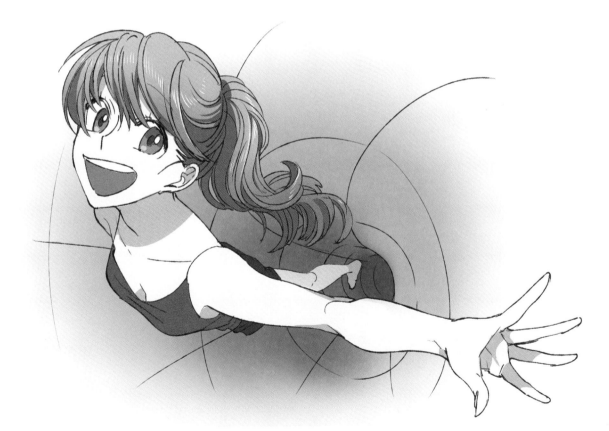

5 The completed work with gray tones in the background of the grid for depth and the figure added. If finishing this off as a standalone piece, it would be interesting to consider trimming the screen to match the figure rather than trapping the figure into the screen.

Render three people's movement on a grid!

This is an actual example of the method of drawing a grid to create depth as explained on page 152.

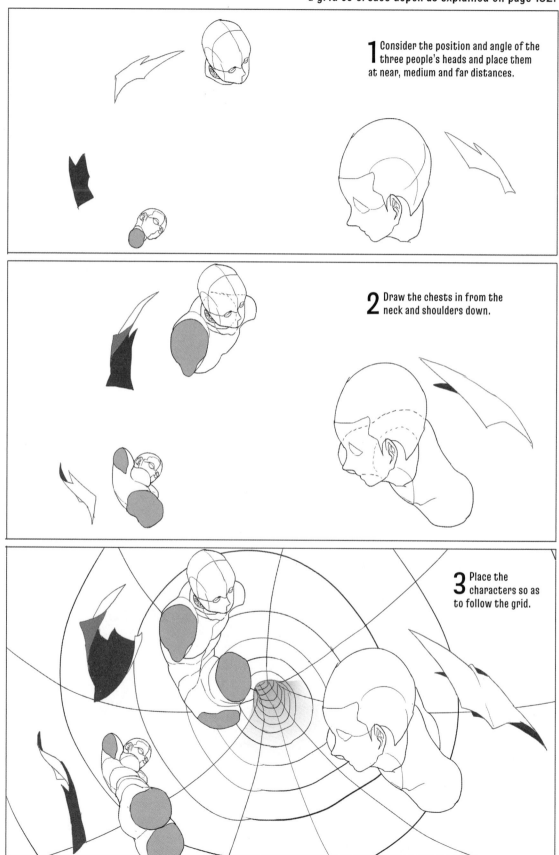

1 Consider the position and angle of the three people's heads and place them at near, medium and far distances.

2 Draw the chests in from the neck and shoulders down.

3 Place the characters so as to follow the grid.

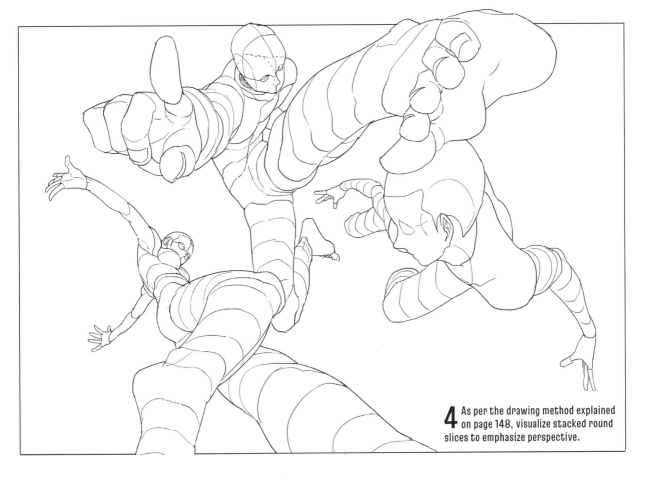

4 As per the drawing method explained on page 148, visualize stacked round slices to emphasize perspective.

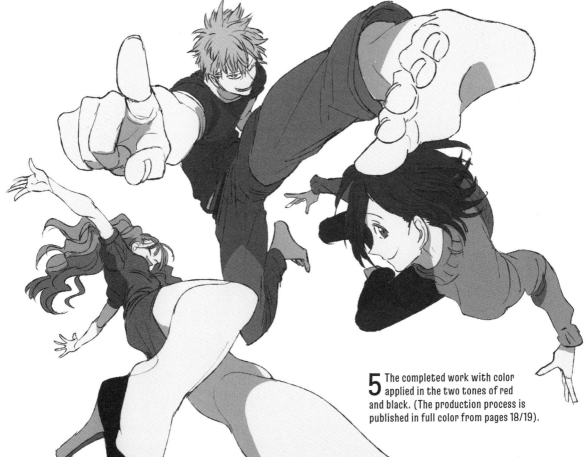

5 The completed work with color applied in the two tones of red and black. (The production process is published in full color from pages 18/19).

Practice for creating space with a "grid"

Rather than thinking in a planned way about how to present a drawing, drawing lines first and then considering what object they resemble makes creating a space fun.

An example of using coincidentally formed optical illusions

"Pudding" shape

Creating a "pudding" shape from a base shape

Draw in a rough oval

1 Draw an ellipse and add a curved line.

2 Mark in a grid, trying various approaches to work out which areas are flat and which are curved.

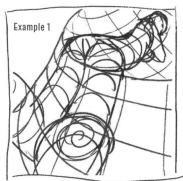

3 Position the character.

The same "pudding" shape can create all kinds of spaces depending on how the grid is marked in!

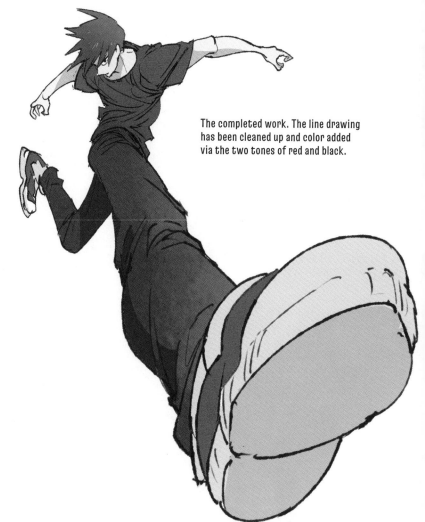

Example 1

The "pudding" shape as a solid object.

The completed work. The line drawing has been cleaned up and color added via the two tones of red and black.

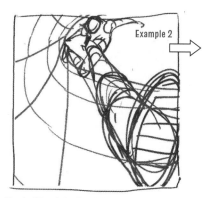

Example 2

The inside of the "pudding" shape as a space. This is done similarly to a cylinder space.

156

Make use of coincidence to create interesting scenes!

Depending on the swell created by the grid, it may appear caved in or protrude towards you, creating such a space that fills the screen. When adding in figures, extremities such as the limbs and head may be cut off or objects may all be positioned towards the edge of the screen, but this all leads to fun in terms of the picture. There is often the sense of a story and momentum in pictures with parts cut off or with objects all on one side, but I think it's difficult to consider arranging objects like this without knowledge of how to show them. Using the method of placing figures in a space created by chance via a grid gives rise to interesting unintentional balance and fit within the screen, with parts cut off or lots of blank space. Use the grid as guidelines to arrange objects such as small items in the background to achieve a work with a high degree of perfection.

Making a triangle appear hollow

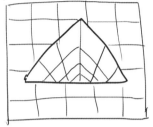

1 Draw a triangle in the middle of the grid and add in lines so that it appears to narrow towards the bottom.

2 Position a figure to fit over the triangle.

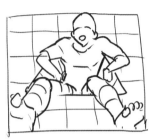

3 Make the figure sit with its legs spread out to take up the whole screen.

Make a triangle appear pointed

1 Draw grid lines on each side of the triangle.

2 Position figures on each side.

3 Create specific poses.

The cleaned up example of the work in which the triangle was depicted as being hollow. Here, the toes which were cut out of the screen have been drawn in, but it would be fine to finish off the work without them. Depending on the composition, cutting out the feet may bring out bold movement in the work.

Draw a Character with a Sense of Perspective

1 Use overlapping to bring out depth in front and behind

In order to draw a figure that follows grid lines, it's necessary to make them completely "deforme". "Deforme" means to consciously distort forms. Here, I'll introduce the example of the "arm extended out in front" pose which is often seen in signature poses. Work with the strong sense of depth to make the figure and its parts large or small in deforme style, with overlapping to render the sense of front and back.

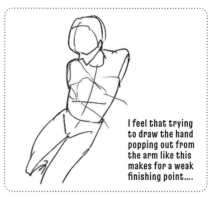

I feel that trying to draw the hand popping out from the arm like this makes for a weak finishing point….

1 Don't apply too much perspective to the figure that will form the base.

2 First off, draw in the hand in front at the size you want.

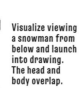
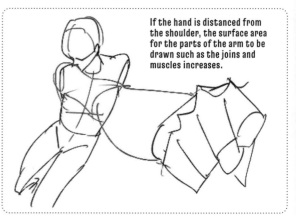

Visualize viewing a snowman from below and launch into drawing. The head and body overlap.

If the hand is distanced from the shoulder, the surface area for the parts of the arm to be drawn such as the joins and muscles increases.

3 In order to render a stronger sense of perspective, forget the concept of an "arm" for the moment and draw with the momentum of sticking circles together.

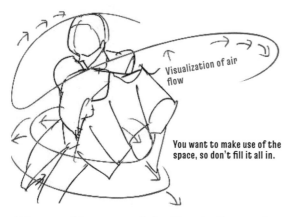

Visualization of air flow

You want to make use of the space, so don't fill it all in.

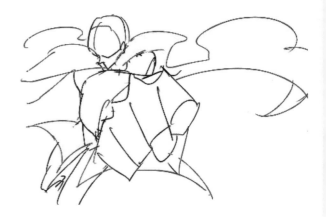

4 In a pose with momentum, depict things that flutter such as hair and clothing being caught up in the current of air.

5 Rather than being worried about the structure of clothing and so on, one way of doing things is to just draw it flowing out to get an idea of the overall movement. As long as it looks like it should, it's fine.

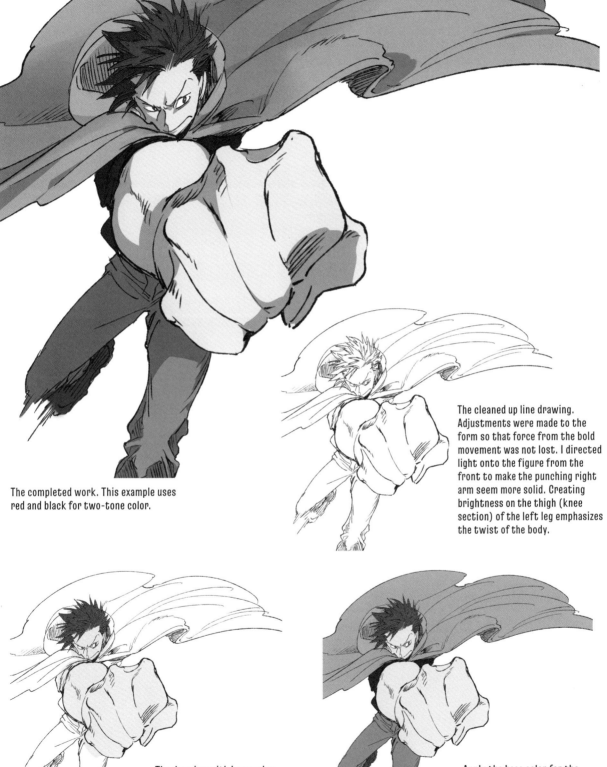

The completed work. This example uses red and black for two-tone color.

The cleaned up line drawing. Adjustments were made to the form so that force from the bold movement was not lost. I directed light onto the figure from the front to make the punching right arm seem more solid. Creating brightness on the thigh (knee section) of the left leg emphasizes the twist of the body.

The drawing with base color applied to skin and hair.

Apply the base color for the cape and clothing and check the overall balance.

2　Move the figure beyond the range of motion

When expressing a sense of speed or liveliness in addition to a strong sense of perspective, "slightly unrealistic" movements that are beyond the range of motion for the human body work perfectly. Let's boldly move each joint to create poses. Similarly to the example on page 148 where cylinders replaced body parts to express perspective, this works smoothly when the figure is divided into round slices. Just as in the rough drafts for examples drawn so far, adding in various lines to act as guides enables a smooth grasp of the body's form.

Make use of cross-section outlines

Drawing in cross sections (parts colored red) to connect the neck and shoulders which will not be visible in the end result makes the physical form easy to understand. Use this method effectively in cases of extreme perspective such as from low or high angles or to check the shape of the body when twisting. Once you've got used to it, you'll be able to create a rough draft without drawing them in.

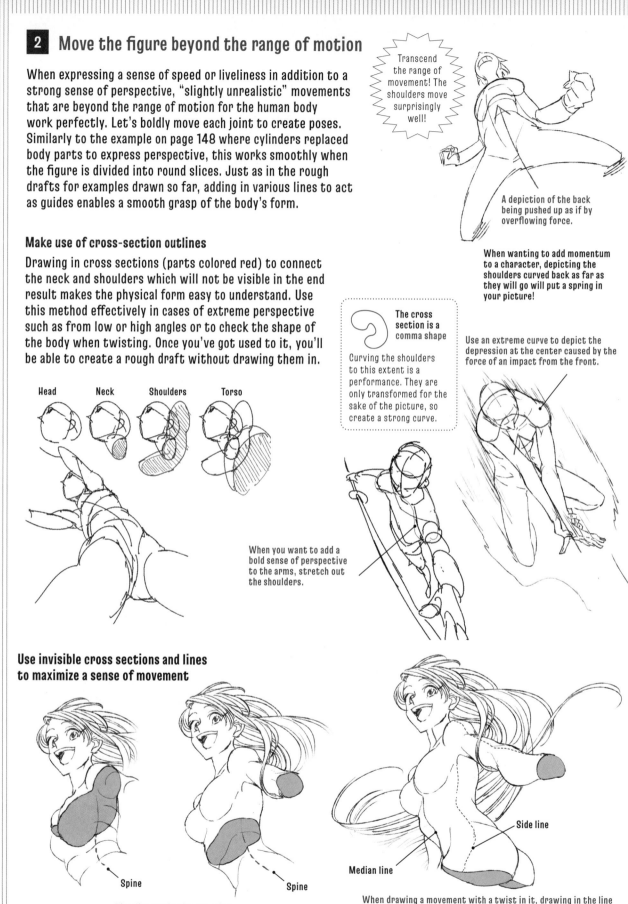

Transcend the range of movement! The shoulders move surprisingly well!

A depiction of the back being pushed up as if by overflowing force.

When wanting to add momentum to a character, depicting the shoulders curved back as far as they will go will put a spring in your picture!

The cross section is a comma shape

Curving the shoulders to this extent is a performance. They are only transformed for the sake of the picture, so create a strong curve.

Use an extreme curve to depict the depression at the center caused by the force of an impact from the front.

Head　　Neck　　Shoulders　　Torso

When you want to add a bold sense of perspective to the arms, stretch out the shoulders.

Use invisible cross sections and lines to maximize a sense of movement

Spine

Spine

Visualize the line for the spine.

Side line

Median line

When drawing a movement with a twist in it, drawing in the line for the side of the body makes it easier to create a smooth form.

The nude line drawing created from a cleaned up sketch. In this example, the high heels were left out to show the soles of the feet.

An example of the figure clothed and colored in the two tones of red and black. The simple T-shirt and shorts emphasize the liveliness in the jump and attractive curved lines in the limbs. Since it is a piece that shows off attractive legs, high heels were added at the concept stage of the draft sketch.

Use an Extremely Freeform Grid to Draw from a Low Angle

This is an evolved form of the method practiced on page 156 of first creating a space and then placing a figure into the empty space. First, rather than creating a particular form, roughly make divisions within the screen such as sky, earth, the horizon line or horizon to form the space. Then, draw in only the positions for the character's extremities such as the height of the head and where to place the feet. It doesn't have to be the feet, it could be the hands. Even with the same positioning, whether you place the feet or hands on it makes for a different composition, so it's interesting seeking out patterns that are easy to draw.

1 Draw a curved line to divide the screen, with the curve facing up

1 Draw a dividing curve like the horizon line slightly towards the top of the screen.

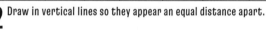

2 Draw in vertical lines so they appear an equal distance apart.

3 Draw in horizontal lines as well to form a grid. Decide only on the positions of the head and feet.

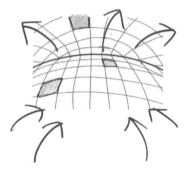

In order to more easily visualize "looking up from below," create a curved grid that swells out from the bottom to the top.

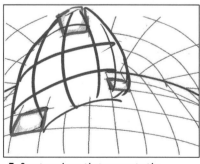

4 Create a shape that connects the squares representing the positions of the head and feet.

Following the grid in the background to visualize an object that swells out towards the front.

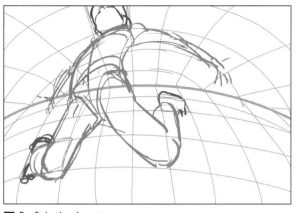

5 Draft in the character.

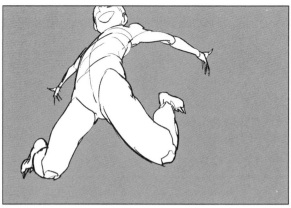

6 The finished sketch. Even without the grid in the background, the jump is powerful and conveys a sense of space.

Key Point

When blocking in, place the character so that their body and limbs arch to follow the curved lines of the grid.

Use soft curves to form the lines for the arms, legs and body.

Key Point

For these situations also, keep cross sections of the body in mind (see page 160) and use cylinders to form a solid look!

7 The cleaned up sketch with color applied. The head that was cut off in the initial sketch has been added and the hair and clothes have been given movement. I added the head in order to form the character, but it would also be interesting to leave it as-is to create a standalone picture.

2 Mark in a dividing curve to face downward

Adjust the size of various parts to match the squares created in the intersecting grid lines. Draw in the line of the character's body so that it bends to follow the curved lines.

1 Mark in a dividing curved line towards the bottom of the screen.

2 Mark in vertical lines.

3 Mark in horizontal lines as well to form a grid.

4 Decide only on the positions for the extremities of the head and feet.

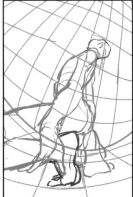

5 Sketch in the character.

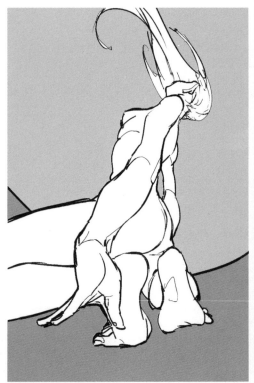

6 The completed sketch.

Key Point

Exaggeratedly distort the space!

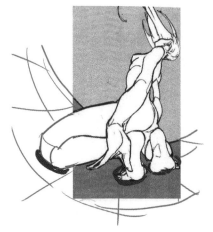

The legs are drawn at such a size that they poke out of the screen. In order to draw a "figure with insane proportions," prepare a "background with insane distortion." The feet and knees follow the curves of the floor so are in contact with the ground.

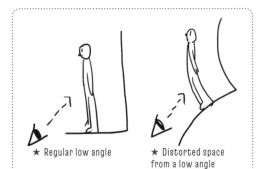

★ Regular low angle ★ Distorted space from a low angle

3 Try overlapping two grids

Visualize the height of the head and lower body (buttocks) but overlapping two grids of different sizes. This is a composition viewed from an extremely low angle. Even if you intend to start out by drawing as if looking from directly below the figure, it's difficult to visualize. Using grids to "basically determine the size of body parts" makes it easier to determine the size of the torso sections that connect them.

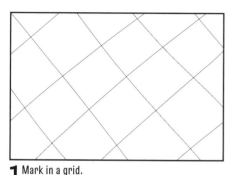

1 Mark in a grid.

2 The other grid is in the background so make it on the small side.

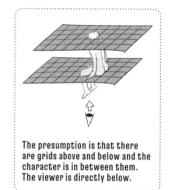

The presumption is that there are grids above and below and the character is in between them. The viewer is directly below.

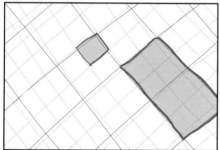

3 The small square is the height of the head while the large square is where the buttocks are positioned. When looking up, the top grid can be seen through the grid in the foreground.

4 Roughly block the figure in to proceed with the draft sketch.

5 The completed sketch.

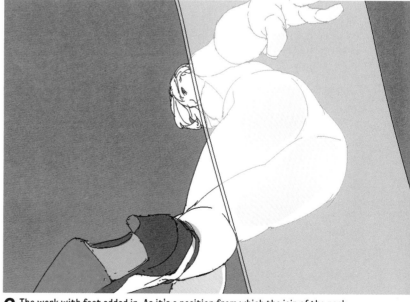

6 The work with feet added in. As it's a position from which the join of the neck cannot be seen at all, it's difficult to place the head on. Creating cross sections in the neck and shoulders in the rough draft to connect the body makes for smooth drawing (see page 160).

Use an Extremely Freeform Grid to Draw from a High Angle

Pull a curved division line upward

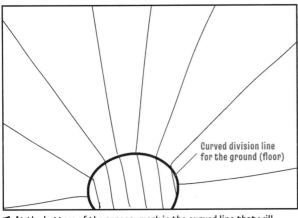

1 At the bottom of the screen, mark in the curved line that will demarcate the ground and draw in vertical lines.

For a low angle where the feet are in the foreground, it's easy to make use of the width in the pose, but in an overhead angle, the head is in the foreground and unlike the legs, it's not possible to move it anywhere you like, so it's very difficult to create variation. Then again, I think it's easy to bring out subtle nuances in the shift of gravity to one side, how the character is standing and so on.

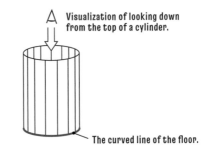

Visualization of looking down from the top of a cylinder.

The curved line of the floor.

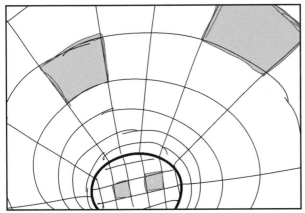

2 The pink squares ▨ at the top are not where the heads will fit in, but markings to use as guidelines for the heads' size and height (from the floor).

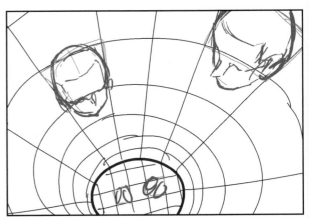

3 It's difficult to create balance in pictures with body parts sticking out from the screen. Using squares which happened to be cut off when the grid was marked onto the screen as the positioning for heads and limbs makes for a natural fit.

4 Figure 1 is leaning against a wall while figure 2 is standing straight and tall. In order to make their postures clear even from an overhead angle, change the visible ratio of the upper and lower bodies (see page 58) and divide the figures into blocks.

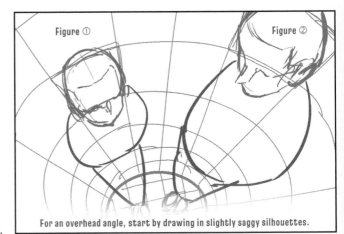

Figure ① Figure ②

For an overhead angle, start by drawing in slightly saggy silhouettes.

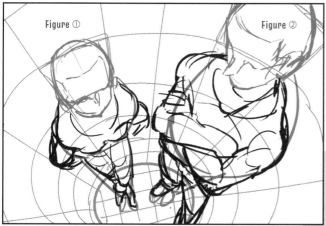

Figure ①

Figure ②

Figure ①: Lower body is readily visible.

Figure ②: Upper body is readily visible.

5 Visualize the height of the space using the grid, determine the height of the head and feet and consider how the upper and lower bodies will fill in the space between them in order to draw them in. As there is a difference in the characters' physiques, it's a good idea to firstly mark in the positions where they differ, such as their heights and the height of their hips, before proceeding.

6 The finished sketch. Mark in male and female differences and add hairstyles.

7 The work with clothing, color and fine details added. I've directed light onto figure 1 to bring the chest and crossed legs into focus. When drawing a figure viewed from overhead, parts that are readily visible and parts that can hardly be seen vary, such as in the drawn-back hips, lean in the body and so on, so use light to guide the line of sight.

Let's Review Bold Movements with Perspective and Twisting

Compress parts as much as you like

1 Start by drawing a giant foot. For the moment, ignore its size compared with the head, how it will fit in terms of the size of the canvas and so on.

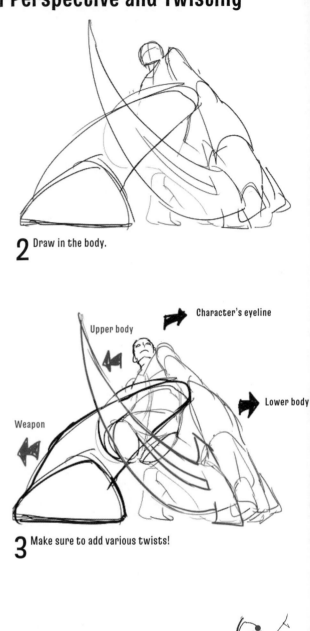

2 Draw in the body.

3 Make sure to add various twists!

Character's eyeline

Upper body

Lower body

Weapon

Various twisting poses

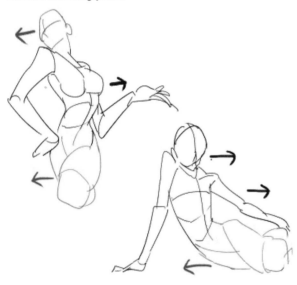

Depicting reduction of length in the legs

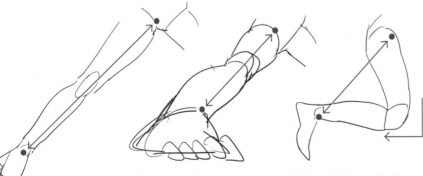

Actual length
(in extended state).

Foreshortened to create
a sense of perspective.

If the knee is bent to the side...

Applying perspective when the leg
is bent alters the angle of the leg,
so depending on the composition,
can make for an awkward look.

Bring out a sense of movement with the undulations of the hair

It is a good idea to draw the hairline onto the head as it makes it easier to capture the shape. As on page 130 where we divided the hair into blocks, Try substituting in objects for hair to create movement.

Loop type

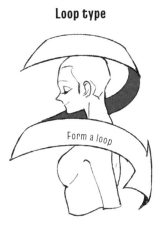

One-way type

Sudden brake type

1 Don't overdo things when drawing complicated hair, but take a flexible approach by substituting in objects that you find easy to create movement in. Here, let's consider it by using arrows.

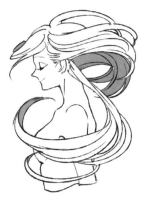

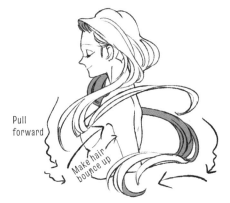

2 Create form by following the surface and underside of the arrows, keeping in mind the outer and inner surfaces of the bundles of hair.

Draw in movement that contrasts with the flow from the hairline and blend it in with the hair bundles drawn in step 2 for a more fluid look overall.

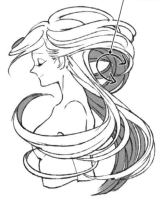

3 Play up the flow of hair created in step 2 by adding relaxed bundles of hair in the center. Adjust the volume and blend to finish.

*The center is an important focal point.

Experiment with different types of hair movement

Draw the base character.

Type that follows the shape of a circle

1 Draw a donut-shaped space.

Application of the one-way type

1 Try placing loops so that they enclose the entire figure.

2 Make the hair follow the swell of the donut to bring out volume on the inside surface of the hair (refer to page 131 for a colored version of this example)

2 Maintaining the sense of the outer and inner surfaces of the round slices, make the hair follow the path they create. Even though it is broken up into parts that cling to the body and parts that spread out into the background, the overall look that was created by the round slices is retained, so it flows properly.

3 Cast shadows onto the hair bundles that correspond with the undersides of the round slices to build depth.

Application of the loop type

1 Fill the entire screen with loops joined together.

2 Draw in only the parts that will form the outer surface of the hair, following the curved lines to cut sections off.

3 Add the inner surfaces and connect them to the outer surfaces, creating huge, curly pigtails!

4 Add in fine lines with soft movement to create nuance in the finished work.

Observe a real person

It was like this

The sagging of the collar creates space in the gap between the hair and neck which appears refreshing and sexy.

Let's consider what the person is looking at and what they are thinking, or what they are noticing. For instance, if you see a woman's hair on a train and think that the way it flows from her neck over her shirt collar is pretty and sexy, make a sketch or take note of it before you forget. It will come in handy when you want to draw a sexy picture or a character with a bit of sex appeal. Being on trains and other transport allow you to observe other people at extremely close quarters, so spending your trip scrolling on your phone is a wasted opportunity. I actually have a feeling that sources other than pictures offer more opportunities to get ideas for creating pictures.

Once you can specifically remember (or write down) "what you saw and how it made you feel", and when you have more memories of favorite body parts and beautiful scenes, drawing people is really fun. Don't let your own sensitivities slip away. Unless you have a strong sense of the kind of thing you want to portray, it's hard to create a work that is worth looking at.

Boost the Sense of Storytelling via the Hand Gestures

I think the gesture of holding an object is a very helpful way to make a composition cool, whether in an everyday situation, a battle scene, or pose-oriented situation. For example, a pole-like object is convenient as they can be held in various ways and they work in easily with the human body. If you're struggling with a pose or action, simply giving the character something to hold allows you to avoid getting stuck recreating the same look over and over again.

Try making the character hold a pen

"Holding a pen" is not only for writing something, so with that in mind, there must be at least 50 different situations that this gesture could be used in, making familiar objects extremely valuable as small props.

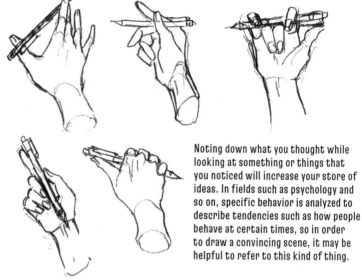

Fiddling with something unrelated to the conversation and looking away, resting the chin on the hand... in a scene where the character is talking to someone, this indicates minimal interest in what is being said, or that the character is relaxed and not being overly attentive. Combine the expression and behavior to depict the characters' mental states and the relationship between them.

Noting down what you thought while looking at something or things that you noticed will increase your store of ideas. In fields such as psychology and so on, specific behavior is analyzed to describe tendencies such as how people behave at certain times, so in order to draw a convincing scene, it may be helpful to refer to this kind of thing.

Bringing out nuance in the way an object is held

Try making characters hold various small props. Even if it's the same item, if the weight changes, the way it is being held and how much strength is needed to hold it will vary. Draw to differentiate whether the character is holding something unconsciously or intentionally choosing how to hold it, depending on the scene. This makes it easier to convey the character's emotions and situation to someone viewing the picture.

Try making the character hold a plastic bottle

The bottle is gripped firmly, using all the fingers and the entire hand. It is quite full.

The cap is caught between the fingers and the bottle is gripped with the back of the hand. There is not much in the bottle and it is quite light.

The bottle is held between 2-3 fingers. The contents are not very heavy.

The bottle is held pinched between the fingers. Usually when holding something in this way, the thumb and index finger are used, but try using the thumb and middle finger. The fingers will spread out, so you can create the look of holding something this way intentionally.

When people have nothing to do or are at a loose end, they tend to fiddle with body parts or with objects around them, so when drawing a scene with nothing much happening, adding movement to the hands dramatically boosts realism. Get in the habit of observing the unconscious behavior of people around you and memorizing your own unconscious gestures and poses.

In a decisive shot that emphasizes the pose, the shape of the hands is very useful for building tension.

Final Thoughts

Until I was invited to write this book, I was an amateur artist. It was my "making of" posts (about how I created pictures as a hobby) that led to Tsubura Kadomaru, the editor, emailing me to ask if I would publish a book on techniques. At the time I was quite suspicious about it. Since then, I've had offers of work from various places, with the result that the title of "illustrator" now follows my name.

This is a book of techniques for drawing figures, but there is no heading such as "first, let's learn the human bone structure, muscles and proportions!". The reason is simply because I know nothing about them.

Drawing pictures shouldn't be a process of practicing purely to prepare for producing a masterpiece. All the processes and drafts are important, and they can all be works of art.

The how-to tutorials that I post on the internet are artworks in themselves. I try various approaches and methods of drawing when I prepare them; they're artwork that puts my ideas into practice.

If there are drawings that can be done because one has the knowledge, there are also drawings that can be done because one doesn't have the knowledge.

What I found difficult while creating this book of techniques was producing misfires, examples of poor technique or what not to do.

It doesn't look right when a person with knowledge attempts to mimic the work of someone without it. That's why once you gain more knowledge and techniques, you won't be able to draw the pictures that you can now. Despite the growth and change you seek as an artist and illustrator, it's also important to enjoy the expression that is only possible at this moment.

I'm saving the basics of the human body and sketching for when I want to learn them. I'm looking forward to a future moment when I've mastered them too.

Ebimo

The author's work environment. I use a laptop and LCD tablet. Only recently have I started using an LCD tablet; before that I used one with a keyboard. Currently I'm also setting up a desktop computer.

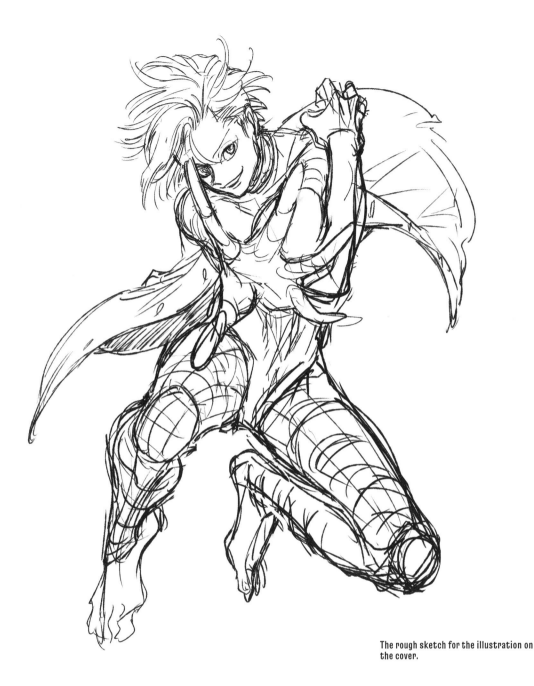

The rough sketch for the illustration on the cover.

Well, everyone, here it is. We present to you the sketch technique book from Ebimo, "master of the omnidirectional approach" and "grid magician." Her way of capturing bold poses and dramatic movement is so powerful that words cannot express the impact felt when viewing her work. When I asked her to draw for me with a mechanical pencil, it was just one fresh surprise after another. It seems that for Ebimo, her numerous "making of" tutorials are extensions of the sophisticated sense of "play" she brings to her work, but for those of you who enjoy drawing and are looking to improve, there is a wealth of hints to strengthen your skills. As I write this, all sorts of ways to bring out the charms of your characters are coming to me... but it looks like we'll leave that until next time.

Tsubura Kadomaru (Editor)

"Books to Span the East and West"

Tuttle Publishing was founded in 1832 in the small New England town of Rutland, Vermont [USA]. Our core values remain as strong today as they were then—to publish best-in-class books which bring people together one page at a time. In 1948, we established a publishing office in Japan—and Tuttle is now a leader in publishing English-language books about the arts, languages and cultures of Asia. The world has become a much smaller place today and Asia's economic and cultural influence has grown. Yet the need for meaningful dialogue and information about this diverse region has never been greater. Over the past seven decades, Tuttle has published thousands of books on subjects ranging from martial arts and paper crafts to language learning and literature—and our talented authors, illustrators, designers and photographers have won many prestigious awards. We welcome you to explore the wealth of information available on Asia at www.tuttlepublishing.com

Published by Tuttle Publishing, an imprint of Periplus Editions (HK) Ltd.

www.tuttlepublishing.com

DAITAN NA POSE NO EGAKIKATA
Copyright © Ebimo, Tsubura Kadomaru/HOBBY JAPAN
All rights reserved.
English translation rights arranged with Hobby Japan Co., Ltd. through Japan UNI Agency, Inc., Tokyo

English Translation © 2022 by Periplus Editions (HK) Ltd.

ISBN 978-4-8053-1675-7

Library of Congress Control Number: 2021942691

25 24 23 22 21 10 9 8 7 6 5 4 3 2 1

Printed in Singapore 2108TP

Distributed by
North America, Latin America & Europe
Tuttle Publishing
364 Innovation Drive
North Clarendon, VT 05759-9436 U.S.A.
Tel: 1 (802) 773-8930
Fax: 1 (802) 773-6993
info@tuttlepublishing.com
www.tuttlepublishing.com

Japan
Tuttle Publishing
Yaekari Building, 3rd Floor
5-4-12 Osaki
Shinagawa-ku
Tokyo 141 0032
Tel: (81) 3 5437-0171
Fax: (81) 3 5437-0755
tuttle-sales@gol.com

Asia Pacific
Berkeley Books Pte. Ltd.
3 Kallang Sector, #04-01
Singapore 349278
Tel: (65) 67412178
Fax: (65) 67412179
inquiries@periplus.com.sg
www.tuttlepublishing.com